A WORLD IN
HDR

BY @TREYRATCLIFF
AKA STUCK IN CUSTOMS

D1532177

New Riders

VOICES THAT MATTER™

A World in HDR
Trey Ratcliff

New Riders
1249 Eighth Street
Berkeley, CA 94710
510/524-2178
510/524-2221 (fax)
Find us on the Web at: www.newriders.com

To report errors, please send a note to: errata@peachpit.com

New Riders is an imprint of Peachpit, a division of Pearson Education.

Copyright © 2010 by Trey Ratcliff

Editor: Rebecca Gulick
Production Editor: Lisa Brazieal
Development and Copy Editor: Anne Marie Walker
Proofreaders: Liz Welch and Elle Yoko Suzuki
Cover and Interior Design: Fabien Barral
Compositor: Fabien Barral with Maureen Forys
Indexer: Valerie Haynes Perry
Prepress Coordinator: Mimi Vitetta

ISBN 13: 978-0-321-67994-9

ISBN 10: 0-321-67994-6

9 8 7 6 5 4 3 2 1

Printed and bound in the United States of America

DEDICATION

For my wife Tina and my children Ethan, Isabella, and Scarlett, all beautiful and clever.

ACKNOWLEDGMENTS

I am well known for saying that I like to surround myself with very smart people, so that I am generally considered the dumbest person in the room. I feel like this is certainly the case with this book.

To be frank, I strongly considered self-publishing. I figured that because I have a very popular Web site I could do everything on my own. In the end, I chose to go with New Riders, and it's one of the best decisions I've made. The team that was assembled around this book was quite impressive, and they have made this book more solid than it would have been on its own.

Rebecca Gulick ran point for the team as the Senior Editor. Most of my day-to-day editing was overseen by Anne Marie Walker who always seemed to figure out what I was trying to say by untangling my philosophical ramblings. I'm very right-brained, so these two had a yeoman's job of keeping that bit accessible to a wide audience, and they did a great job.

Other important members of the team were Nancy Ruenzel, Scott Cowlin, Nikki McDonald, Mark Levine, Mimi Heft, Sara Todd, Lisa Brazieal, and Laura Pexton. And I can't forget Ben Willmore, who wrote such a kind foreword. I'll never forget how we first met. He had some auto parts shipped to my place so that he could later install them on his bus parked out front for a week. I knew that any man who lived on a bus and created fabulous HDRs therein was just the kind of fella I would like.

In addition, I'd like to thank my fabulous graphic designer—the indomitable Fabien Barral who had many personal issues throughout the production of the book but was still able to work through it. He is an absolute genius, and I always enjoy working with him.

CONTENTS

FOREWORD

This book could have only come from the mind of Trey Ratcliff. He has the unique perspective of someone who is not a full-time professional shooter yet can produce more finished art shot in exotic locations than any pro I can think of. I've been following his adventures through the daily posts on his www.StuckInCustoms.com Web site. I'm simply amazed that he can handle working at a "real job" while producing a constant stream of top-notch images.

His passion for photography comes through in this book, where he guides you through each shot, giving you a sense for what he was thinking when shooting and just enough technical details to give you a sense for what was needed to make the image successful. Along with that comes a healthy dose of imagery that really shows off what HDR is capable of. He also shares with you his approach to photography in general and helps explain why HDR photography can capture an image that is often closer to how your brain interpreted a scene than to what a single image capture could produce.

Here you're given equal doses of inspiration, example, and tutorial that make this a unique book that would feel quite at home on the coffee table, and it almost feels like a shame to let it hide away on a shelf populated with a bunch of Photoshop technical tomes.

What's refreshing about this book is that Trey does not get bogged down in overly technical discussions where you feel you might need a dictionary at your side to make it through a chapter. Many other HDR books seem to have more of a technician's perspective where it is uncertain if the author is capable of producing aesthetically pleasing imagery. Trey, on the other hand, stays focused on the artistic process from how to think when shooting to how to work your image from start to finish. He also avoids wasting your time by not trying to explain features that do not relate to photography, and he is not afraid to ignore features that he doesn't find to be useful. That makes for a book that is easy to read and can keep any artist's interest. By the time you finish the book, you just might find yourself planning a vacation trip to one of the destinations shown in the book.

—Ben Willmore

WELCOME TO THE WORLD IN HDR

I saw the light. Now I want to tell you about it.

Just a few years ago I embarked on a journey into the world of visualization. Along the way, I've been joined by many new friends who share my excitement for capturing this elusive world of light. I'd like to begin this book by thanking all of them for making this grand experiment possible.

In the beginning, I saw High Dynamic Range (HDR) imaging as an amazing mechanism to help people capture the world in new and exciting ways. I began extensive trials and invited the world to join the HDR community, provide feedback, and share what they learned and created. It seemed that art was evolving as quickly as the mechanisms for social sharing and distribution online.

The nexus of all this emergent activity and study was my StuckInCustoms.com blog. It went unnoticed for a long time; it was just my mom and me who paid attention to the lonely site. I certainly never expected it to grow into the beast it has become. It turned out that HDR photo experimentation had a life of its own, and the tutorials I whittled together spawned a new generation of enthusiasts.

A lot of us have seen the light for a long time. Now with HDR we have a way to capture and share it with the world.

WHAT IS HDR?

High Dynamic Range (HDR) photography is an evolving form of art that enables the photographer to capture and display the full range of light that can be realized by the human eye. Note that I say it is a form of art. I will not get into a long, protracted conversation about reality versus art because it's a pedantic argument. To me, art is a representation of the world we experience and all forms of photography fall within this sphere.

HDR photography can be achieved through a series of steps in the camera and in postprocessing. These steps (and more!) are described in detail in Chapter 5, "The HDR Tutorial."

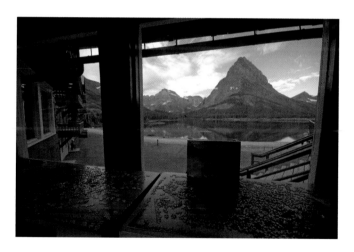

This is the before shot.

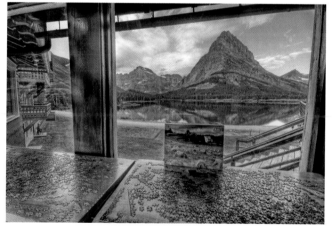

This is the after shot that shows in plain view how HDR can accomplish in a photo what the human eye can accomplish on the scene. What a wonderful new world of photography this has become!

SEEING THE WORLD IN DIMENSIONS AND LIGHT

I've come to know HDR through a circuitous route. Perhaps the retelling of this winding progression will help you to begin the process of thinking about how the brain processes light.

Thanks to a few unlucky (or lucky?) cards dealt in the genetic poker game, I grew up blind in one eye. Most people experience the world in 3D, and their brain helps

> *Thanks to a few unlucky (or lucky?) cards dealt in the genetic poker game, I grew up blind in one eye.…My brain could receive meaningful input from only one eye, so everything got wired up a bit differently.*

them to navigate the world using wonderful tricks like parallax and dynamic perspective. My brain could receive meaningful input from only one eye, so everything got wired up a bit differently. Consequently, for all practical purposes, I've spent my whole life looking through a camera lens.

My mind and memory have always worked in such a way to enable 2D vision to map action into a 3D world. I played sports actively: Soccer was just "different." Instead of detecting where the ball was using 3D parallax, my brain would work out the diameter of the ball and map that to the distance from my foot. In addition, I would pay special attention to light and relate that to distance. The

oversensitivity to light, 2D mapping, depth compensation, and memory worked together in an imperfect symphony. When you grow up with a distinct set of givens, you have no perspective on how it can be different from other people. I believe that everyone has a unique visual situation when growing up, and the way our brains were wired is worthy of introspection.

A fortuitous childhood fascination with computers and programming, thanks to my Uncle Richard, also prompted me to look at the world in an unordinary way. This blossomed into a major in computer science and a minor in mathematics. From an early age, I've thought of the world and actions in terms of simple inputs that can be iterated upon to create complex patterns. I've also been fascinated with the inverse of this—the deconstruction of the seemingly endless complexity of nature into its constituent bits. This resulted in a desire to bring order to the entropy via visualization techniques.

Now, you don't have to be blind in one eye and have a computer science degree to understand HDR. Throughout the book, I'll explain it in a variety of ways and provide an assortment of examples. You will come to know HDR in your own way, and I hope my experience in these matters helps to get you on the fast track.

MAKING SENSE OF THE WORLD

Little did I know when I started to refine my approach and create HDR images that so many people would embrace and identify with my results. It turns out that many people see the world like this, a vibrant, dynamic, and beautiful place that we can only hope to capture with the camera.

When I first used a DSLR camera, I noticed the resulting image was not how I remembered the scene. I very quickly began studying the fundamentals of HDR techniques and started to adapt the algorithms to something that made sense for me. Over time I arrived at a unique series of steps to facilitate a final image.

I did all of this as a personal experiment. I never expected it to resonate so widely with people. Now I realize that this style of visualization is in fact how many people remember the scenes around them. Many of us have a "romantic" memory, see a striking world, and attach all sorts of unexpected emotions and feelings to images. We can freely associate a beautiful sunset with smells, childhood, and the people we were with at the time when we saw a similar sunset.

The human memory is a tempestuous demon. Unbeknownst to us, the experience of one sense can evoke loosely related memories in another. I believe we all have, at least, a light dusting of synesthesia—the curious medical condition where one sense impinges upon another. From my personal experience, I know that the sound of ice cracking under warm Texas tap water brings up strange unfocused memories of the past. A quirky song from the 80s brings up softly shaped feelings of contentment. An unexpected scent causes an unfiltered sense of concern and wonder. I very much expect that the kind of person who would take the time to pick up a book such as this has had a very similar, yet unique, life experience.

THE NETWORK OF IMAGERY IN THE MIND

All the preceding experiences mentioned are tied together in a wild network of memories and reactions in your brain. No one image stands alone. They are inexorably tied to your unique history and the memories you bring forward into any given scene. Like a many-tentacled cephalopod, your mind immediately starts wrapping around the image and rooting it deeply into previous experiences and associations you've made in the past. A rich network is built around the image, and the neuron connections are sometimes unexpected.

When you view an image in HDR, the various light levels ripping through your retinex (the hinterland betwixt the retina and the cortex) can have unexpected consequences. Through the years, your brain has become quite accustomed to seeing photographs on a 2D plane with limited light levels. You never really expect a typical photo to be

as beautiful as being there. But when you see an HDR photo, the various light levels you experience as your eye traverses the image "tricks" your brain into thinking you might actually be there. This short-circuiting process means that your mind must immediately start mapping a new reality around these sorts of photos. Your mind will jump near and far as you build a new network of associations, feelings, and memories around the images. In other words, whenever you encounter something unexpected, your brain will map it to your own distinctive network of memories, which makes your experience of the new sensation uniquely personal.

VIEWING AN HDR IMAGE

Don't worry; viewing an HDR image is not as hard as seeing an autostereogram (also called a Magic Eye)—those strange pictures where you have to focus beyond them to see the hidden image.

There is only one rule for "ideal HDR viewing conditions." See it big. Here's why.

Imagine you are standing inside the edge of a forest. Beyond the forest are a grassy plain, a pretty lake, and

When you look at an HDR image, you also want your eyes to move around. When seeing lots of light levels, your eyes darting around help to "trick" your mind into accepting many disparate light levels at once.

some distant mountains. It's high noon, and dark but dappled shadows surround you in the forest. Think about what your eye does in that situation. It darts around like a hummingbird, painting all the various light levels into your brain in quick strokes.

When you look at an HDR image, you also want your eyes to move around. When seeing lots of light levels, your eyes darting around help to "trick" your mind into accepting many disparate light levels at once. If you have ever seen a small-sized or "thumbnail" HDR image, you may well have noticed that your brain may reject it because it's strange to have so many light levels without the eye needing to move. It's the same reason I've chosen to place large images in the book and on my blog. The small images that appear as the default size on the most popular photo-sharing sites like Flickr and Face-book are so woefully tiny that they really don't do justice to the HDR image.

NEW COMMUNITIES OF ART

The nature of the StuckInCustoms.com site has enabled more and more people who see the world in this wonderful way to immediately engage in a community. They invite their friends, show their favorites to loved ones, and are able to immediately share their experiences with others. Everyone has their distinct set of experiences that they bring to each daily post. The photo is often just a starting point for the conversation. Many of the conversations are internal, personal experiences. Everyone experiences art differently, and that's okay. Not everything is evocative or makes sense, nor should it. However, I do feel confident that the images herein will be evocative enough to encourage you to try making some HDR images.

I firmly believe that everyone in the world is creative and can create art. I'm also sure that the education system in a postindustrialized world of specialization-for-profit beats the artist out of most of us. If you happen to be part of an institution that encourages and nourishes the artist in you, consider yourself one of the lucky few. From the experience of helping tens of thousands of people realize this new art form, I am convinced that anyone can take the steps necessary to begin creating their own experiences using HDR imagery.

I cannot overemphasize the point that you can do this too! My simple tutorial in Chapter 5 can enable anyone to begin this fun process of visualization. Like everything else, it takes practice to produce better images consistently, but you will certainly be surprised by your first few attempts. This is a strange analogy, but it's not that different from golf. Even the beginning golfer occasionally hits

I firmly believe that everyone in the world is creative and can create art. I'm also sure that the education system in a postindustrialized world of specialization-for-profit beats the artist out of most of us.

a shot that is personally impressive. Over time, that "hit" rate will increase.

The book is a wonderful launch pad and reference, and this experience can be expanded to the extended community. Don't be scared: You'll find that photographers are some of the kindest people in the world.

ABOUT THIS BOOK

If you like photography, enjoy being stimulated by new ideas, and want to learn how to work with HDR photography, this book is for you. Whether you are someone who has an entry-level camera and enjoys taking photos or you are a professional with more lenses than your spouse knows about, this book holds something for you. Since this is a new and evolving area of photography, we all have new things to learn. Everyone, no matter if you are a beginner, an amateur, or a professional, wants to take better photos. This book speaks to a completely new style of taking photography, and there are lessons to be learned at every level. I've taught thousands of people to take their photos from the ordinary to the extraordinary, and I am confident I can teach you too.

The main part of the book—Chapters 2, 3, and 4—contains a portfolio of HDR photos along with descriptions, anecdotes, and various tips that describe how the photo was achieved. I've endeavored to include practical techniques throughout so that the format is pleasant for a straight-through read and perhaps as reminders for you to consider as you begin to work on your own. Chapter 5 includes my step-by-step HDR tutorial, and Chapter 6 discusses helpful pieces of software and other tools, as well as the equipment I use for HDR photos.

With this book I endeavor to give you all the tools and tricks to get you started or help you to further hone your craft.

Now, let's start exploring the world of HDR together.

RESOURCES

VISITING

- **Daily photography and community blog**
 www.StuckInCustoms.com

- **Free Newsletter with the latest news, tips, and community activity**
 www.StuckInCustoms.com/Newsletter

- **Photography Videos, including free ones referenced in the book**
 www.StuckInCustoms.com/Videos

- **Twitter**
 www.Twitter.com/TreyRatcliff

SHARING

- **HDR Spotting. Share your work with the world for free!**
 www.HDRSpotting.com

- **Facebook Fan Page (for discussions, sharing your work, news, and more)**
 www.facebook.com/StuckInCustoms

- **Flickr Community: Stuck in Customs' Brilliant Cabal—My Cool and Clever Friends**
 www.flickr.com/groups/
 stuckincustoms_brilliant_photographers

PHOTOGRAPHY EVOLVES

The equilibrium has been punctuated. Photography provides us all with a rich petri dish for artistic and scientific experimentation. With any discipline that encourages multidisciplinary tinkering, evolutionary principles are at work. We can see examples of how biology, industry, language, and more evolve, and this template for change also holds domain over photography.

The eleemosynary nature of the Internet and the artist has driven the evolution of photography forward faster than ever before. Artists love to share their work with others. As the economy evolves, it can be argued that attention is the new currency. Not since the Salons of Paris during the Impressionist movement have artists been able to engage in a global competition and cooperation in the endless quest to define the beautiful.

Is it possible to look at the world of photography from another vantage point, perhaps from another order of magnitude? We get caught up in the daily logistics of just getting through our lives and can miss major trends that are right under our noses. As we move throughout the frenetic Brownian motion of distraction of our immediate world, the human sense of near-term memory has trouble seeing much beyond the status quo. We stand in the middle of a confluence of the rich experimentation in the artistic side of photography with the ever-increasing advancement of the hardware. If we can learn to navigate these waters, we can use the rich tapestry of photography's past to create the incredible possibilities of the future.

HAPPENSTANCE EXAMPLES OF EVOLVING SYSTEMS

Evolution is often a series of small improvements interrupted with major events that can be seen, in perspective, as punctuated equilibrium. A good example known worldwide is the evolution of music. Culture, as well as biology and technology, are subject to these Darwinian forces. Previous centuries and decades had shown steady changes in music. Once Elvis appeared on the scene and introduced a super genre that came to be known as Rock & Roll, the entire music industry was transformed. People did not even know they had a taste for this new style of music until it magically appeared. Since then thousands of bands (pick your favorite) have taken the roots of these artistic rhythms into a broad array of new subspecies of music.

In a biological example, simple organisms had tubes (a series, if you will) and muscles. At one point, a muscle lay across a tube, electrically fired, and sent blood flowing downstream. This was the creation of the heart, and it enabled a broad new range of central-circulation species that were remarkably more efficient at growing complex bodies that needed blood and nutrients to be delivered to remote parts of the organism. It's hard to imagine the diaspora of wonderful creatures on the planet without this watershed event.

I asked Matt Ridley, the best-selling science writer and clever connector of disparate disciplines, for another unexpected evolution. He gave the visually stunning example of birds of paradise, which perhaps you have seen on *Planet Earth* or another documentary where vainglorious birds prance about in the forests of Papua New Guinea. The color, shape, and texture of the plumage in the male bird that gets exaggerated are completely random. The female, who prefers extravagant ornaments, then selects from those males. Ridley continues, "Rerun the tape of evolution and you would never get the Raggiana Bird of Paradise again, but you would get something just as bizarre (like Elvis!)."

THE SOFT MANIPULATION OF BITS

Photography is going through its most violent evolutionary cycle ever. Note that I am not talking about the evolution of hardware. Yes, cameras get more megapixels, better light sensitivity, more features, and the like. But I am referring to the evolution of photography.

For about 100 years, we have come to know photography through the coincidental mechanisms that have coalesced to create the "state of the art." Shutter speed, ISO, aperture, and such were the accidental apparatus of photography. The beginning of photography could have started in a much different way. It could have started with backlit plates or stereo dioramas, or perhaps even camera obscuras could have been the main trunk of evolution. However, none of that matters because today we have a photography industry that is fundamentally tied to the mechanical operations of shutters, apertures, ISO, and the like.

Marching into the second decade of the 2000s, the question is, why are we still holding up this Da Vinci-esque mechanical device to our eye to capture the world around us?

In my humble opinion, after sharing HDR photography with a wide variety of photographers and photography lovers from various cultures all around the world, I am sure that the HDR style of visualization will constitute a major step forward in evolution. Remember that the evolution of a new species does not mean the previous iteration will die out. There will be competition for resources, as in any ecosystem, but the market will expand to enable older and newer forms of photography to coexist peacefully.

Evolution is often a series of small improvements interrupted with major events that can be seen, in perspective, as punctuated equilibrium.

A TREASURE MAP TO YOUR FUTURE

An important point to you, the reader, is the fundamental concept that you are helping to drive this evolution forward. HDR will splinter into over a dozen subspecies, each with its own style for a variety of tastes. Do not look at the existing state of photography and assume there is no room for you to develop your unique style. There will always be room for something new, and the rapid change in the industry will help give you the tools you need to take your photography in whatever direction you desire. Think of The Beatles, The Go-Go's, or The Eagles: They took what Elvis made popular into wonderful and unexpected new directions.

This Chapter includes the first third of the HDR portfolio, complete with descriptions, tips, and various thoughts about science, philosophy, and art.

My goal is to get your right brain to release and start thinking differently about the "state of the art," a term that bristles with ever-new sensations in today's world.

Ultimately, I believe we are traversing the most exciting period in the history of photography. The use of emerging

There will always be room for something new, and the rapid change in the industry will help give you the tools you need to take your photography in whatever direction you desire.

visualization tools combined with your creative spirit can make something that is singularly beautiful and *uniquely yours*.

HONG KONG FROM THE PEAK ON A SUMMER'S NIGHT

I had a long day, waking up at 5:00 AM to take a series of subways and trains up to Shenzen for some meetings. I had a Chinese VISA, which you don't need to get into Hong Kong, but I had to use it to cross the official Chinese border after getting off the train. I failed to realize that it was a one-time use VISA, and I was scheduled to go to Shanghai the next day. This caused a lot of problems with the Chinese officials, a body of government with which I do not enjoy causing problems.

After returning to Hong Kong from a day in Shenzen, I was hot and sweaty and in the sort of meeting clothes that aren't great for being hot and sweaty. But everything about Hong Kong was awesome, and I had to look hard for something to complain about. The sun was setting, and I made it up to The Peak just in time for a shot.

This is a 5-exposure HDR shot taken at 100 ISO with a sturdy tripod to get all the lights as steady as possible. Don't fret if you don't know what "5-exposure HDR" means. All will be revealed in the tutorial in Chapter 5, which I suggest you read after you go through the first part of the book to get a good idea of why and when to use HDR.

There were a few people milling around nearby, which always makes me nervous because I fear they might kick one of the tripod legs. So I sometimes spread out my biped legs like a dork to provide a human shield while the shutters go about their merry way.

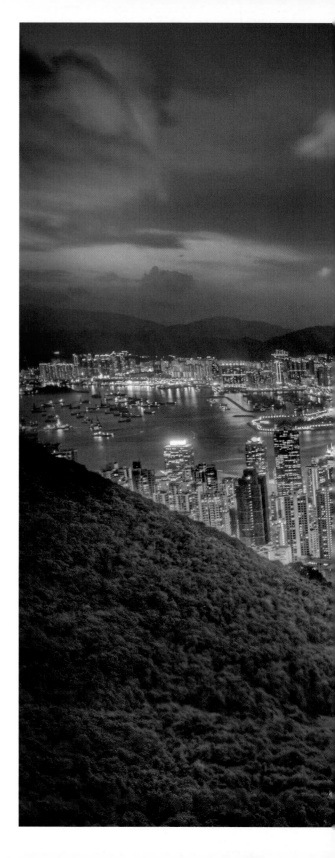

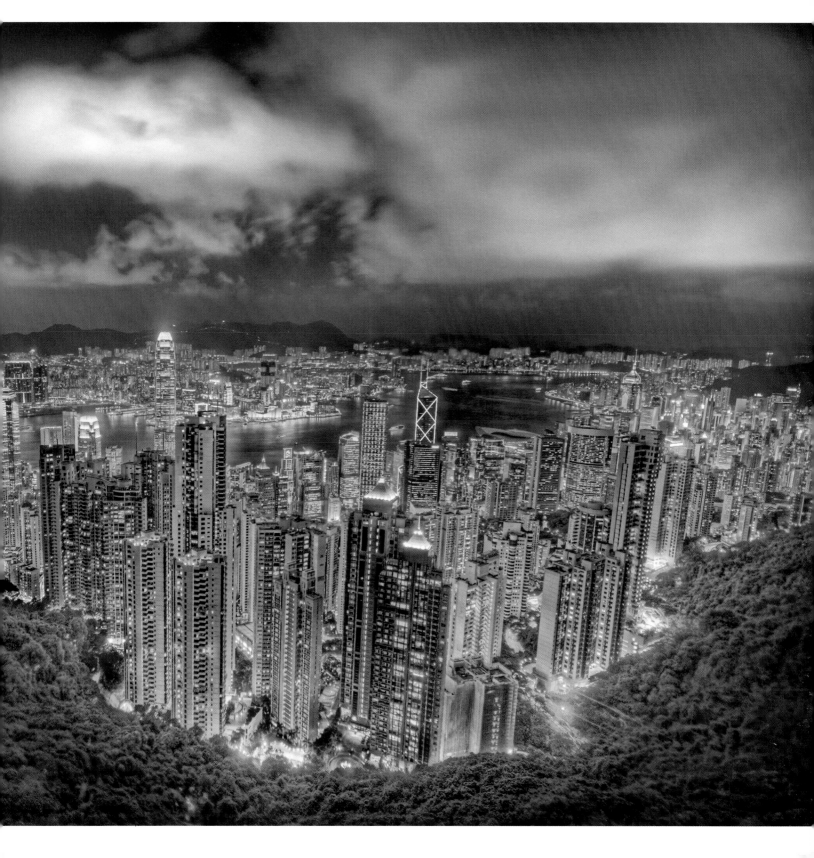

A NEO-ROCKWELLIAN CHRISTMAS

Now that we're getting to know one another, I might as well show you a family picture, eh? Here are my three kids in our home on a recent Christmas.

When dad is a photographer, there is a major degree of pressure to deliver photos on all the requisite holidays and celebrations! So, I decided to try and reinvent the family Christmas photo with HDR. Note that many of my inventions go down in flames, but as Winston Churchill said, "Success is the ability to go from one failure to the next with no loss of enthusiasm."

Christmas scenes have many light levels—the lights on the tree, the deep greens within the branches, a roaring fire,

lights in the room, reflections off the ornaments, and so on. It's wild! I'm pretty sure this is why people like Christmas scenes so much—a wonderful treat for the eyes that is rich in texture and light. Traditionally, it's been very difficult to capture so much richness in a single photo, save for a lucky and heroic combination of shutter speed, aperture, ISO, and lenses.

The tree lights made the faces of my three stunt children (who are also my real children) glow perfectly. No flash could have achieved this unless you are the kind of Rambo-flash guy who would bury one inside the tree to light their faces from the left. But let's face it; that's hard.

This is also a 5-exposure HDR. You will notice that I often use 5 exposures, but I could have done it with three exposures at -2, 0, and +2. Some silly Nikon cameras, like the D3X I use, will not let you step by twos, so I had to take five at -2, -1, 0, +1, and +2. The middle exposure, from which the kids' faces were masked in and perfectly lit, was shot at f/4 aperture, a shutter speed of 1/250, 100 ISO, and at 28mm.

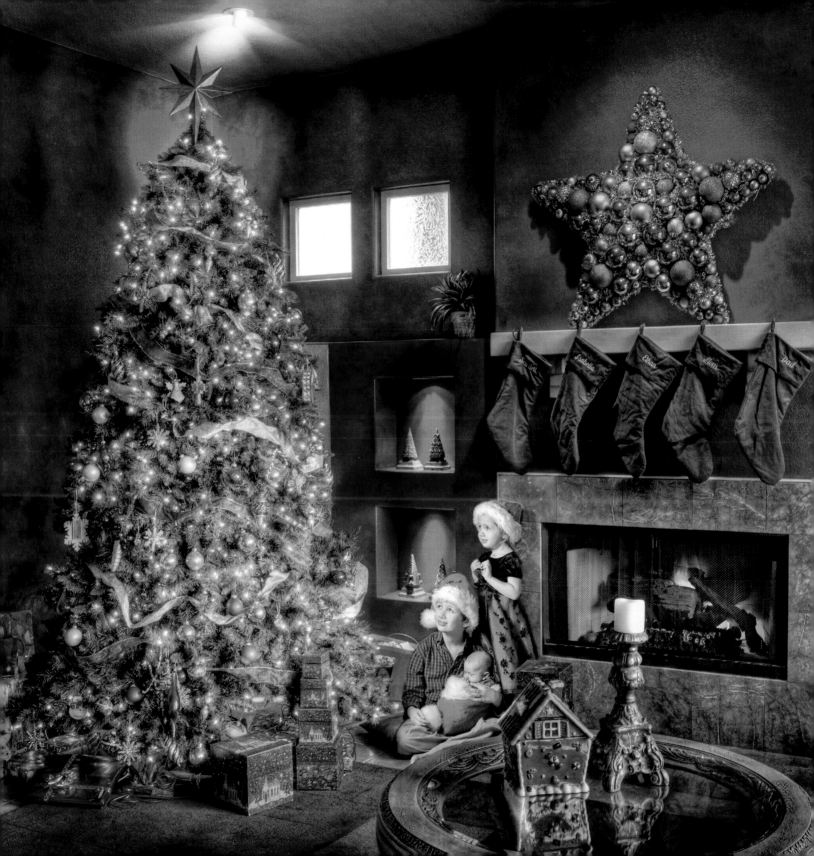

FAREWELL, INDIA

India is a beautiful and magical place. I wish I could say my journey getting to this exact vantage point was just as beautiful and magical, but it wasn't.

I really wanted a unique viewing angle, and I was reticent to set up inside the complex with the teeming crowds. So, I talked my driver into taking me to the back side of the Taj Mahal because I had noticed a river running behind the complex on Google Maps. We started circumnavigating the place and came to an old trestle bridge. It was quite a long stretch to get across the river. The bridge was just barely standing, and everything about the dilapidated structure was sketchy. We were the only car on it, and it was hard to get around all the ox carts, donkeys, and bicycles.

Looking out the window at the rusting girders, I asked our driver, "When was this built?" He wobbled his head and said, "Eighty-three." Well, I thought for a moment. That doesn't sound so old. Then he turned back to me and said, "Eighteen eighty-three."

When shooting something epic, why not make it double-epic with a reflection? Reflections are always romantic, and good composition can double the punch of whatever aspect you are trying to grab. When shooting a reflection, it's sometimes best to get as close to water level as possible. In this case, even my tripod was too high. The mud bank was soft. I asked my camera for forgiveness before I buried it bracket deep in the mud to keep it steady for the exposures.

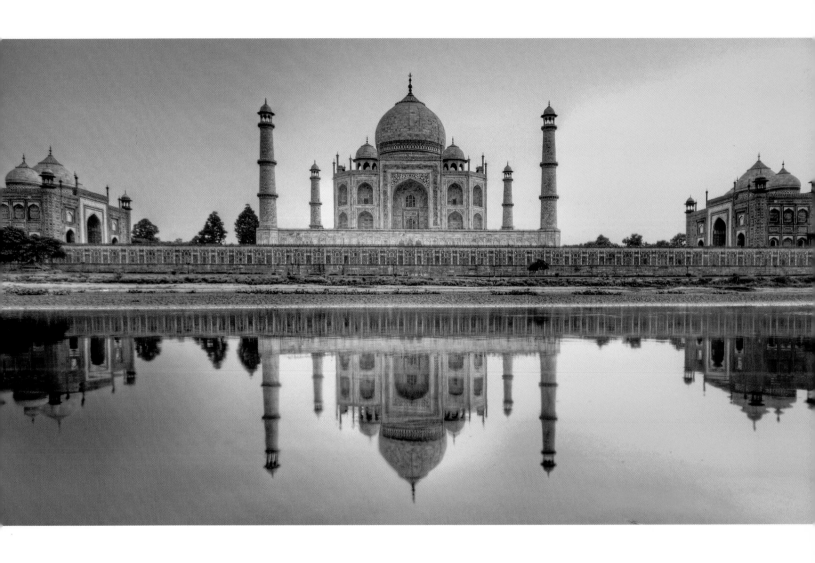

THE GRASSY ROOF

While driving from one side of Iceland to the other in what was supposed to be winter, I spent a fair amount of time in the grassy inlands where some sort of heat inversion kept the ground green and fertile. I came across a few homes with thick, peat, grassy rooftops on the edge of a farm.

I've always wanted to live in a house with a grass roof. I don't know where this desire has come from, but it remains unsated.

This is a 5-exposure HDR shot at f/5.6 and 100 ISO at 14mm. During the HDR process, you may find that it overamplifies the grass and makes it look a bit radioactive. I always reduce the saturation in the grass to bring it back to its original color. Something that is counterintuitive here is that the electric color actually comes from the yellow in the grass, not the green. Most of the color you see in vibrant grass is actually yellow. I realize you might find this unbelievable, so next time you take a photo of a grassy area, jump into Photoshop, open the Hue/Saturation dialog, change the drop-down menu to Yellow, and drag down the saturation. The grass will turn almost all gray with very little green remaining.

Also, notice what it is like to process grass when the sun is hitting it versus during cloudy or dusky conditions. Grass is translucent and reflective, so it can bleed a yellow glow. Depending on the time of day, you may find yourself doing slightly different maneuvers with the HDR adjustments.

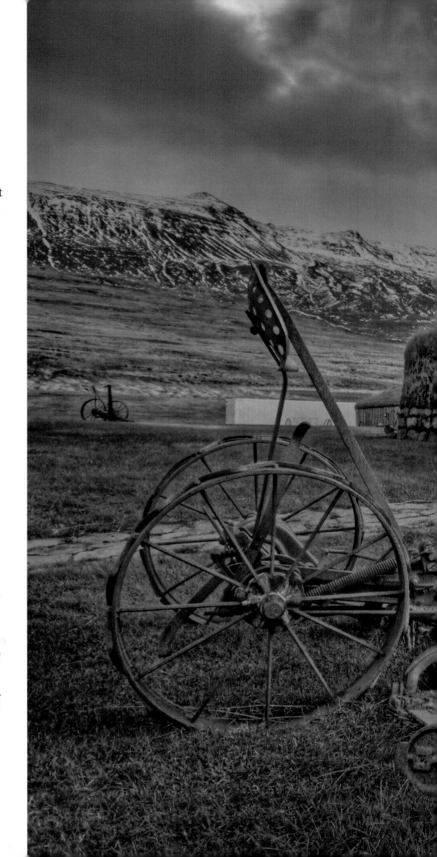

ADVENTURING DEEPER INTO PATAGONIA

After a four-hour plane ride deep into the Andes, we started to get farther into the wilds of Patagonia. Perhaps I should explain that I was on this trip with a very good Russian friend named Dima, who is also a photographer. He brought four other Russian friends with him. Despite our friendship, he paired me with a non-English-speaking roommate named Yuri who never ceased to amaze. Within five minutes of dropping him off in my room, Yuri was in his underwear and I noticed his approximate overall size was that of a smallish beluga whale. This ended up propagating many other problems. For example, on the flight to El Calafate, our small plane had a bit of a hard landing because I was not sure the pilot was fully informed of Yuri's weight.

After setting up camp in El Calafate, we went out to the edge of Lago Argentino that night to shoot the sunset and the Perito Moreno Glacier. Every few minutes you could hear giant shards of ice calve and drop into the lake below.

The photo shows dark bits of ice floating in the water. Those are actually the clear bottoms that were once underwater but recently flipped over. In the midst of all this, and from out of nowhere, Yuri produced a giant bottle of cognac, which seemed to keep the Russians happy in the freezing cold. When I posted this photo on the blog and across the various social networks, many of my Facebook and Twitter friends requested a photo of Yuri. That night, while he slumbered, I endeavored to take a panorama of him. I considered the glacier as practice since it was also big, white, and cracked.

This image was shot with the Nikon 14–24mm 2.8 lens. The second of the five exposures (the -1 EV shot) was at f/8.0 with a shutter speed of 0.033 secs and a 250 ISO. As for the focal length, I think I had it cranked all the way to 14mm to take this shot. I'm always flummoxed as to whether or not I should take a panorama of these places, which essentially means I'd have to map out an invisible grid and then take a photo in each cell for later stitching using post-processing software. For this photo, I did use a Nikon D3X, which already has a 24-megapixel sensor, making the final product a fairly detailed 6000 pixels across or so. There is some invisible point when enough is enough, and I never quite know what it is. One limiting factor is time of processing. Panos take a long time to shoot and post-process, so that comes into the decision-making tree fairly early on.

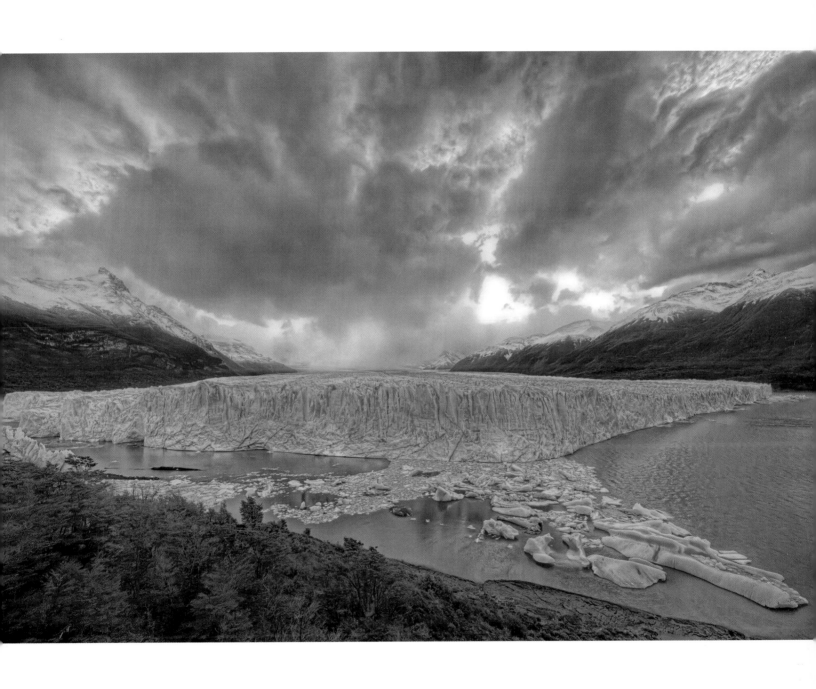

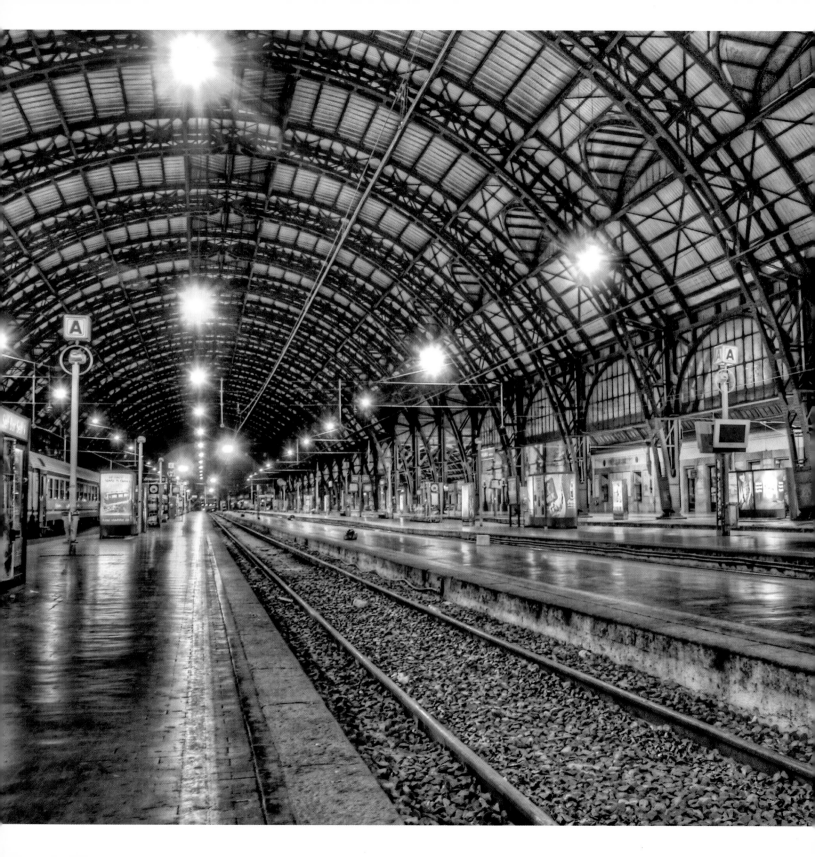

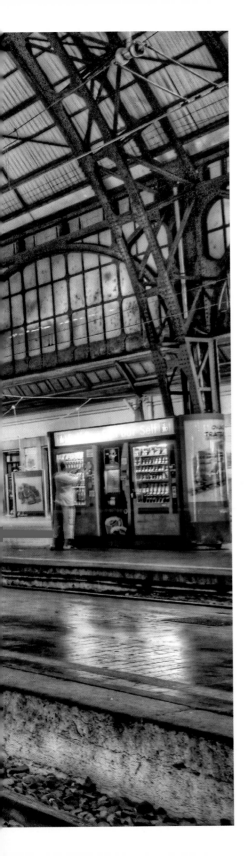

MILAN TRAIN STATION AT MIDNIGHT

The day running around Milan never seemed to end. So much to shoot and so little daylight! It turned out that my best shot of the day had absolutely no daylight at all.

I was tired and just wanted to go back to the hotel to have a cappuccino in the bar and edit photography on my laptop. But I remembered the really pretty train station and how I wanted to get a shot with nobody around.

I went in around midnight, found the perfect spot, and then shot away.

The HDR process always takes that slick concrete and makes it extra reflective. Reflective ground is great for photography. People often think that I "colored" the lights at the top, but there is none of that going on. In fact, I never "paint" on my photos. Colors that you see in them are actually there except in the cases when I apply a texture treatment.

Dare I give composition advice? I never know what to say in these cases because I am frankly confused about whether or not composition can be taught or it just comes naturally to some people. Since this book will attract people who have a native understanding and appreciation for art and composition, there is probably no need. However, on occasion I do run into people who are confounded on how best to compose a scene. I have extreme empathy for teachers who are forced to teach composition all day long. My three best pieces of advice are as follows:

- *Make the interesting bit off center. Did you know Hitler was also a painter? His work was constantly criticized because he always put the subject of his painting in the exact center. Don't be like Hitler.*

- *If you want to really nail the scene, make the interesting bit 1.61:1 from an edge. This is a magical number, and it comes from phi, the golden ratio. You can Google this and watch videos, and everything will become clear over time.*

- *Be prepared to break the previous two rules and center the subject in cases where the symmetry of the subject is perhaps more interesting than the actual subject. You can see this for example in a few other photos in this book like Humayun's Tomb and The Open Road. But even in those cases, points of interest should either gravitate to the 1.61:1 spot vertically, or the shapes of interest and contrast should conform compositionally to a Fibonacci spiral.*

A SUNSET ON A TEXAS FARM

In Texas, we get quite spoiled by the sunsets.

I grew up here, so I've been able to see thousands of them. This has inadvertently resulted in the ability to predict a good sunset a few hours before it happens. Then I have no excuse not to gather my rig and go set up for some shots. In fact, I have seen so many sunsets, I have a whole secret vocabulary to describe them, so I feel like the Eskimos who have 100 types of snow, the French who have 365 kinds of cheese, or the Seattleites who have 100 curse terms for rain. I'd love to combine these into a perfect storm and be at a sunset with a light snow, sitting beside an Eskimo, talking with a Frenchman who has brought the perfect cheese for the occasion, and drinking a coffee.

This is a 5-exposure HDR shot at f/16. This setup kept everything in focus and kept the shutter open long enough to let the clouds drag across the sensor. In these conditions, you don't have a lot of time to fool around with settings because the sun is bookin' it toward the horizon.

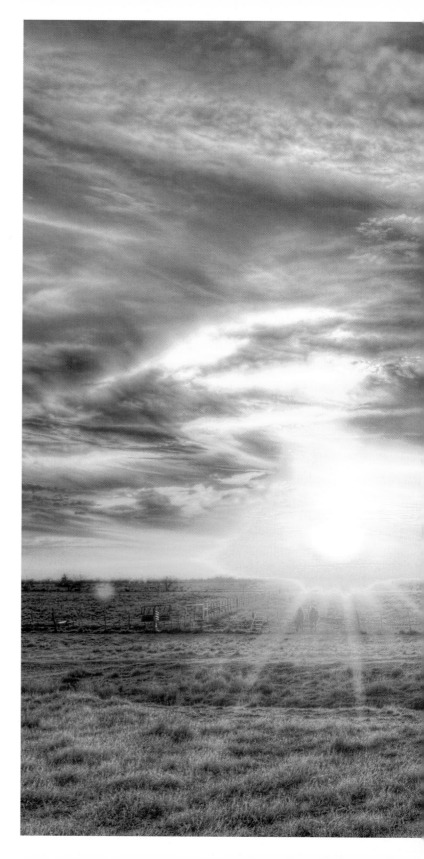

THE ICY PIT TO HELL

This is Gulfoss, the frozen waterfall in Iceland. Dark Age theologians used to believe this was the entrance to hell, which was originally a cold place; the innermost circle of Dante's version was frozen. True believers would come here and cast themselves down into the chasm to try to rescue souls they were told had gone to hell.

It's hard to describe how slippery this place is. I guess I could say it's slippery as hell. The ground is already solid ice, and then there is a fine mist from the waterfall that forms tiny little perfect spheres on top that somehow take friction into a negative physics impossibility.

My advice to other photographers in such a situation is simply to be very careful. No shot is worth dying for, and getting a few steps closer for a shot that would only be 2 percent better does not fall within the margins of error inside our bang-for-the-buck actuarial tables.

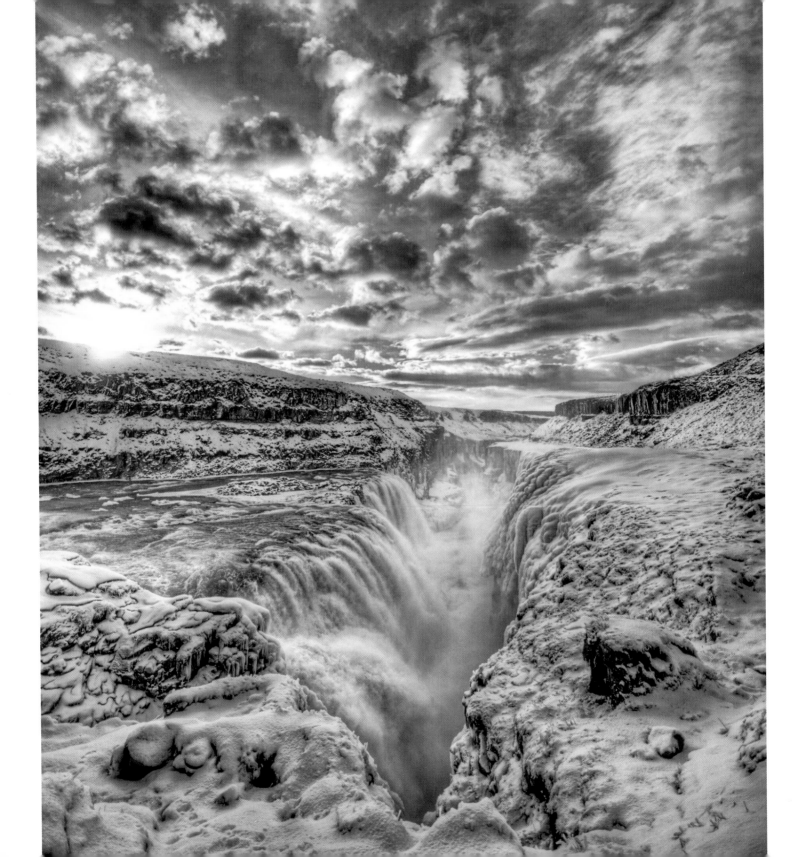

PUZZLING OVER BEAUTY

I was captivated by this scene for some reason, and I spent a good deal of time thinking of how best to shoot it. On the final day of my trip to Glacier National Park, I decided on this treatment. There are many interesting details in this scene, and you can probably be thankful you were not beside me to hear me go off on a theoretic (a new Neal Stephenson word).

We enjoy beauty and puzzle over beauty at the same time. In a world of entropy, it is calming to take beauty, break it apart into what makes it so, and then piece it back together to bring order to the chaos. But I could not bring myself to work on the puzzle at all. I just drank in everything I was there to be with for the moment. I thought a little about the nature of wanting to create a puzzle, just to solve it, a notion that is meta-puzzling in itself. Other guests who come into this view no doubt sit down and work on the puzzle, possibly thinking they might finish it but with a sneaking suspicion that they are just putting a few pieces together for the next guest who comes to visit. It seemed to be sort of an altruistic long-term battle against entropy. So I chose not to mess with the puzzle and simply to focus on the beauty aspects as I held them in my mind's eye. Puzzles tend to work themselves out on their own, which is a comforting thought, I suppose.

Shooting this photo is an exercise in frustration for traditional photography. There is just no good way to get the brilliant bright light from outside and all the warm light and textures from the inside at once. Even if you were to set up artificial flashes and lighting inside, it would be tough to get the reflections to "look" natural. See how the light streaming in casts appropriate shadows on the table, how the warm lights of the inn reflect on the column, and how other small details of light and shadows appear. Think about all we go through with fake lighting to get things to appear natural: It's kind of crazy. The light is already there, so use it.

Let the HDR process accomplish what your eye does on the scene. First, your rods and cones capture a lot more data than the best camera sensors on the market. Second, your autonomic reflexes can adjust the amount of light getting into your eye by flexing the pupil and contracting your eye muscles. Next time you go from looking at something dark to light, think about how your eye muscles flex to adjust for the new light. The HDR process does all of this for you, albeit in a series of software steps that you've taken for granted all your life.

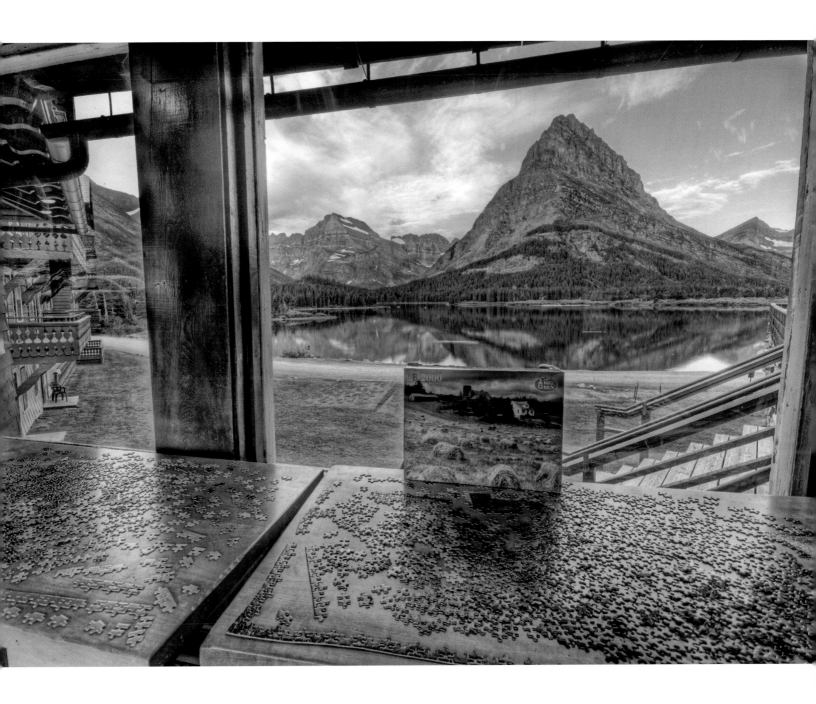

MY KINDA TOWN

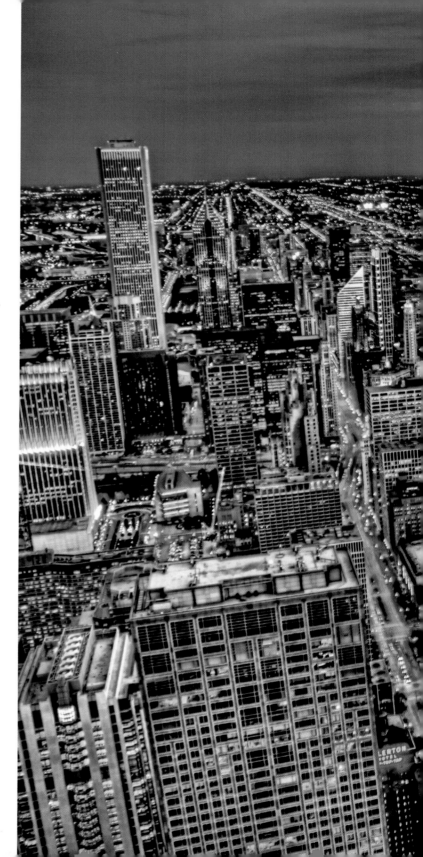

This is the first shot I took with my Nikon D2X. I've since upgraded, but I'll never forget that camera. I was already a serious photographer, but that beast made it official.

As you can plainly see, this effect delivers a "painterly" style. I often have my work printed on canvas, which accentuates this effect even more. If you are reading this book, you are probably somewhere within the delightful sphere of "photographer," so you understand a bit about what is going on here. This is one of the photos that hangs at galleries and always draws a lot of attention from people who have never seen HDR. They continually come over to it and start scratching the surface to figure out what the heck it is. The general public still has no idea what HDR is, and when people first see a printed canvas, they are always wonderfully perplexed as to how such a thing can exist on this mortal coil.

This was shot from the top of the John Hancock around sunset on a summer night. I had to catch a flight to Malaysia the next morning, and I was anxious to get the shot back to the hotel, processed, and uploaded before I left. I remember that the D2X let me take 9 bracketed exposures, so I decided to really blow out this HDR. I did all 9 exposures from -4 to +4 with 1 step betwixt. Honestly, that was pretty much overkill and the HDR processing just about melted my CPU, but it did turn out nice.

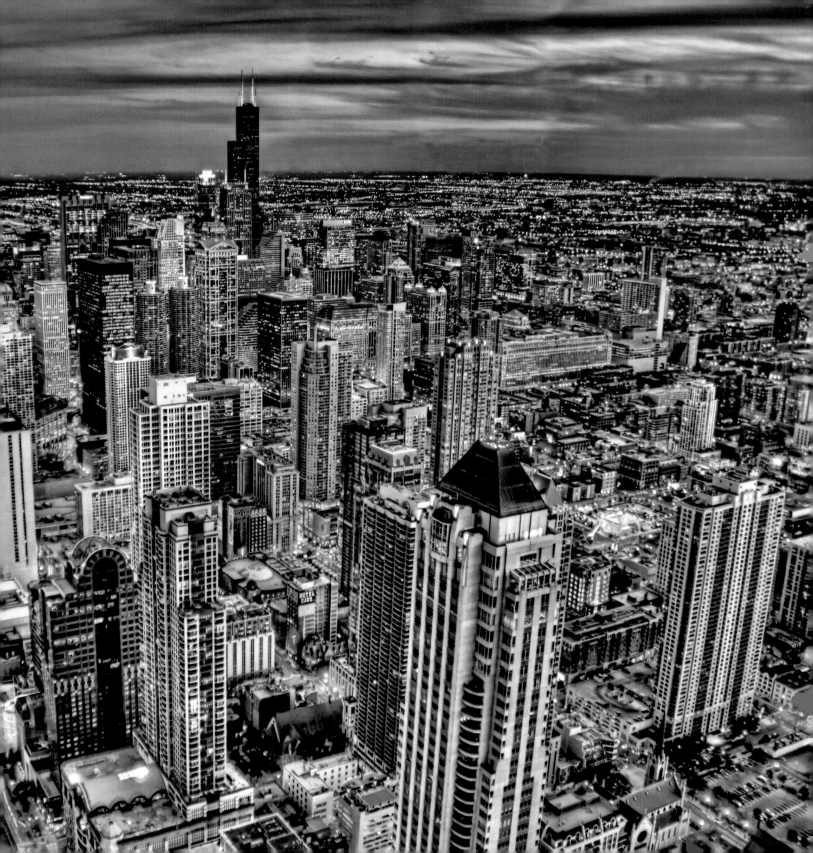

HORSES IN THE FJORD

I consider myself very lucky to have a network of great photographers worldwide. I met most of them through the Intertubes where we are constantly commenting and giving feedback on one another's photos. This has enabled me to meet up with master photographers wherever I travel. They are wonderful people to hang out with because they already know the prettiest places and the best shots around where they live!

One of the people I was lucky to have a photo adventure with was Rebekka in Iceland. If you are not familiar with her, Google "Rebekka." We met at a coffee shop in Reykjavik and talked about where to shoot. We jumped in her car and drove a while until we reached a fjord. Nearby were horses running around like wild beasts. They have no fear of humans, so we were able to get close to them. The horses have long hair that reminds me of the shag carpets in our house when I was growing up. I'm sure the thick layers of hair evolved from the hypercold winds whipping around the edges of the sea.

I don't shoot (take photos of) many animals, because I find it hard to improve upon what other great animal photographers have done in the past. However, here is a tip for shooting animals. It's kind of a lame trick, but it always works. Use a wide-angle lens and get in close. It makes the animal's head look really big and cute. Humans love big-headed animals; they always make people smile. Why this is, I have no idea. Note that this trick also kinda works with babies.

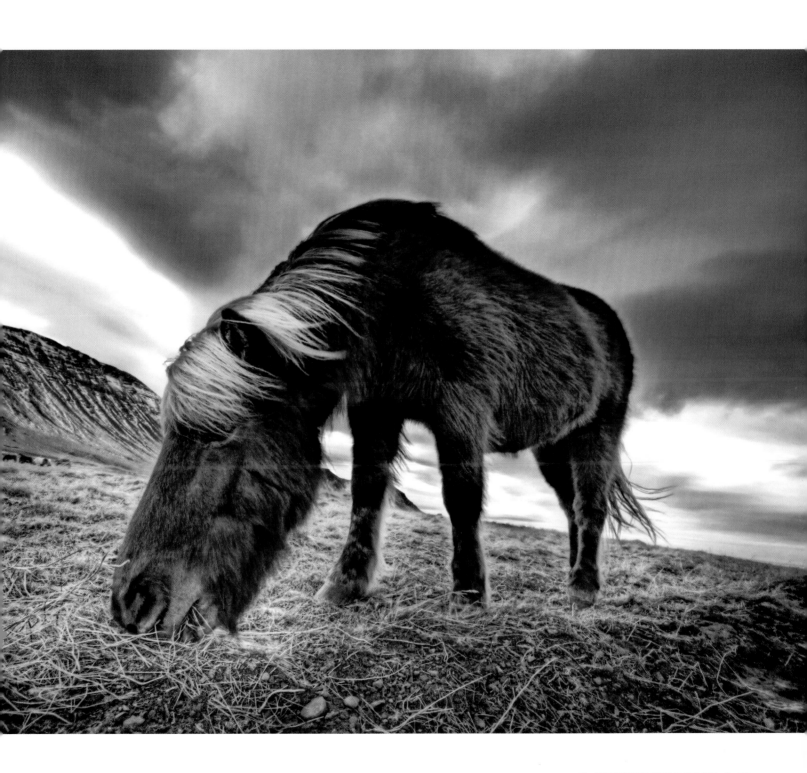

THE MAGIC OF DISNEY

This was taken in the evening at MGM Studios in Disney World before we went to the big fireworks show. The only problem with making your family and 6-year-old son (he is now 8) stand around while you set up your tripod and take a bunch of shots is that it gives them ample opportunity to find little toys they cannot live without. I took so long to nail this shot that we ended up buying two toys that lit up in garish colors and made a lot of racket.

This is another great example of an image that was impossible to create before the evolution of HDR. I suppose the argumentative, know-it-all photographer (you know the ones at photo clubs who like to stand up and make pedantic points) could say that there was always something called "compositing" in which you take several photographs and frankenstein them together. That's fine, but that is quite different than HDR because it does not get down to the pixel-by-pixel level of image adjustment. As you can see in this photo, a variety of light levels are under the hat, on the hat, and above the hat. Each of those areas would need hundreds of mini-compositions to look right. That would have been a near impossibility with traditional film, and it's even still painstaking with digital. But the HDR process makes it all a heck of a lot easier.

This is a 5-exposure HDR shot at 100 ISO. Whenever there is anything like streaming lights, sun rays, search lights, and the like, the HDR process always makes them pop a bit. If you don't want the meandering masses of Mickey ears to get in the way of your shot, be sure to use a high f stop, like f/10 or higher, to ensure that the shutter stays open long enough so that the photons they reflect are inconsequential.

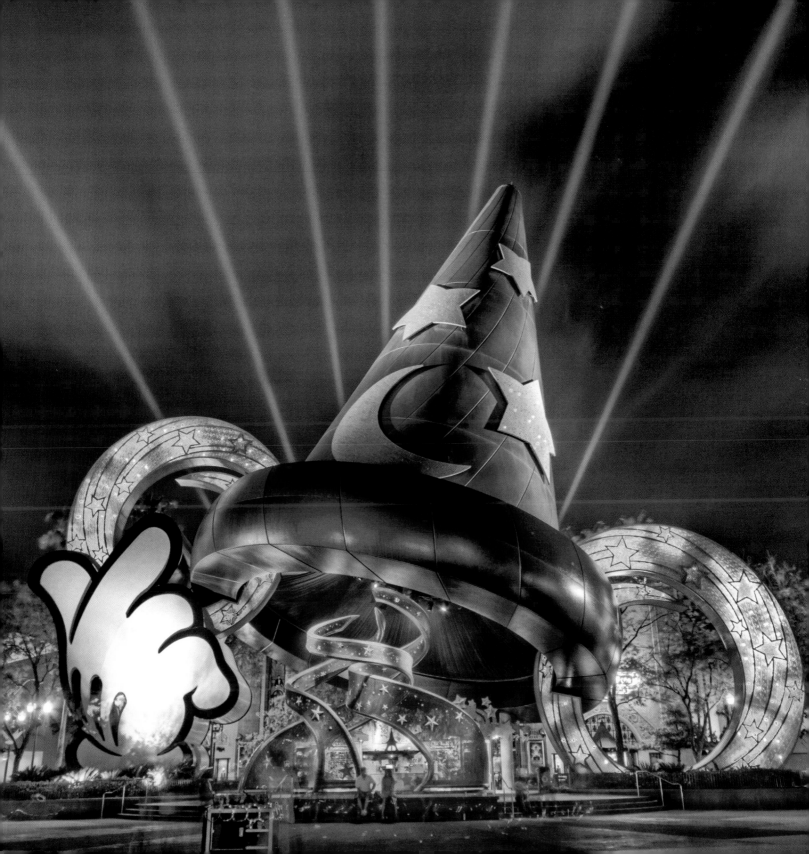

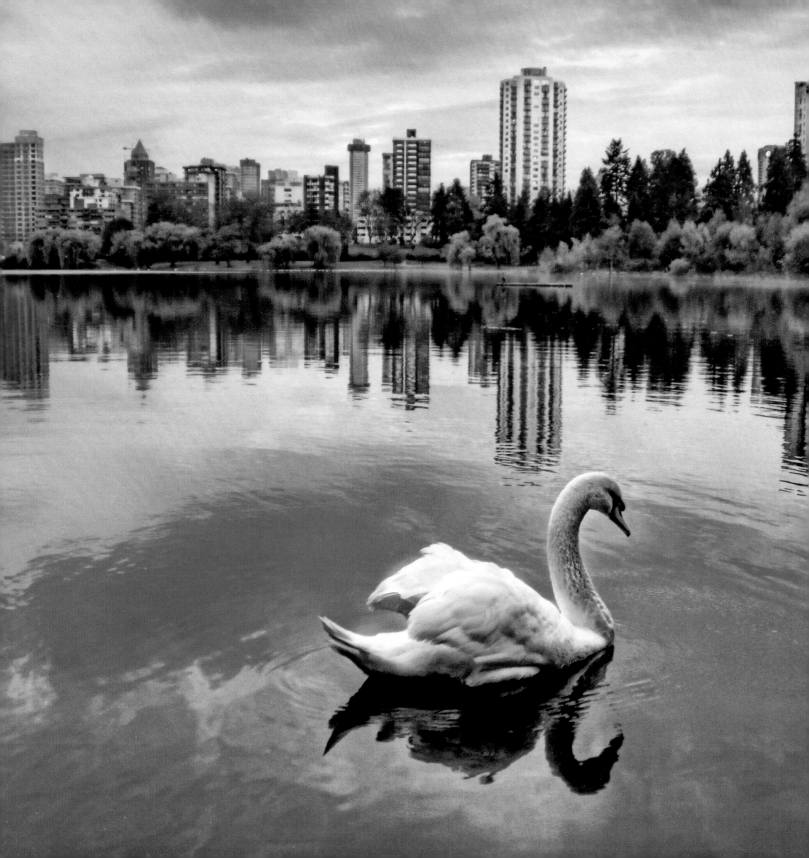

MORNING MIST ON THE LAGOON

This shot was taken one morning in Stanley Park in Vancouver, BC. Vancouver always seems to be somewhat cloudy, so the colorful trees around the park stand out nicely. A giant swan was floating nearby while I was walking around, so I took this single RAW and converted it to HDR to ensure that I'd get all the numerous colors in the trees and the various shades in the sky and water.

One of the most common questions asked online about my photos is: "How do you take an HDR of a moving subject?" While it is true that most HDRs are taken with multiple exposures, that need not always be the case. The single RAW photo method of HDR is described in detail in Chapter 5. One important point I can add here, however, is to make sure that if you take a single RAW, keep the ISO as low as possible. A lot of noise can turn into a real problem when you're trying to convert a single RAW file to an HDR.

FOURTH ON LAKE AUSTIN

This has always been a special photo in my portfolio for a variety of reasons.

It's the first HDR photo ever to hang in the Smithsonian. This made my mom very proud of course, and it resulted in her sending off more emails than the average Nigerian. It also helped to bring much notoriety to StuckInCustoms. com and did quite a bit to establish HDR as a mainstream art form.

As for the process, it was a tough night because I was up on the edge of a bridge that was rumbling as cars crossed it. I was on the edge of the bridge because I wanted to get the full vertical reflection while still capturing the scope of the lake. The evening was very windy, and there was a light driving rain flying into my lens. I had to wipe it down after every few exposures and try to cup my hands over the top during the shot.

This was shot at f/4 with a 28–70mm lens. There were 3 exposures at +2, 0, and -2 in aperture priority mode. I was happy the fireworks were shot off when there was still some ambient light from the sunset illuminating the storm clouds.

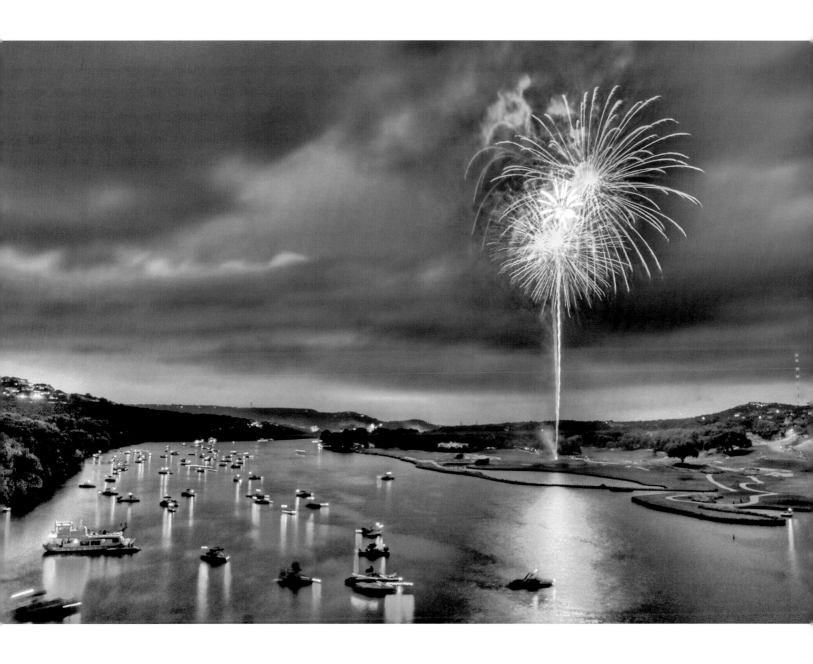

HUMAYUN'S TOMB

This is the Tomb of Humayun in Delhi. I arrived during Diwali, the biggest annual festival that involves burning lots of flammable religious memorabilia. Most of the tombs, mausoleums, temples, and the like were surprisingly empty, giving me clean access to cool places like this without tourists getting in the way of sweet photography. I know, I know, we are all tourists, but we don't really like other tourists, right? It's a strange phenomenon. However, I can say with ontological certainty that I don't like tourists in my photos unless it is absolutely unavoidable.

The TV news broadcasts were filled with families celebrating Diwali along with nonstop, live, on-the-scene action reporting from the grand opening of *Om Shanti Om*, the Bollywood film of the year starring the incomparable Shahrukh Khan. From the previews I saw, the movie seemed to involve a lot of Shahrukh with his shirt off in huge musical numbers and copious amounts of slow-mo water exploding off his coppered abs.

The air in Delhi during Diwali was covered with smoke from the festivities. There was an acrid smell of stale carbon that was not exactly like a trip to Sedona. Luckily, my hosts got me a private car so I could get out of the city and head north to clearer climates near Agra.

The setup here was vertical because I felt the height of the tomb was more interesting than the width. Also, and this is a bit of a strange reason, vertical shots often look better in a blog! Yes, this is actually part of my reasoning. I think a lot about the way 90 percent of the people in the world will consume the image. If it is vertical and 900 pixels across, I can get 1200 or more pixels high, which will give viewers a nearly full-screen display.

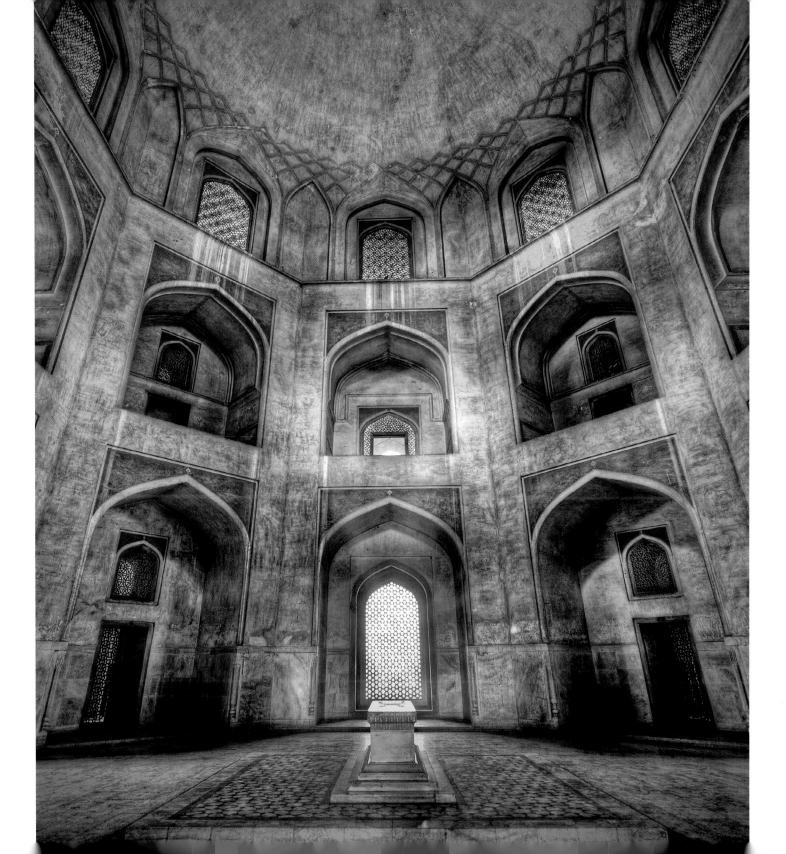

MERRY CHRISTMAS FROM
NOTRE DAME

The French-powers-that-be erected a giant Christmas tree in front of Notre Dame. It seemed like a perfect place to be at dusk, so I made it so. This is one of those places I visit every time I am in Paris, because it always has a soothing feeling about it. I've always wanted to get up on the roof at sunset, but those same powers-that-be won't let me do that. This ends up posing a bit of a problem (albeit only in my mind), because all I can think about are the shots I didn't get.

This was shot at f/4 and 100 ISO on a tripod. I wanted a little bit of blur of the people moving but not too much. Recall that I just said I don't like tourists in the photo. Well, forget I said that. Obviously, sometimes it's cool to capture a little hive of activity around an exciting place. If I were to crank it up to f/16 or higher, all the people would have disappeared. The focus was set at infinity, so I didn't have to worry about a thin focal plane obscuring the important bits of the photo.

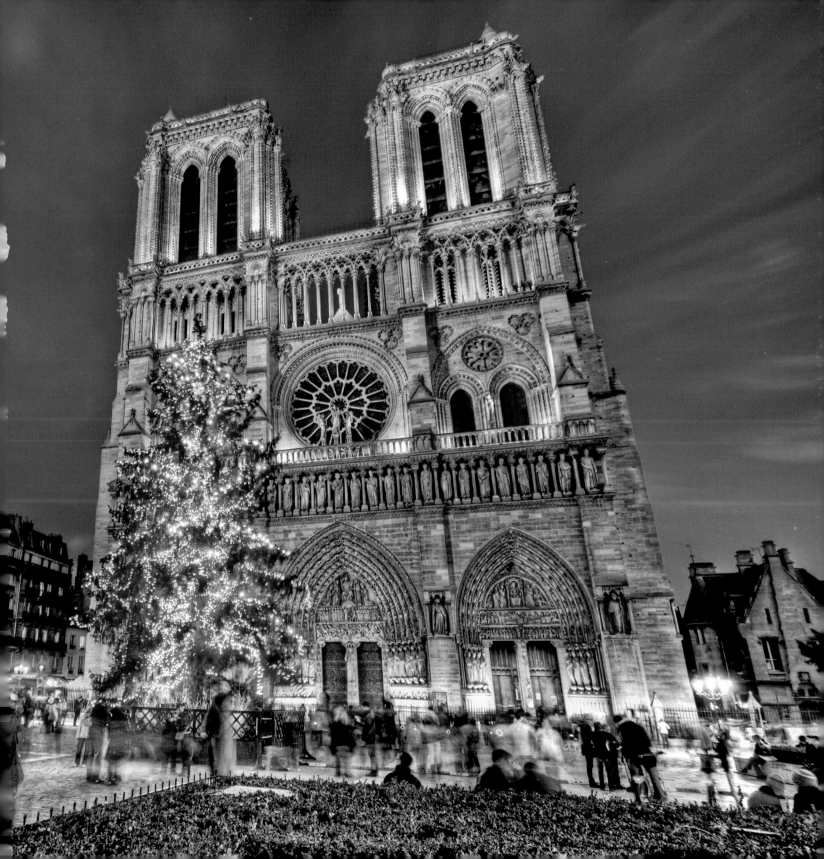

THE OPEN ROAD

I had a long lonely weekend in Iceland, so I took a jeep out into the wild. I drove all over the country from dawn till dusk to see what I could find. The sky and landscape were an ever-changing palette of colors and clouds. The sun is so low on the horizon during the winter that you experience almost a five-hour sunrise followed by a five-hour sunset. I drove up and down one of these highways to the next, listening to all kinds of strange and eclectic music on my iPod, occasionally jumping out to take a shot of something like this: In the distance, you can see the snowy mountains that always seem to be just a few songs away.

Speaking of a long and lonely time, I both enjoy it and I don't at the same time. I expect your reaction to being alone might be similar, since photographers tend to independently think in the same patterns. At times I really love being alone because it gives me distraction-free thought and creativity. But then again, sometimes I need people around me in order to be thoughtful and creative. I can't decide which is best, but I'm pretty sure a mix is important.

Road shots are always fun, and although I hate to offer this advice because it is dangerous, it is often best to be in the exact center of the road. If you are a little bit off to the side, the photo looks a little bit off. I don't know why this is, because we normally don't drive down the center of the road. So you would almost expect a shot from the right lane to look more satisfying and familiar, but it doesn't. Anyway, if you are going to follow this advice, make sure you do this on a road like this one in Iceland, which sees one car every two hours.

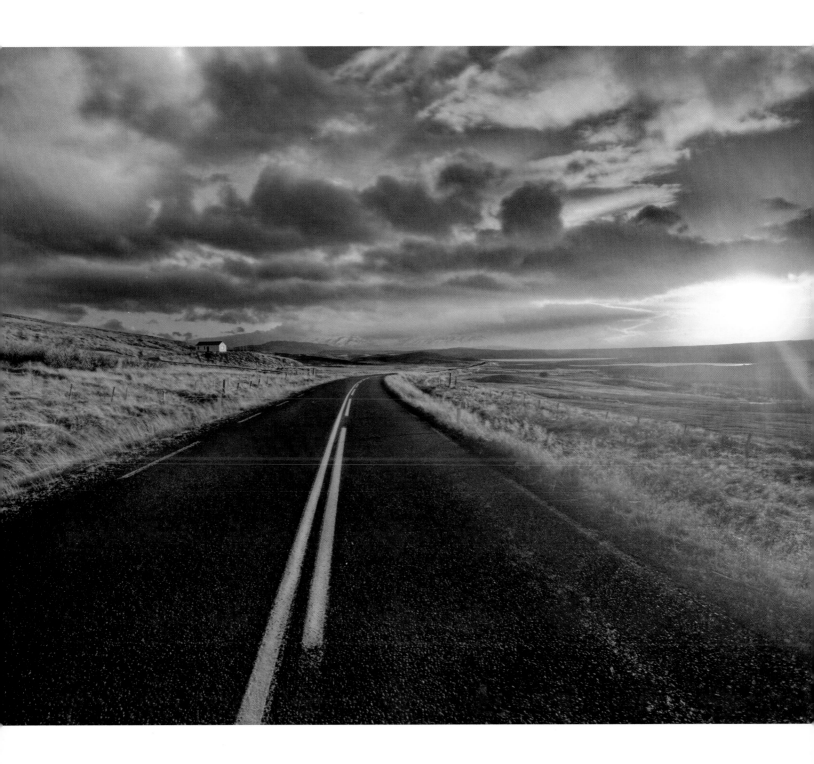

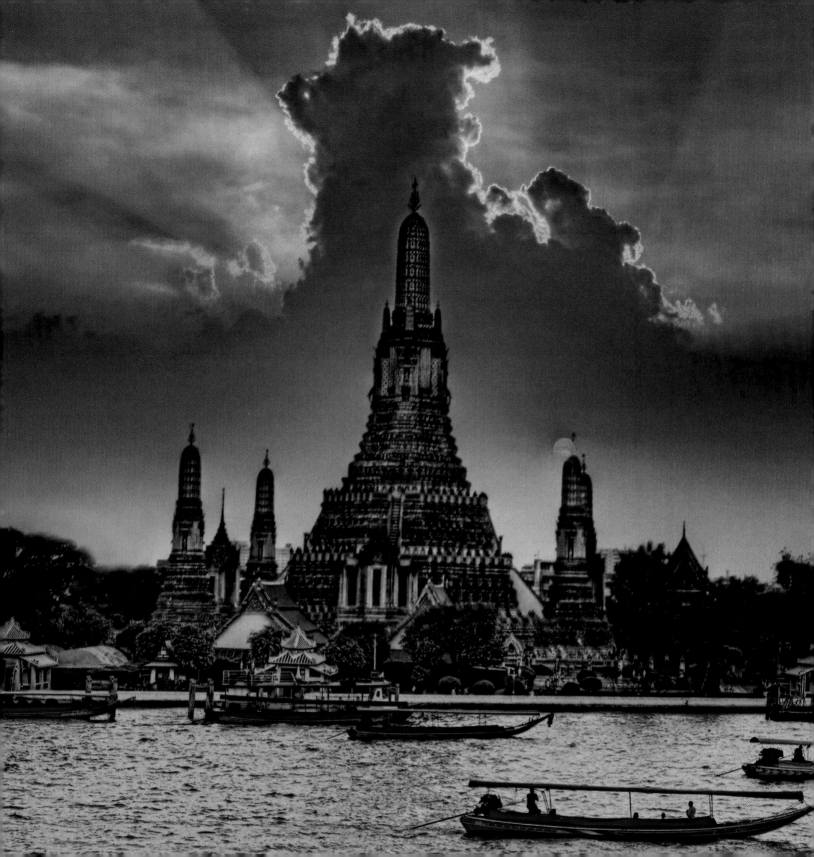

ONE NIGHT IN BANGKOK

This photo is of Wat Arun, a famous Buddhist temple in Thailand. It is surprisingly hard to get photos of these places because the city congestion blocks out all the good photo spots. I'm used to rivers having a little sidewalk on the edge that allows me to set up anywhere. But the edges of this river were packed with all kinds of warehouses and fisheries, none of which I could get into. I finally found an Italian restaurant with a second-floor balcony. I was able to sit there, order appetizers, eat, drink, and take shots every few minutes as the clouds changed. The weather was very unusual that day. You can even see the sun burning through the low-lying fog beneath the fortuitous cloud formation.

At the restaurant I met another traveler. She was from Syria and made all sorts of funny and quirky observations. While I was taking pictures, we were talking about random topics. The conversation turned to coffee, and she started analyzing why Americans are so in love with Starbucks. She said, "You Americans walk around with those Starbucks cups with tops on them. They look like sippy cups. It's like you are a bunch of babies."

Earlier that day, I had spent much time on the boats you can see in the water. I had the sort of boat driver who apparently had little reason to live as we flew through tiny canals at 50 mph. It was a hair-raising experience! We would pass under small bridges that were covered with dozens of Thai children. After we passed, they would all jump and cannonball into the river.

This was a 3-exposure HDR at -2, 0, and +2. The shots had to come in quick succession, since this is one of those sunsets where you can actually see the orange disc of the sun moving.

THE ATOMIC EXPLOSION AND MUSHROOM FALLOUT AT SUNSET

I think about all the sunsets I've missed. I always seem to be out and about somewhere noticing a great sunset and then realize that I am not even close to my camera and tripod. It's just unacceptable! This day and evening I was in Yellowstone alone. I had just seen a grizzly bear and a black bear about 30 minutes before I took this shot, both of which are pretty rare to see. They went on their way, and I was left in the middle of this area with just a few elk meandering a few hundred feet from me. I tried to not get overly "sucked into" the sunset, keeping in mind that those bears were lurking about. The ground was pretty marshy, which is not the most optimal condition for running from a bear. I'm not sure there are ever optimal conditions for running from a bear, but this was certainly not it.

With sunsets, I suggest moving around a bit between each shot. Make a game of composing as many shots as you can with the fore-ground. Remember to make the bottom third of the photo interesting. It's quite important.

We've all seen these glorious sun rays in certain sunset conditions. They are traditionally harder than heck to capture with a single expo-sure. The HDR process helps to make the sun rays pop. Consider that there is nothing brighter in our visible spectrum than the sun, so when you are aiming in that direction, HDR is about your only option if you are trying to grab some of the colors in the darker areas of the landscape.

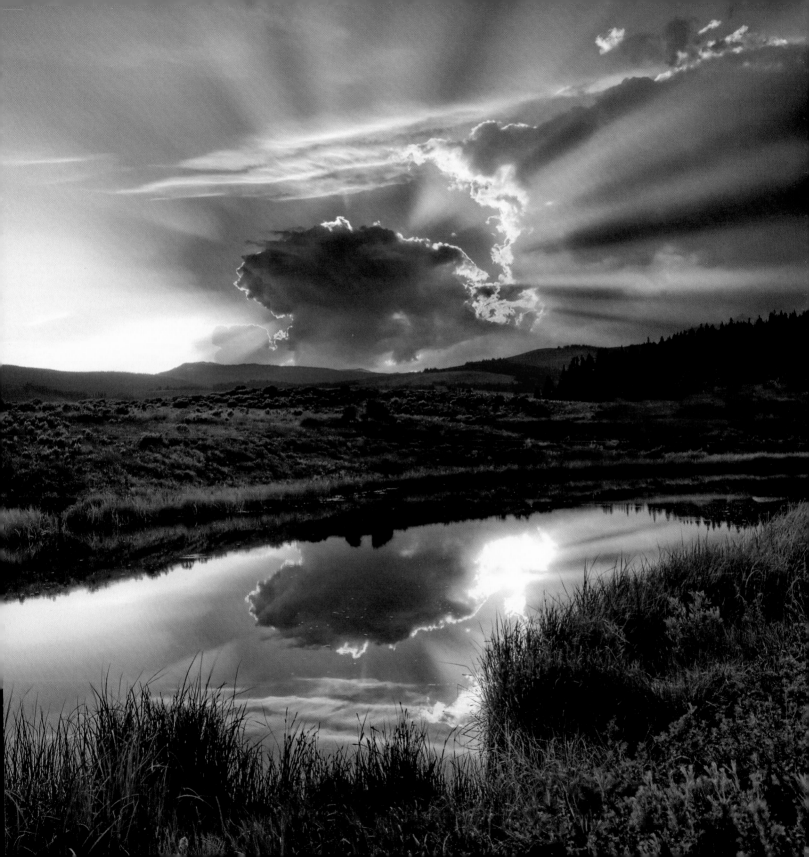

FLOATING THROUGH THE TEMPLE

Akbar the Great has an amazing temple. It doesn't have a bad angle, texture, or light condition. I wish I could send him an email and thank him for all the photographic forethought he put into building this place.

This temple is called Fatehpur Sikri, and it's in the northern part of India, not too far from Nepal. Many examples of Mughal architecture are all over India, but this is one of the best.

An interesting tidbit about Akbar is that he was extremely religiously tolerant and allowed all religions to flourish for a while under his rule. This is why I found this scene so appealing. Although the architecture is Mughal in artifact, much of the influence is Hindu. Hinduism is certainly the predominant flavor in the area currently. To see this Muslim woman in her black niqab walking slowly across the chamber seemed to capture the spirit of the place. I had set up to take a shot of an empty room. But when this woman entered and started looking around, I waited until the appropriate time to capture the moment.

This HDR was taken from a single RAW photo. I had to keep it fast to make the woman as sharp as possible. The camera was set to f/4 and the ISO at 200. The shutter speed was 1/80th of a second.

I suggest that you get to know your camera really well so you can make nearly instantaneous changes. You will find that when you set up for an HDR shot, the conditions are much different than taking a portrait or other types of quick shots. For example, if I was going to take a multi-exposure HDR, I would have made the f stop higher, the ISO lower, and the shutter speeds would have inevitably been longer. I was able to quickly change these settings when this woman entered the room. If you have to sit there and fumble with your camera for even five seconds, the moment can be lost forever.

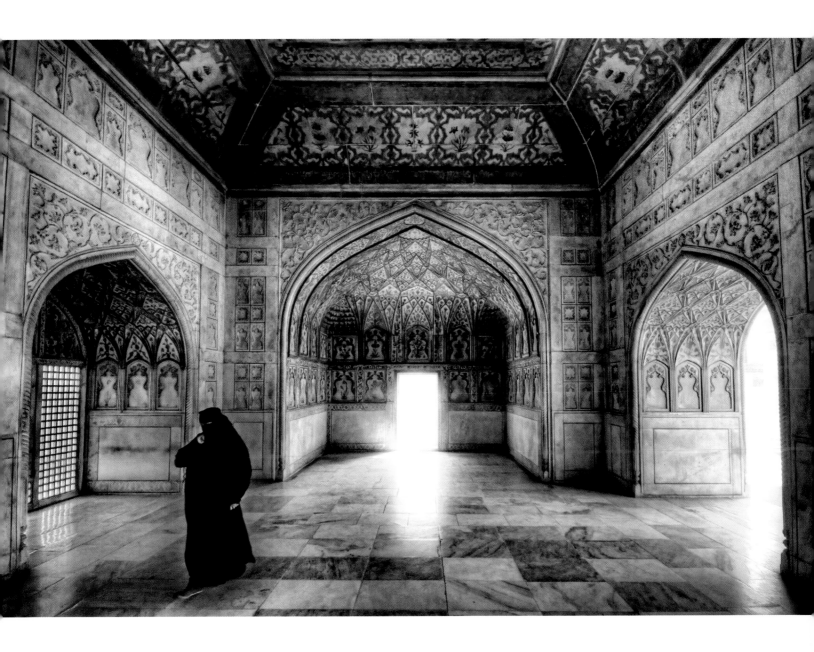

PRAMBANAN SUNSET

This is a remote Hindu temple in the Indonesian jungle. It was a horribly stormy day, and I could have easily found myself quite miserable, but I had seen this before, seen these patterns, and I knew I'd have the chance to see the sun again. Just for a few moments the sun appeared, and it was timeless. I didn't think about the future, I just sat there, unconsciously moving around the temple and taking it all in.

I was with my best friend Will. We were completely soaking wet and smelled like wet puppies. I had a small clear plastic bag to keep my camera dry, and I gave him my extra one, which he promptly lost. For the trip he had bought a new Nikon camera and was using this place to test it out, which is not a bad place to experiment. This gave him something else to do rather than the usual thankless job of carrying my tripod. I try to tell him how many emails I get from people asking to travel with me and carry my tripod, but this falls on deaf ears. The best thing about having Will there, besides his perfect memory of movie scripts that he can quote any time, is that he can attest to the colors in the sky. It was an amazing night.

I encourage you to not stay indoors during a storm, unless there is lightning of course, in which case you should probably stay inside. Otherwise, forget what your mom told you about rain. We are all smart enough to know that you can't catch a cold by getting wet and cold, and it's OK to track in a little bit of mud now and again. Get out there and catch the drama of the scene, and on occasion you can combine the storm with a moody sunset to really create an image that you and others will see only once in a lifetime.

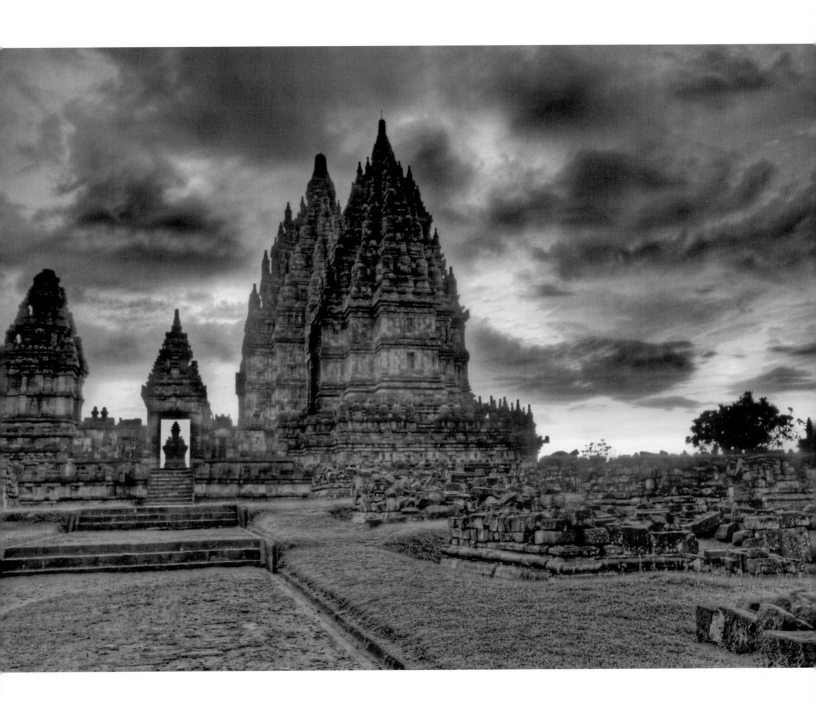

A SMALL CAROUSEL IN FRANCE

It was just past 10:00 PM and I was purposely getting lost on the streets near Sacré-Coeur. I bobbed and weaved through various little alleys, streets, and tiny bakeries (where I would just have to stop for a moment) before finding my way to this little faire. A small carousel was spinning away with petite French children screaming wonderful expressions of joy. I took four years of French in school, and I can still recall one of my first little books that had a cartoon of kids on a carousel in it. One tiny French girl was telling another to hold on: "Ayeeee! Sylvie! Agrippe toi!" (Sylvie hold on!)

It's hard to say exactly how I knew the right shutter speed for this one, other than experience. I love the way the Nikon shutter sounds. The Canon shutter always sounds a bit weak in comparison. If you are a Nikon shooter and you hang out with someone who owns a Canon, listen to the effete shutter sound. Then you can place your camera body near your friend's ear, fire off a serious cli-click, and rock that person's world with your mechanical-decibel power.

I realize this is meaningless, but it's just more fodder for the always entertaining and draining Nikon versus Canon argument.

Back to the shot: This was a 5-exposure HDR at f/4 aperture, shutter speed 1/6, and ISO 100. I can put my head near the Nikon and listen to the cadence of the five shutters opening and closing. I've done this so many times that I can just feel when it's right, and you will too over time. By looking at the light and listening to the amount of time the sensor gets the light based on the aperture, I can feel confident that all the needed light levels were captured across the exposures.

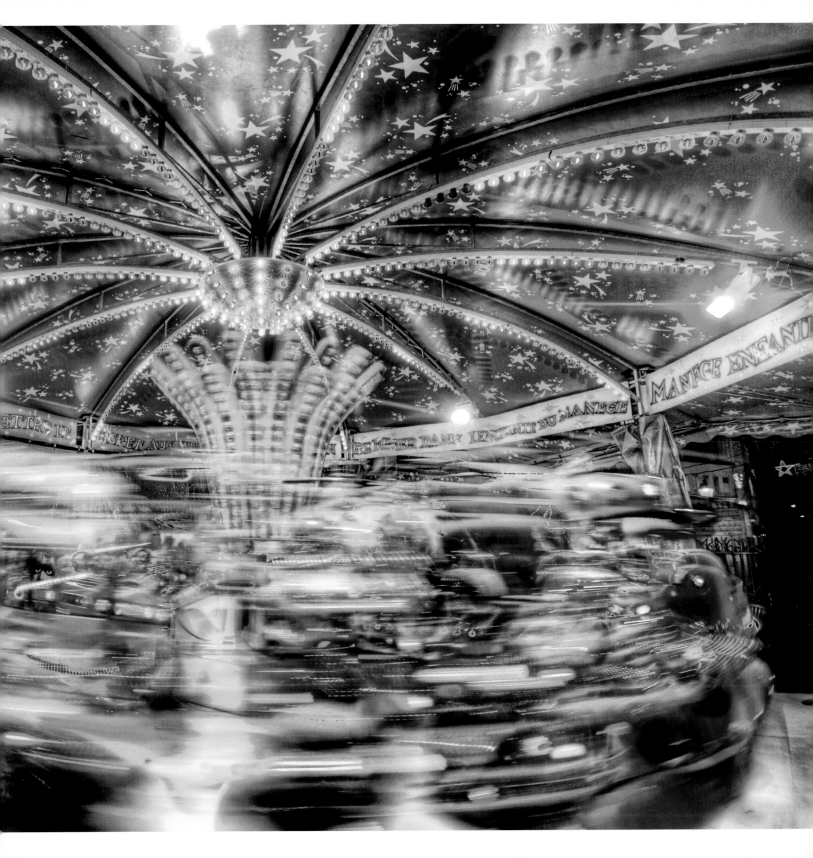

THE STATE CAPITOL OF TEXAS AT DUSK

One evening I went downtown to do some shooting around Austin and caught the capitol just as the sun was going down. The Texas capitol possesses all kinds of interesting architectural elements, like this cool underground Illuminati chamber you see in the photo. The one fact that all Texans seem to know is that our capitol is 14 feet taller than the Capitol Building in D.C. This is a source of pride for Texans along with another cool and trivial fact that we maintain in our state constitution, which is the right to secede from the Union.

The capitol is made out of pink granite, which gets pinker at night as soon as the lights are turned on, especially against the blue sky.

At this point in the book, I'm sure you can tell that most any time is a great time to shoot HDRs. But the best time is just around sunset. If you can find objects or scenes that are lit up right around dusk and there is enough ambient light to complement that lighting, you can get some wonderful combinations of colors. Of course, in these situations you always need a tripod because your shutter is likely to be open for several seconds on one of the exposures.

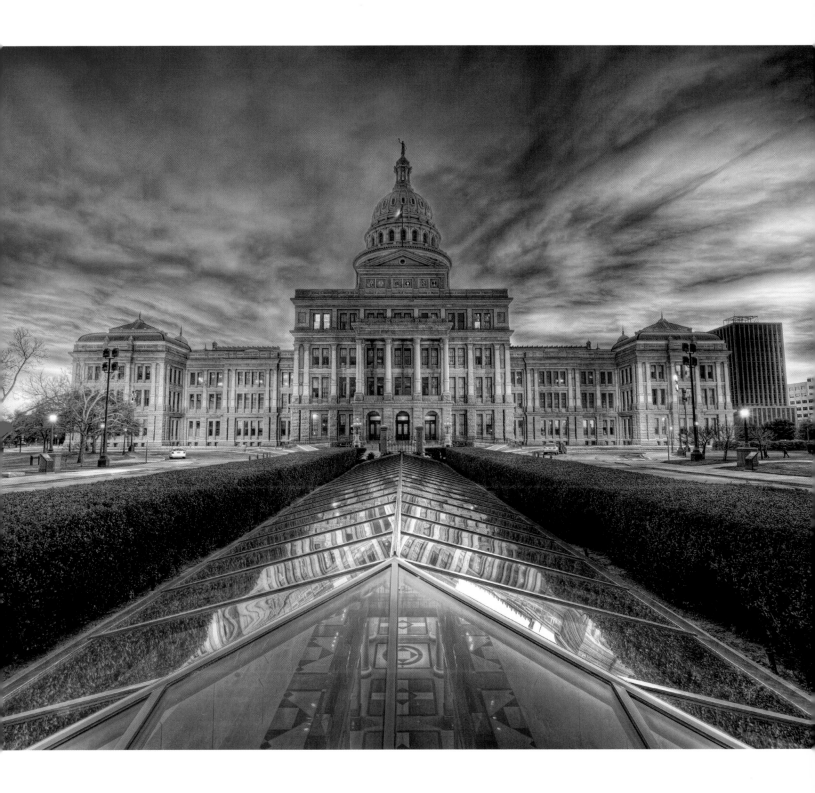

MIRACLE

A good photographer friend in Iceland named Asmundur took me to the southern part of the island for a bit of shooting. One of his favorite spots was this little church that sat by itself on a hill. A small cemetery nearby was the perfect place for me to set up to take this shot.

The skies in Iceland always seem to be idyllic. The icy cloud particles often stream out in impressionist formations, and the HDR technique really helps to bring back the colors I saw and the emotions I felt when I was actually at the scene.

This image speaks to a larger idea around the notion of traveling and finding cool sights to shoot. I will normally jump on Flickr, search for tags, sort by "interestingness,"

and then pick out some amazing-looking locations. Often, the first few pages of the results will show images from the same photographers repeatedly. I then contact them and ask if they would like to go on a shoot together while I am at their location. This method usually works out swimmingly because the locals know the most beautiful places that are also off the beaten track.

My wife is always worried about this tactic and is convinced after watching decades of fear-inducing news reports about the murderous ways of strangers on the Internet. I find, however, that photographers are normally kind souls. After looking at their photographs, I think you can often intuit the sort of person they might be.

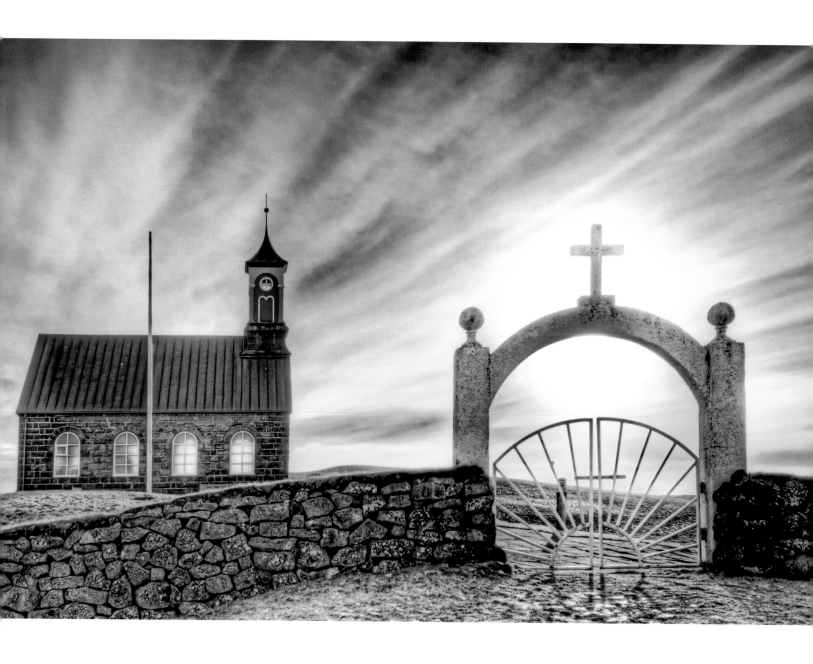

SHANGHAI FROM THE BUND

Shanghai looks huge and amazing no matter what side of the river you are visiting! I must have gone back and forth eight times or so to see it from one angle and then the next as the sun was setting. An electric train goes through a tube under the water, and it is surrounded with enough flashing neon to produce seizures in the average Japanese kid. It's all fantastic and electrifying, and both banks were covered every night with people admiring the view.

Normally, I don't wait until it is quite this dark. This is that short five-minute period between dusk and the black of night. You have no choice but to use a tripod in this situation. I also recommend using a wireless or wired trigger because pressing the button on the camera can cause a tiny amount of shake, which will affect the focus. And that's not good. You'll soon realize that the HDR process has enough complications without having to worry about lining up multiple exposures! Try to minimize the coefficients of error.

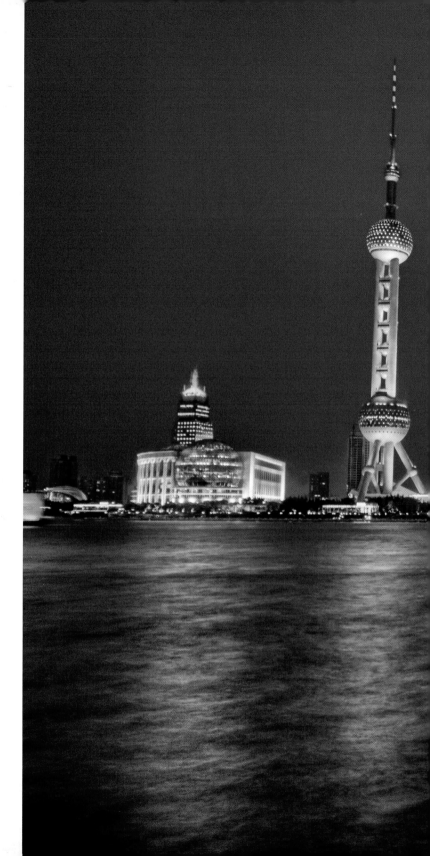

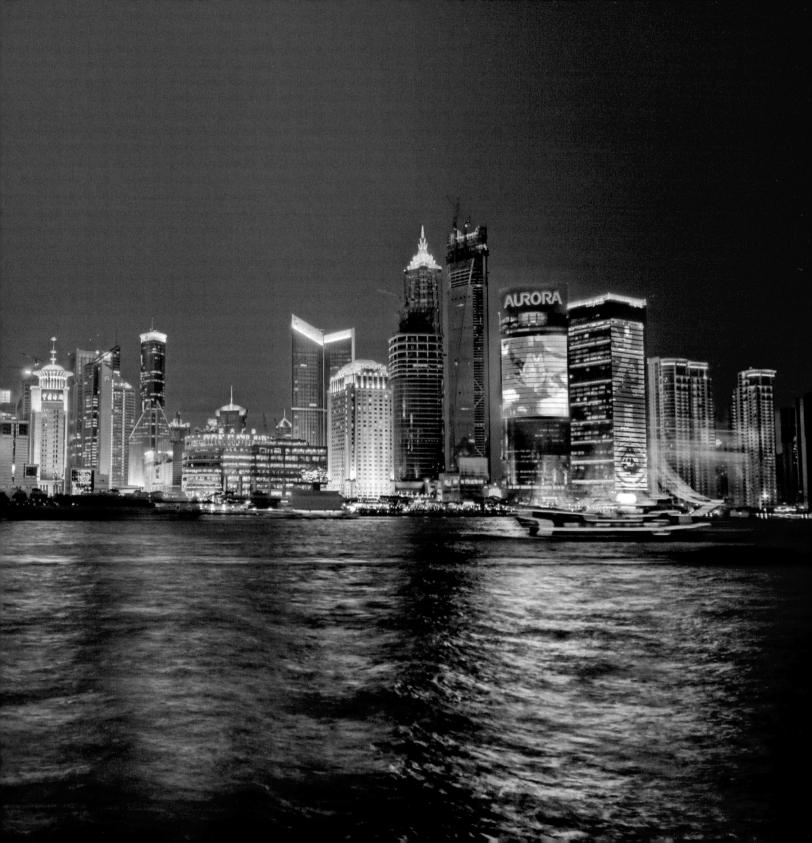

STAMPEDE OF WILD HORSES

After a long hike through the mountains of Yellowstone, I came across over 40 horses sprinting from one meadow to the next. I stepped behind a tree to get out of the way and shot this scene. You can see the dead husks of the trees that still remain after the big Yellowstone fire.

This is an HDR shot from a single RAW file. People will tell you that it is impossible to make an HDR from a single RAW. Don't listen to them. That RAW file contains a lot of light information. This was shot at f/4.5 at a shutter speed of 1/800, ISO 100, at 13mm.

I also recommend shooting most of your shots in aperture priority. Just get your focal length to the f stop where it feels good, and let your smart camera do the rest. You will need quick access to the ISO to adjust it based on the available light. Check the histogram after a few test shots. If there is not enough brightness, just dial up the ISO until the histogram looks like a bell curve.

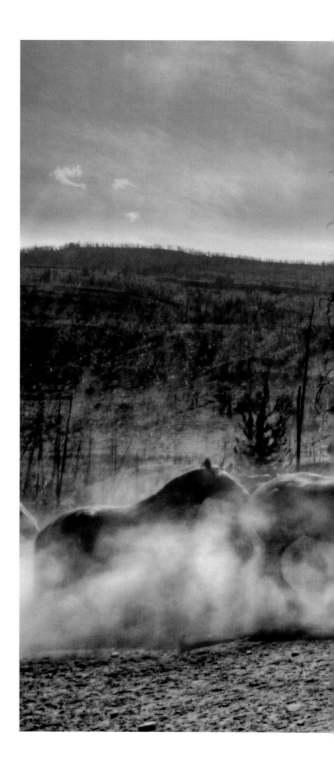

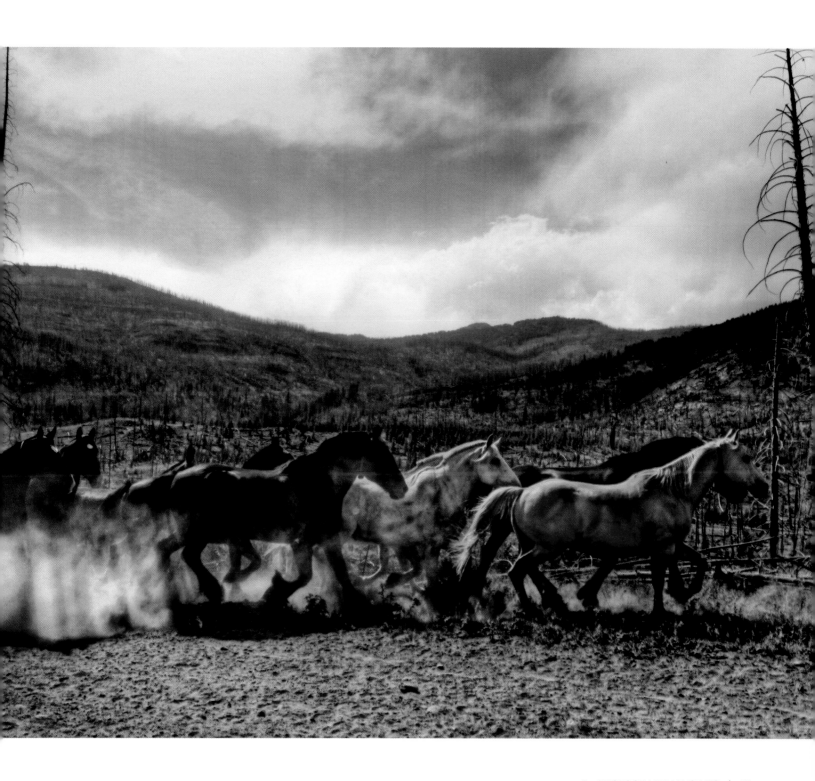

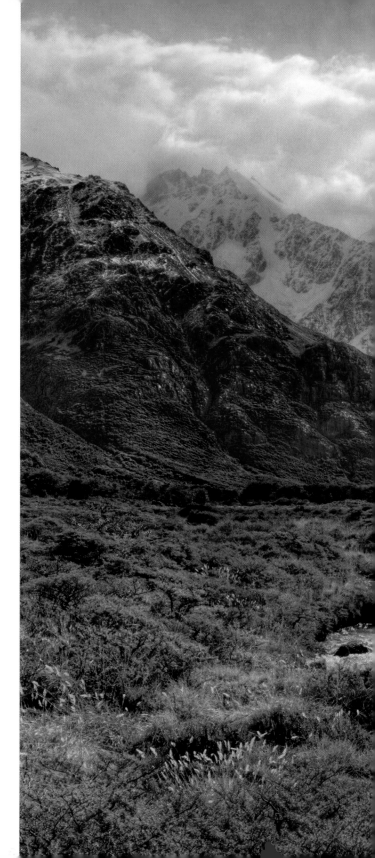

ABOUT TO CROSS THE STREAM ON THE HIKE, APPROACHING THE BLUE GLACIER

This shot was taken about 20 km into our backpacking expedition in the Andes. Colorful life sprang up everywhere from the fertile soil deposited from recent glaciation, even as the valley was changing to its autumn colors. Little rivulets trickled here and there and flowed into larger streams. Fording some of these tributaries was a bit hairy when you're carrying a bunch of expensive camera equipment, but it was always worth it. I can't tell you how often I stopped to take photos along this hike! I'm sure the hike took about four times as long as needed, but after all, that was the point of the whole trip. If you look closely, you can spy a glowing blue glacier spilling out from between the edge of the Andes.

The best way to capture a landscape in a bold way, other than understanding the fundamentals of HDR, is to use a wide-angle lens. Now, all the professional photographers out there will scoff at this and say, "Of course!" But I've met hundreds of novice photographers using their first DSLR, and they are just using the "kit lens"—the one included with the camera. There are a variety of lenses that are wide-angle and are quite good.

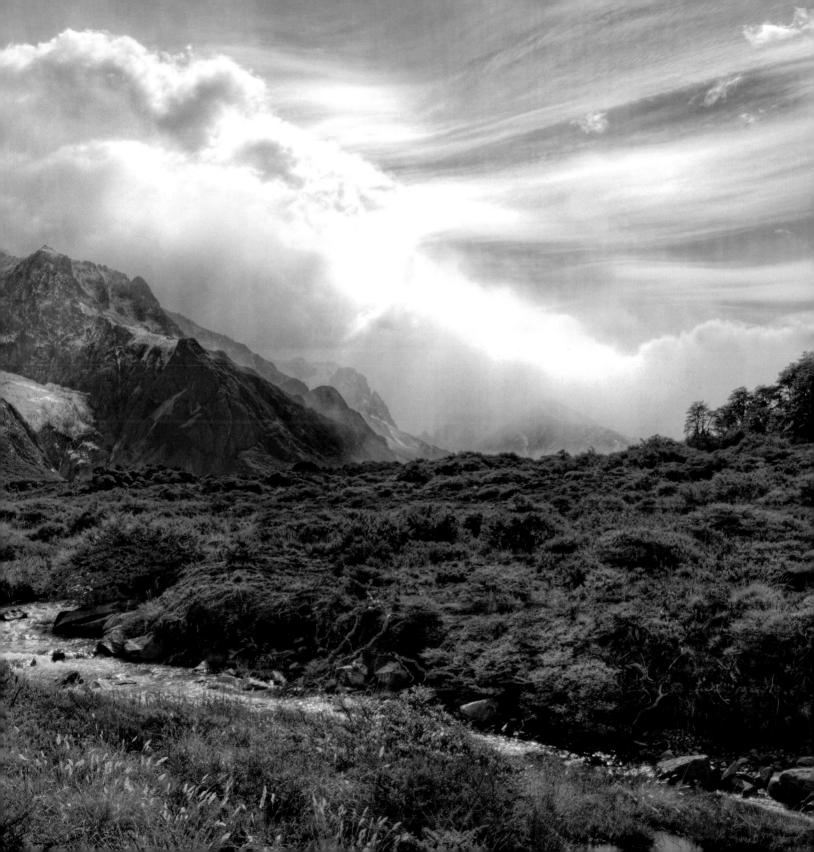

LA BASILIQUE DU SACRÉ-COEUR DE MONTMARTRE

North of Paris in Montmartre, in the 18 arrondissement, Basilique du Sacré-Coeur sits high on a hill and is beautifully lit in the evening. This hill is the birthplace of the Jesuits back in 1534. This fact is interesting to me because I was a Jesuit student back in the day. You would think that after attending that all-boy school, having to wear a tie every day, and taking four years of Latin and four years of theology that I would be allowed to venture inside to take all the photos I wanted using a special key that everyone gets upon graduation. But I had no such key, so I was forced to remain on the perimeter with all the other heathens.

Since the basilica sits high on a hill, I wanted to capture it in that light as best as possible. The third of the five exposures, or what I like to call the "anchor" was shot at 18mm. This made for a good crop, since a square frame seemed best for this subject. There's no rule of thumb for cropping. The aperture was f/5.3 and the shutter was open for 1.1 seconds. This was the appropriate anchor setting to capture the full range of the lights from the church and the sky.

Is it appropriate to end a chapter on evolution with a photo of a religious destination? I don't know. But I do know the Jesuits taught me from an early age to ask a lot of questions and never take anything for granted. The most important lesson they instilled in me was to continue questioning the world around you and to learn how to learn.

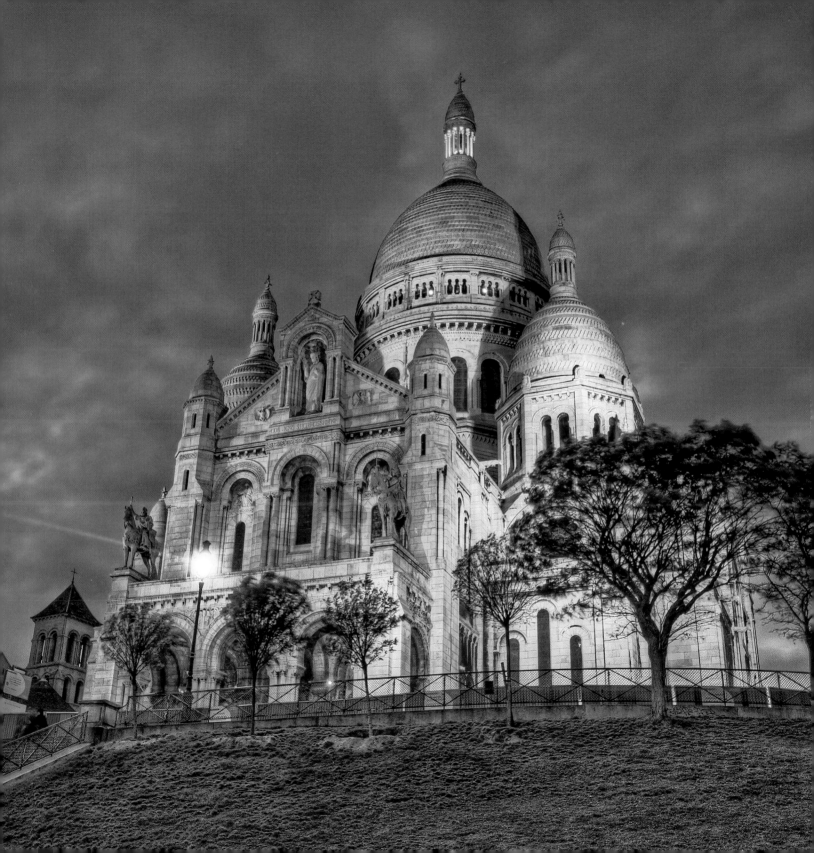

Q&Q VS. Q&A

Oftentimes, it is better to ask good questions than to get good answers.

Hardly anything in life has a definite question and a definite answer. So few notions have discrete inputs and outputs. Even though we live in a digital world, what we appreciate most deeply is the analog. The millions of digital bits that make up a photo are nothing without the inexplicable feeling it gives you.

As I encounter new events and learn new lessons, they only seem to open a new line of questions. I expect that your experience is quite similar. Asking lots of questions about topics you think you don't know tends to spawn even more questions once you start getting close to an answer.

I derive great joy from the process of thinking about unknown matters and find the elusive bits to be of particular interest. We all grew up in a school system that was based on the idea of asking definitive questions and responding with definitive answers. That's fine for the rote rudiments, but most of the problems and opportunities we face in adult life seldom have a "guide" we can follow seriatim. For the fuzziness of life, be wary of any step-by-step guide to success: School systems and society in general has trained us that such snake oil is possible.

I look closely at the nature of the questions I receive regarding photography. I wish I had time to answer every email and analyze the character of each question, how it came about, and what the person really wants to know. Since I can't possibly answer every email with the attention each person certainly deserves, in this chapter I'll talk a little about how people can address these sorts of questions on their own.

I DON'T KNOW

Of matters photographic, people often think I have an array of answers at the ready. Most often, my answer is, "I don't know." But then I'll go on to give a few descriptions of the general shape of an answer. Any definitive answer should be treated with suspicion.

Think about Kepler's law of planetary orbits in which he said the sun is a static focus in the middle of the elliptical orbit. He was then corrected by Newton, born 72 years later, when he wrote the laws of motion that proved the sun has to move a little bit in reaction to the gravity of the planet.

Another frightening example in which people clung too tightly to "answers" determined by esteemed scientists less than a century ago is that of eugenics. Scientists showed clear evidence (no good scientist proves by example) that the human race was on a path for disaster because "lesser" human beings were breeding faster than the superior ones. Eugenics was supported by Woodrow Wilson, Winston Churchill, and two Supreme Court justices who even ruled in its favor. Teddy Roosevelt said, "Society has no business to permit degenerates to reproduce their kind." The heavy politicization of this bad science resulted in the deaths of millions of people. We look back on this as flawed, just as we do with the Salem witch trials. But they all made sense back then because of well-intentioned people who trusted and believed such answers from "experts" who were often full of utter nonsense.

When it comes to looking for answers in the art world, a wrong answer does not carry the risk of societal upheaval,

Of matters photographic, people often think I have an array of answers at the ready. Most often, my answer is, "I don't know."

nor death and destruction. However, the method of memorizing answers can create an insidious self-perpetuating process in which your mind, by default, will look for answers from without rather than from within.

I'll discuss alternate ways to think about the unknowns in your art. The remainder of this chapter and the photo descriptions discuss unconventional ways that I have gone about feeling and thinking my way toward answers. I hope that as I share these experiences they will also help you to think about the nature of learning differently.

SYSTEMATIZED LEARNING IS A DISSERVICE TO ARTISTS

"If I only knew how Van Gogh mixed his paint and made those brush strokes, then I could do it too! I shall ask him!"

Does that sound funny? It should. It's an absolutely ridiculous thought. However, the point is that your desire to paint like Van Gogh is not hopeless; you are just going about it the wrong way.

I posted a screen shot several months ago that showed I had over 20,000 unread emails in my photography inbox. It turned out that most of the questions in those emails asked me trivial bits about the HDR process.

Now, all the HDR and photography-related questions were good, taken in context, but insofar as they miss the mark, it further convinces me that our collective system of learning is broken. Worse, its misappropriated emphasis does a disservice to people who are naturally creative at their core. This inborn creativity can end up getting quite confused within the educational system whose very foundation is a one-size-fits-all happy-meal template that gets propagated to millions of kids every year. Fortunately, there are other options available besides McSchool for parents and kids who have a desire to maneuver the world in a smarter way.

I proffer that there is another way of seeking answers that will do more for your fundamental basis of learning and more for your art. To me, it is better to "guess" at how something works, experiment, fail, guess again, fail, and keep repeating that process over and over again until you either figure it out or you discover a multiplicity of other cool tricks along the way.

For example, I've seen a certain effect created by other photographers that I still can't figure out! It drives me nuts and I love it. Perhaps you have seen this effect too. In some photos of children is a wonderful blown-out effect where everything is this heavenly white except for eyes and a few other features that pierce through the brilliance. Many great portrait photographers who are personal friends do this all the time. I could just ask them, but I refuse to ask because I am determined to figure it out myself. Please don't email me the answer! I've been working on an answer for over 18 months, and I am sure I'll figure it out soon. In the process, I've discovered countless new tricks and unexpected finds, and have taken the search on strange tangents that have been intriguing and educational.

A QUESTION IN TWO BRAINS

Let's talk about the right brain and the left brain for a moment. At speaking engagements, I often say, "The left brain is for getting through life and the right brain is for living."

In case you are a bit nebulous on the left versus right brain scenario, here is a simple breakdown. The left brain is the logical half. It's the part that remembers to take movies back to the store before they expire and retains the fact that the square root of 25 is 5. The right brain is the half that remembers how that movie made you cry and how square roots are silly.

If you have any doubt about this left versus right brain idea, watch the TED video by Jill Bolte Taylor (you can Google this), a brain researcher who had a stroke in her left brain and remembers everything.

Your best art will emerge from your right brain, which will use the left brain for the monkey that it is. The more little tricks your left brain can collect, the better you can get that wet sticky stem into the termite mound. Both sides of the brain will work together. As with the greatest musicians when they are jamming freely, their left brain already knows exactly how to make all the little movements, but the music and ideas flow from the right.

Let the right brain be your foundation for your art and make it enslave the left brain.

The left brain is for getting through life and the right brain is for living.

Beware of any art book that lays out the answers for you or provides step-by-step guidance. Even be suspicious of my tutorial in Chapter 5! I'm still not convinced it's the best way to teach HDR. It can give you a wonderful taste of the shape of the process and inform you of how to get the proper mind-set, but do not let it form the underpinning of your art.

TYPE OF VISA: VISA ON

ENTRY: SINGLE

QUESTIONING AND IMPRESSIONS

Impressionism raised a new series of questions that had never been asked before. Manet, Renoir, Pissarro, Caillebotte, Monet, Degas, and others popped onto the scene using the "new technology" of portable paints to create paintings outside the studio and translate the scene directly as they experienced it.

It may strike you when looking back at these Impressionist landscapes that they are all in "high dynamic range." The painters didn't think anything of it. It's what their eyes saw and their minds experienced. All their questions about light and what they knew about painting internally motivated their art. When these were shown to the public and other artists in the Salons of Paris, a whole new set of questions erupted from the onlookers.

At the time, other classical artists hated the Impressionists, but the public loved them. Artists (especially the subset therein of photographers) are some of the most persnickety people in the world. I find that all irrational behavior, in any arena, sprouts from a fundamental insecurity. People often build up bulwarks of artistic beliefs that support their worldview in the absence of having a solid inner core of self-confidence. For this reason, unfortunately, some people base their self-worth on what others think of them, so they build elaborate defense mechanisms and habits to get them through life. Artists are some of the most introspective people in the world, and some of the feedback they receive should spawn more good questions rather than shake their confidence.

Consider one of my recent experiences: A gentleman emailed me to ask me to look at one of his photos and give him some feedback. Usually, I am too busy to provide personalized feedback, but I had a rare free moment and took a look. I then sent him a quick note saying that "the sky was way too electric blue and looked a bit crazy." He quickly emailed me back and told me I was wrong and that's how he liked it! Ha! Well, good for him! I like to see a bit of backbone from artists (even if the sky was an eye-popping blue).

Art inevitably goes through periods of upheaval, and I believe this is happening now with HDR. Get ready for it, and keep in mind what happened before, during, and after the Impressionistic movement. Once a new set of cultural mores emerges, it leaves behind a wake of more questions than answers.

HARMONIOUS ART

Holding a variety of questions in your head while experiencing a certain truth is a magical moment. We all have these moments of perfect clarity, when the world seems to make perfect sense. Even though these moments of harmony are fleeting, they are important. Winifred Gallagher, the best-selling author, tells me that the spiritual masters are especially adept at being able to hold these harmonious moments in their immediate cognitive grasp, and I don't doubt it.

Keep your questions active in your head as you create your art, and don't stop asking them. If you have read this far into the book, I can only assume that you are comfortable swimming around the right side of your brain, although you may not let everyone else in this left-brained world know it. In that wily right brain, you are able to retain a variety of contradictory concepts in a steady state while you realize certain truths with your art. Try to harness these moments of Zen peace and consider that no particular answer got you into that state. We live in a world of quick answers and rigorous how-tos, but you don't have to subscribe to it. Yes, read tutorials, understand, and study, but then release and let your new toolbox form the foundation of new questions that will take you to the place you've always wanted to go.

Holding a variety of questions in your head while experiencing a certain truth is a magical moment. We all have these moments of perfect clarity, when the world seems to make perfect sense.

I'VE REACHED THE END OF THE WORLD

This shot was taken in the final hours of daylight near the southern tip of Argentina and the edge of Chile, just a few hundred miles from Antarctica.

In the morning, we awoke at 4:30 AM in –7 degree cold. I doubt I slept 30 minutes the whole night. I was in a tiny two-man tent with Yuri, my unexpected Russian tent guest. The noxious fumes of our tiny prison reminded me, if you will, of the inside of a tauntaun that had spent its life consuming cognac and cigarettes. In addition, his snore had the sonorous bass and carrying power of a humpback whale with none of the beauty.

I started the day on one edge of these rugged peaks and circumnavigated them to this side so I could get this view from the glacial lake. The tallest of the four spiked mountains is Cerro Torre, and I was very lucky to see them without cloud cover. They are covered 90 percent of the time, I was told, so to have crystal clear air was fortunate. Glacier Grande, which appears on the right, extends behind many more mountains.

The day was filled with adventure and included a 45-minute, 1500-foot ascent up an icy trail that was not really a trail at all. Dima and Vulva (Vulva was another Russian gentleman who joined us on the trip—it was hard to pronounce his name due to the strange V-W sound, but he seemed to respond when I called him Vulva) accompanied me up the mountain in pitch black conditions using only headlamps. But, alas, we were able to see Fitz Roy as the sun turned the tips pink. We then began the long additional 10-km hike that brought us to this location. I stayed here watching icebergs float by until the last morsels of dusk remained.

It was a tough call on which zoom to use for this shot. When you are in a beautiful place at the perfect time, there never seems to be a "perfect" area to shoot from because usually there are several. My attention was drawn to the jagged peaks and their unusual configuration, so it would have been fun just to zoom in tighter on them. In the end, I decided the glacial lake was most eye-catching, and the iceberg kept the image balanced. So this called for a wide-angle (28mm) to get most of the lake into the shot and keep everything near and far in plain view. Because I shot this at f/16 in near dark, the five exposures had very long shutter speeds. I tried to resist the temptation to throw a rock into the lake while waiting!

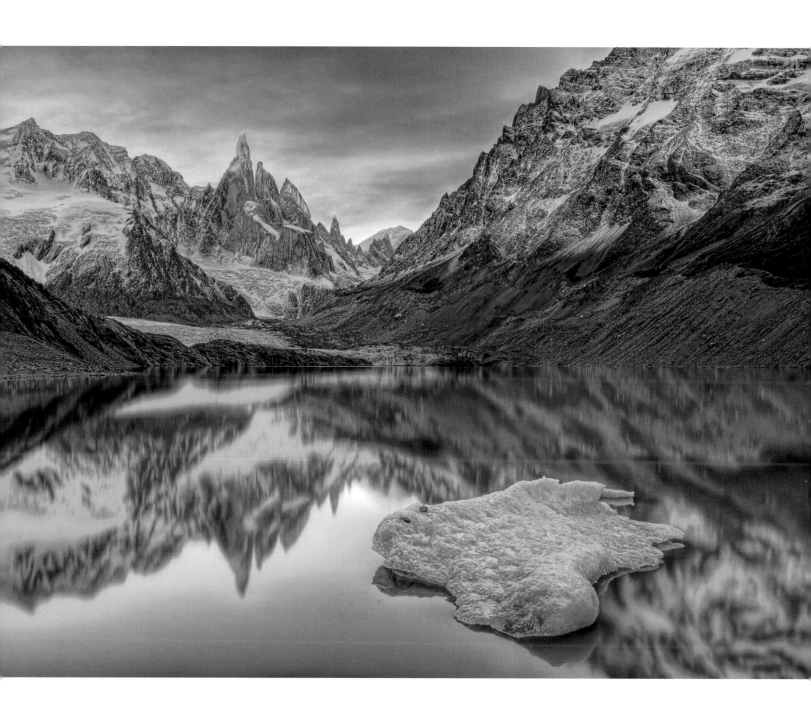

THE SECRET PASSAGEWAY TO THE TREASURE

After the crowds of Angkor Wat, it was nice to find a remote temple in the jungle and be alone. This temple laid under the jungle, completely undiscovered for centuries. The hallway and mysterious chambers seemed to go on forever.

Some nice warm colors are apparent in here. The oranges, yellows, and reds usually make people feel comfortable. To prove my point, if you look at all the fast-food signs, like McDonald's, Burger King, and countless others, you'll see these same tones used to get people in the doors. Not a lot of preplanning went into these signs, and many of the logos had thousands of iterations. But the final signs from these different companies all tend to use the same colors. Airlines arrived independently at this color solution and started using warm colors in the interior of the cabins to calm anxious travelers.

But as photographers we don't have to "guess" what colors will appeal to people in different situations. Copious amounts of scientific and cognitive psychology research has been done in this area. The Impressionists and other artists in the past arrived at the general shape of these ideas independently, but I encourage photographers to look broadly at science texts that are indirectly related to photography. Stephen Pinker wrote a wonderful book called *How the Mind Works* (W. W. Norton & Company, Inc., 1997). Philip Ball, who wrote *Bright Earth: Art and the Invention of Color* (University Of Chicago Press, 2003), states, "For as long as painters have fashioned their visions and dreams into images, they have relied on technical knowledge and skill to supply their materials."

If you like my unconventional advice of not reading photography books as your mainstay but instead exploring the realm of disparate subjects, check out my suggested reading list on StuckInCustoms.com.

In the sort of shots where objects are near and far, such as in this shot, there are two schools of thought when it comes to focus. One is to have a high f stop and keep everything in focus. The second is to focus on the most interesting aspect and make everything else fuzzy and mysterious. I alternate between the two schools based on the feeling I want to convey for the shot. Or sometimes I compromise between the schools and do something that is neither here nor there. I continually question myself about the most interesting part to focus on, and many times there is no silver-bullet answer. And that's okay.

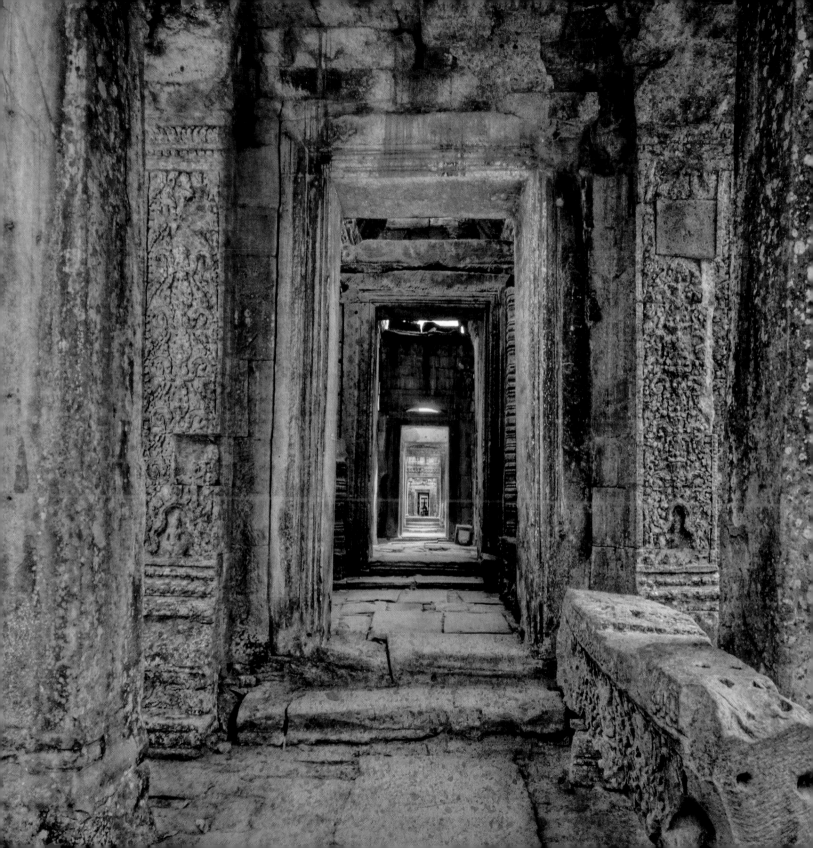

THE VEINS OF BANGKOK

I love getting up to the highest point in cities to get a large-scale view. Unfortunately, I've forgotten the name of this place in Bangkok, but it's the tallest building there. I have a good memory; it just doesn't last very long.

It's remarkable to see how transportation systems look biological in nature when viewed from a different perspective. It turns out that the six link concept of the famous game Six Degrees of Kevin Bacon holds true for all network-oriented instantiations, including cities. When cities and towns naturally build road systems to interconnect populations for industrial, familial, or other reasons, they logically have a series of short hops to hubs that have many hops. Consequently, to get from one city to another within a contiguous area, you never really have to be on more than six different major roads. Within cities, where these hubs are interconnected, you can see these biological patterns that form efficiencies, just like this mixmaster in downtown Bangkok.

On top of many tall buildings you'll often find bars or restaurants from which you can take photos. No one ever really seems to mind. But one big problem is the lights inside the establishment. They bounce off the windows and create an awful reflection. I usually make contact with an employee who looks vaguely important (or perhaps uniformed) and give that person a tip to turn off all the lights for five minutes while I take some photos. However, I first set up my gear so I can start snapping as soon as the lights go off, especially since a mild amount of panic ensues from the patrons.

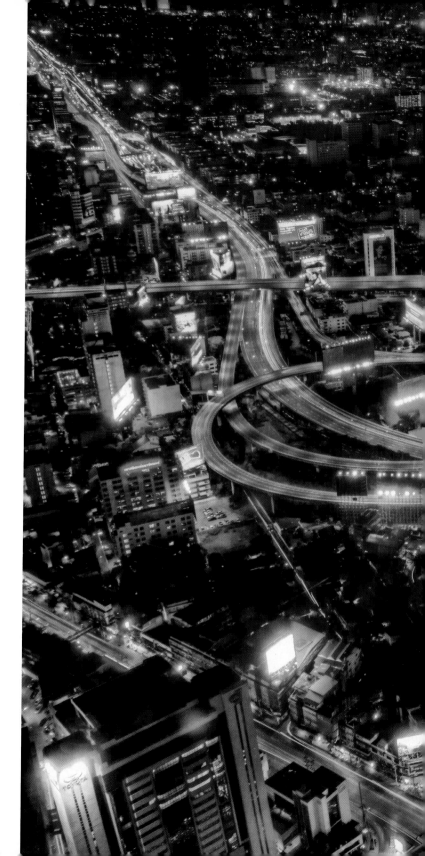

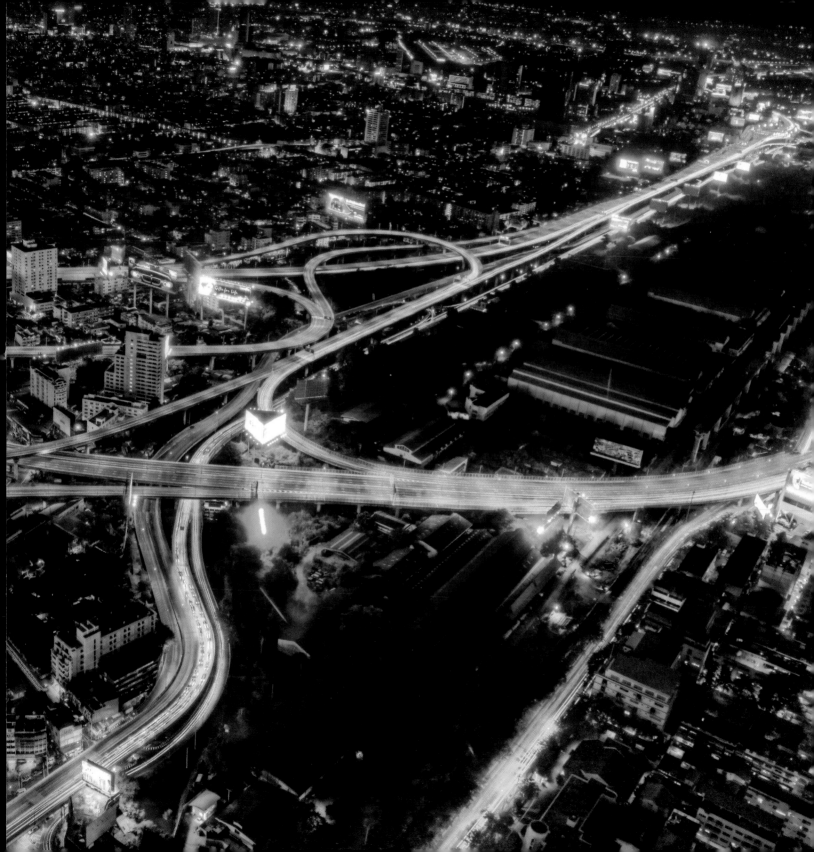

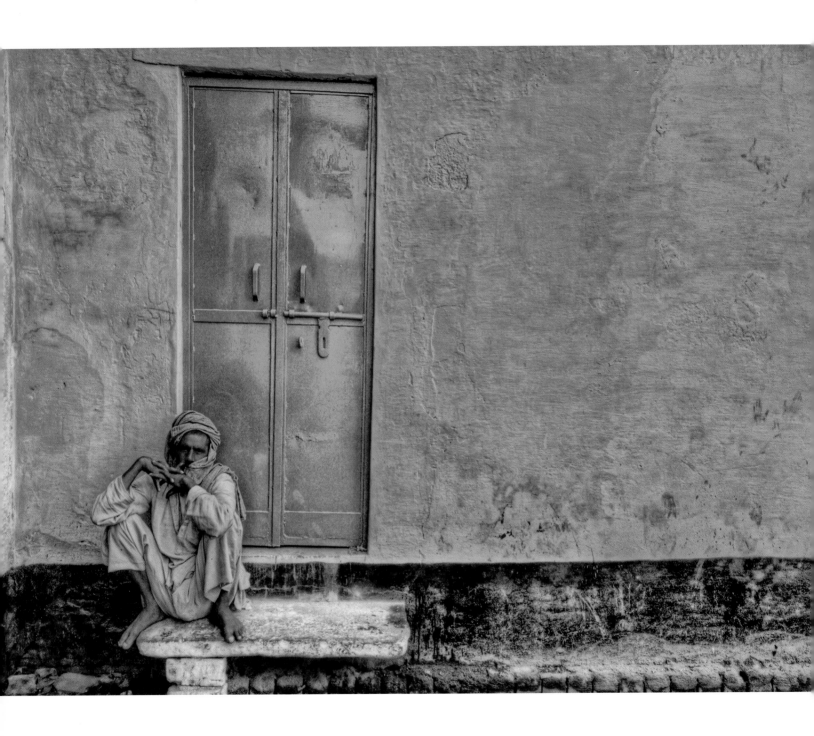

SPENDING TIME INSIDE MY HEAD

It is very easy to distract oneself nowadays. With the Web, games, Facebook, and everything in between, it's quite easy to flail about for an hour or so without really doing anything!

All the tools at our disposal make it difficult for Type A personalities to ever have a moment where we have "nothing to do." There seems to be a steady flow of things to do whenever five minutes of spare time magically appear. We can use our phones and computers to maintain dozens of conversations, projects, ideas, games, and all the other distractions that we are constantly juggling. Whenever we are bored, we quickly look for something to stimulate us.

I wonder: Is this "addiction to nonstop stimulation" good or bad? But after thinking about it a lot, I've decided it's neither good nor bad—it's just another way of being. I'm not sure that's the right solution to the malformed question, but I'll stick with my solution until I figure out something else.

And then I come across men like the one in the photo, who lives several hundred miles north of Delhi in India. He has nothing but time to sit and think about things. Is he able to better figure out things? I don't know. I imagine he has equal amounts of confusion and clarity, just like the rest of us. No matter our habits, we all spend a great deal of time in our heads.

My dad has a funny saying he picked up from AA: "I might not be much, but I'm all I can think about!" Haha! It's a wonderfully modest, egoist, and absolutely true statement to make.

Whenever you have the opportunity to travel and observe people with different customs (and once you are no longer stuck in yours), be sure to take photos of them. Landscapes can be spectacular and breathtaking, yes. But the photos you take of the people will stick with you for totally different reasons. The people are connected to the scenery and vice versa.

Why are people shots and landscape shots so different yet equally interesting? I don't know, but it's fun to think about. This further raises the question, "What is interesting?" It's not just what is different, because in many ways this photo is quite banal. These types of questions are elusive and wonderful to consider.

AN ANCIENT TAPESTRY

Ancient ruins are a great playground for photographers! Sometimes it's hard to make them look alluring. Most of the ancient ruins landscapes are basically just rocks and sky, which can be tough to shoot.

This is a temple about an hour outside of Siem Reap. On route to the temple, I knew I was driving down the same roads as Pol Pot and the Khmer Rouge just 30 years earlier. From what I understand, his entire plan to convert Cambodia into an international rice power was based on flawed interpretations of the ancient uses of Angkor Wat. He sought to return the country to its great agrarian past and in so doing killed about two million people. My guide, monks I spoke with, and many others had relatives who were affected by his violent rule. When my host would talk about his family members escaping into the jungles to get away from the government, he would point to specific places where they made their flight.

When we arrived at the temple, I took my time setting up. While there, I asked myself the question, "How can I do this place justice?" The default photo would have been somewhat boring. I felt like it needed to look timeless and aged because mysterious things had happened in and around there. Stark direct sunlight can be pleasing, but it doesn't leave much room for wonder. Combining the photo with other environmental elements seemed to provide a closer answer to my question.

Whenever I travel to unique places around the world, I get in close to the best textures and take high-resolution photos of them. On occasion, when the photo calls for it, I'll apply a texture to the final HDR, as I did here. This is a very fun process. I won't go through all the details here, but you'll find a Textures Tutorial on my Web site.

THIS IS SECRET

I found this woman with her similarly hooded group walking around the back streets of Mumbai.

Usually when I see a cadre of the enshrouded, they are accompanied by a Muslim man who glares at almost everyone. This time it seemed there was no alpha around, so I asked her name. She looked at me and smiled before furtively looking around to see if anyone was watching. I got the distinct impression that she wanted to talk to me, but since I was a white oddity and we were in public she thought better of it and made a slight bow before gliding away.

Americans often become a bit caddywampus when they see one of these veiled Muslim woman. But these hooded muslimas are quite common in other parts of the world. I'll never forget seeing a harem of them in Malaysia one time. I was having breakfast at the Mandarin Oriental in downtown Kuala Lumpur. Three hooded ones were with a rather dour-looking bearded man standing in line at the buffet. He turned to me while waiting, and I gave him a nod. He did not nod back, but I noticed his outfit—old blue jeans and a t-shirt. Written on the front of the t-shirt was "THE MAN" with an arrow pointing up. The bottom part of the shirt read "THE LEGEND" with an arrow pointing down. I grabbed my best friend Will to show him the shirt, which he wouldn't have believed unless he witnessed it with his own eyes. We were aghast! A few minutes later, he turned to me and very seriously said, "We gotta get a couple of shirts like that."

This shot was taken with the Nikon 70–200mm 2.8. Whenever you are in a crowd of intriguing people, this is a great lens to use because it allows for zooms, candid shots, and other sorts of shots you just can't get with a standard portrait lens.

Keep in mind while photographing people that you can also use your photos to form a basis for questions. I try to imagine the kinds of questions a photo like this will elicit. Where was this? Who was she with? Why is she smiling under the black silk? By purposely not putting all the answers in the photo, I can keep the questions coming.

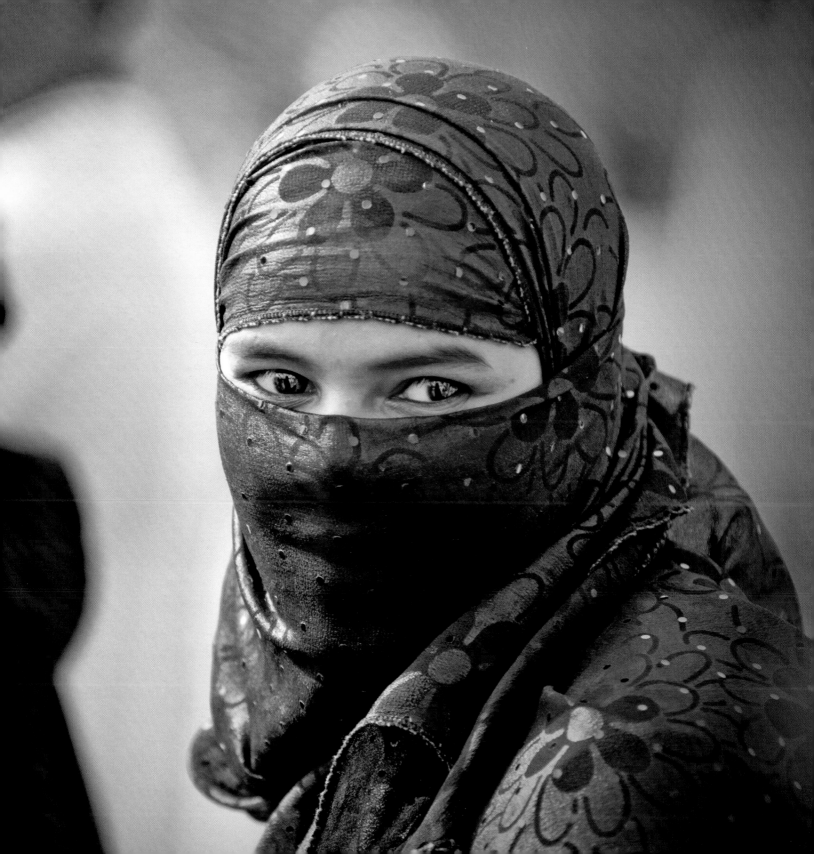

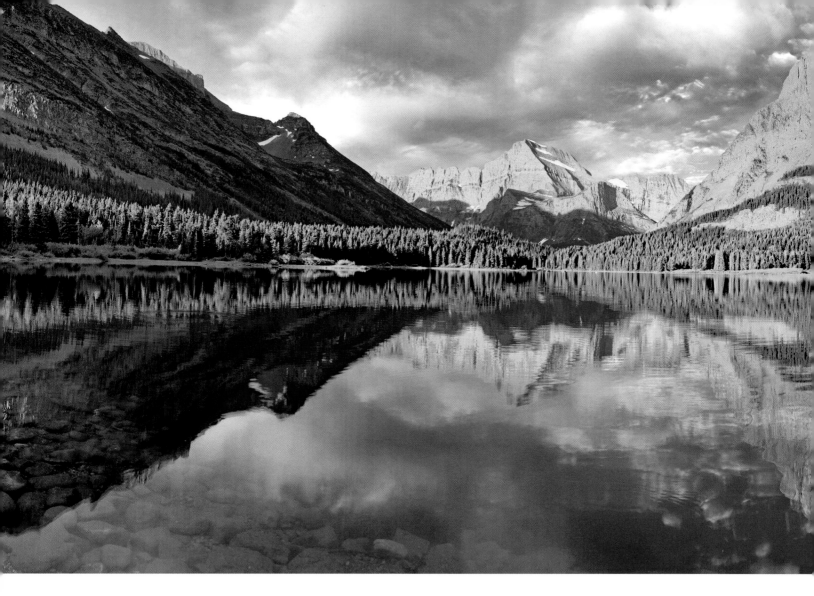

THE MAJESTY

This was the first giant-sized photo I ever completed. The giant TIFF is about 21,000 pixels across. I shot it on a cool, crisp morning at Glacier National Park in this crystal clear lake that is fed by glacial runoff. It is composed of 90 different photos that took a small eternity to stitch together into an epic HDR. I've been thinking about having a ten-foot mural printed at walk-up resolution, but I'm not quite sure where I'd put it!

Frankly, putting panoramas together takes an embarrassing amount of time. Many hours into merging these pieces I start thinking that there must be an easier way to do this!

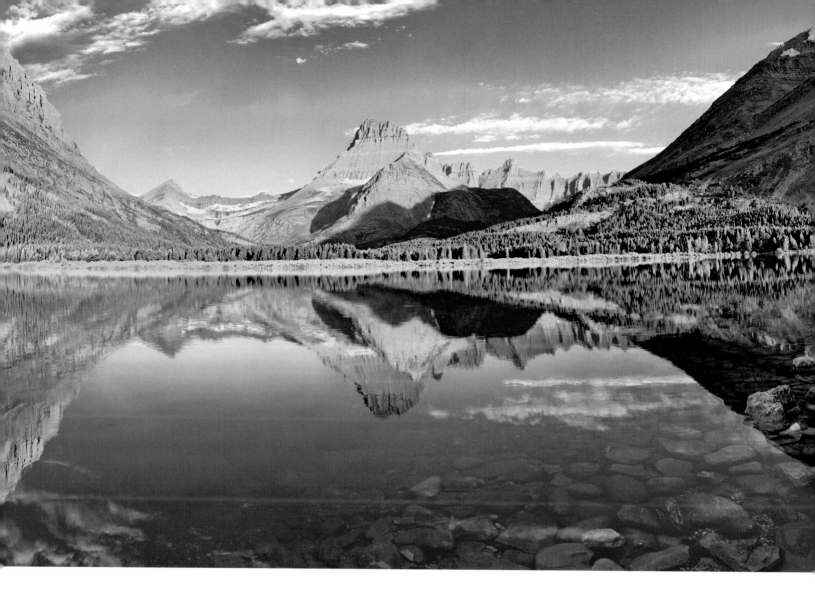

And I'm already using all the latest software to make this task easy! Then I go one level deeper into the recursion of self-tech-reflection and start wondering how much detail is enough. I mean, if I'm serious, why not take 270 photos at 200mm? Or 810 photos at 400mm?

In Chapter 6, "Software" I have a short review of a Photoshop plug-in called Genuine Fractals, which is a great tool for taking a big photo and making it even bigger. Honestly, it's a lot easier than going through the Sisyphean effort that this photo required.

Each grid spot of the panorama required three shots at +1, 0, and -1. I believe it was ten columns across and three rows high. To get good reflections, it's best to get very close to the ground. The added benefit is that you can see details underwater, such as the rocks beneath the surface here.

ACROSS THE LINE

I found this little guy in the Batu Caves just outside Kuala Lumpur, Malaysia. These unique and enormous caverns hold various Hindu temples within, which spill over with plenty of fruit for monkeys. This was shot after a quarter-mile spelunk through the cave as we emerged into a geological oddity—a shaft of sunlight shining downward through an open chamber that had been carved through the limestone after centuries of rainfall.

I believe these monkeys are called Maquaces. My good friend Dave Sands, a geneticist and microbiologist, suggested to me a new mode of thinking about the names of things, which was further bolstered by the nuclear physicist Richard Feynman. Feynman's book is recommended in the Suggested Reading List on my site. This mode of thinking involves the notion of not caring so much about what something is named.

Anyone can learn the names of objects via systematic rote memorization. More interesting, at least to me, about these monkeys is how they behave, how they interact, and why they do what they do. How is this monkey different from similar-looking monkeys I saw in Mumbai, India? Are their high numbers related to their proximity to Hindu population centers? Are the Batu Caves an anomaly in a predominantly Muslim country? Are their numbers related to the subtropic jungle environs, whereas it's tough to find a lot of trees near Mumbai? These sorts of questions represent the type of knowledge I am interested in much more than the names of things.

Was I able to capture all these questions in the photo? Not really, but I do make a feeble attempt. In many ways, the photo can be a starting point for a conversation. For example, when I post a photo on my blog, I may provide some contextual questions, which become a nice jumping-off point for a conversation. The questioning bit can be quite fun, and the photo can help direct the shape of the discussion.

The day was bright and sunny, and the monkey sat alone in front of the inky blackness of the cave entrance. I took this shot as a single RAW photo. Only minor HDR adjustments were made to get the texture in the wall and the details in his fur.

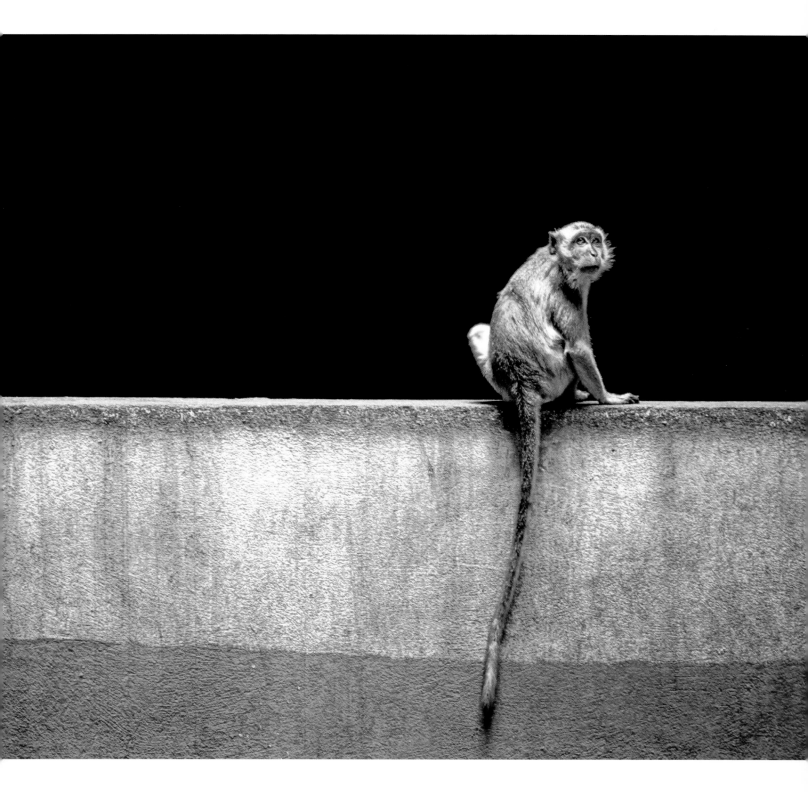

THE BOMBING OF DRESDEN

This Dresden Cathedral was bombed to bits in World War II. It was recently rebuilt, and some of the old, burned, black bricks were reused in the construction. If you look closely, you can see them nestled in randomly with the newer bricks.

That's a nice little tidbit, eh? Oftentimes, very interesting details about a photo are impossible to communicate within the actual image. Sometimes trivia is just trivia, and sometimes trivia helps a shot be better! How do you communicate a fascinating fact in a photo? I don't know!

However, nowadays with the Internet, no photo has to stand alone. It can become one with a conversation.

Think about all the great art that hangs in museums around the world. Perceptive people with diverse backgrounds walk up to them all day long and utter insightful and reflective remarks, and make discerning observations. Unfortunately, all those comments are lost in the echoing walls of the museum!

The Internet has created a conversational web; the photo does not have to sit up in an ivory tower. Put your photos online and let a conversation form around them! Don't wall-off your photo inside a portfolio as your only means for displaying your art. In fact, to get started, why not start posting your photos to our online discussion forums on Flickr and Facebook?

Share your photos with welcoming groups at HDR Spotting (www. HDRspotting.com), Flickr (www.flickr.com/groups/stuckincustoms_ brilliant_photographers), and Facebook (www.facebook.com/ stuckincustoms).

As for the technical aspects of this shot, the camera was set to a 5-exposure shot at 100 ISO and an f stop of 4.2. The third exposure had a shutter speed of 1/15.

THIS IS NATHANIEL

Nathaniel's dream is to get closer to God and to make sure his mom is happy. Nathaniel is four years old and is carrying wood with his two sisters down a dusty cart road in an unmarked Amish village somewhere between Allegheny and Tionesta, Pennsylvania. In pauses between talking to me, he looks sideways at his older sisters, who peacefully nod toward him. I tell him that he looks big and strong, and then I help him carry the wood to his parents' home where he lives with his other nine brothers and sisters.

Many people have asked me how I took this shot. It's not HDR. You can't create an HDR image with people shots because they end up looking like coal miners. The background is "HDRed," a verb form I use a lot in casual conversation, but Nathaniel's face is not. It's best to mask back in the original face whenever possible (I'll describe masking later in the book).

I HDRed the background because everything about this boy was like a painting—his clothes, his hat, his eyes. I wanted a smooth transition between the painting-like boy and the painting-like farm in the background. I doubt most people notice. But then again I'm sure they notice—if you know what I mean.

THE BURNING BLUE STREAM NEAR THE GEOTHERMAL EVENT

Isn't light interesting in water? The way it refracts and reflects never ceases to amaze me. The light and tones can be difficult to capture with traditional photography. HDR allows you to be as surprised by the color and hues of water as you were when you were standing there.

Regular StuckInCustoms.com readers know that I never add color to my photos unless it is a texture overlay (as in the upcoming Great Wall of China photo on the next page). All the colors you see here were actually in the scene, as my Icelandic friends can attest, since they are used to these milky opaline displays.

I found this spot while driving lost in the southern part of the island trying to find my way to the Blue Lagoon. This deep milky blue color appears in all the tiny streams and rivulets that bubble up everywhere across the rocky landscape.

All the geothermal activity is the result of the pulling apart of the North American plate from the Eurasian plate. This rift is part of the Mid-Atlantic Ridge. Subsurface magma keeps all this water nice and toasty. It's a very strange feeling to stand on the edge of Iceland looking south and know there is no land between where you are standing and Antarctica. If you follow the same fault line north, it makes for some of the most scenic photography in Iceland.

For a shot like this, since there are so many opportunities in our daily lives when we come across this sort of scene, I suggest you shoot in cloudy weather. I'm obviously kidding about getting this opportunity all the time, but the same advice goes for shooting a watery location. Sometimes the sun can cause lots of reflections that you might not want. I took another shot of this scene earlier in the day in direct sunlight, and as expected, it did not come out nearly as well.

THE GREAT WALL

The Great Wall of China is one of the great wonders of the world you often hear about, right? I have traveled fairly extensively and had comparatively reasonable expectations for the Great Wall. I thought it would be big and impressive, but wow was I wrong! It was 100 times as big and impressive as I thought it might be! This ancient relic is amazing. The sheer size, width, height, and length of this monstrosity put every other protective ancient wall to shame.

One of my little hobbies is castles, if that is a hobby. I really enjoy visiting castles, studying them, reading about pitched battles around castles, and the like. I've visited dozens of castles in Europe, stood on high parapets, strolled along huge curtain walls, and scaled the ruins of once-huge keeps. But none come close to even one kilometer of the Great Wall. As much as I hate to recommend that you visit a tourist location, I have to say it's a must-see!

How do you take a photo of such a vast monument? This one is tough. I have no good answer. My only advice is to do it an honor and make it look timeless. Make sure your composition does not include modern annoyances like telephone wires, scaffolding, or clueless tourists wearing oversized football or soccer jerseys.

As with any monument, there are many angles of interest. I suggest walking as far away from the tourists as possible to get free of obstructions. Walking some distance on the Great Wall is not easy, but let's face it, we could all do with a bit more exercise anyway.

THE LONELY TRINITY

It must have been a five-hour journey from one end of Montana to another. Not long into the drive the wheat fields start to mesmerize you. While driving along, I like to play configuration games with the clouds and the objects on the horizon. This might sound strange, but I do enjoy seeing them in Euclidean geometric formations—so much so that I had to jump out of the car to capture this shot. Because the Montana winds blow the clouds around quickly, you have to be fast. But on these bright sunny days, the bracketed exposures rattle off very quickly, and there is hardly any movement in the clouds.

Don't be afraid to turn the car around and take a second look at a scene! Every now and then we tend to get lazy and stay in the car because it's easy. You might pass by something and think, I wonder if that would be worth a photo? And then you get to thinking more about it, and after a while time goes by and you figure that you've thought about it for so long that you are now too far away to turn around. Next time, make an immediate bat-turn and go back and take a second look. It's really not that hard, and you do have your camera right next to you, don't you? Don't you?

THE FALLOUT BUNKER

I love this shot! It came out wicked. I used to say wicked a lot in grade school, and it's still a favorite term in my vocabulary. This may or may not make me lame; I can't be objective about such matters.

This is the airport in Bangkok, Thailand. I don't know who the architect is, but it is truly an inspiring building. Taking photos of beautiful architecture can be somewhat of a skill. I try to honor the lines and the textures via a smart composition and a good HDR treatment.

Sometimes I like to use a wide-angle lens to help the lines drift into interesting angles, like they can do. However, this does bother some photographers who like to use a tilt-shift lens to keep the lines in their true orientation. In fact, it really bothers them. But it doesn't bother me at all. In fact, I think it's kinda cool.

Asia has some of the most beautiful airports in the world. The people who work in security are so pleasant and civil when I go through. I had become accustomed to TSA employees scowling at me and giving me more attitude than a Jerry Springer guest list. Unfortunately, the government-run TSA now seems to have the efficiency of the post office combined with the attitude of the IRS. But I digress.

So, how do I capture the beauty of something like an airport? It's the same as any architecture. Imagine that the architect is a true artist and this is that artist's life work. The artist has hired you to take just one shot of the magnum opus. That should put a little pressure on you to make sure you find an angle that will impress the architect.

This photo uses a special technique I call my super-double-secret "double-tone-mapping" trick. Not all situations lend themselves to the technique, but the results are amazing in certain circumstances. This technique is described later in Chapter 5, "The HDR Tutorial."

HINDU ASCENT

A 94-year-old woman ascends the final stairs in the 272-step climb in the Batu Caves, a pilgrimage site in Malaysia that attracts over 800,000 Hindus per year. Her hair is three meters long (about 9 feet) and has never been cut. It is so long that she folds it back and forth a few times and wraps it to keep it from dragging behind her.

Religious places make for good photography, so I'm often drawn to them. It's a bit tricky taking photos in these places because you don't really want to get too close and interfere while worshippers are praying to a particular saint or god in the pantheon of possibilities in their respective religion. Before taking any photos, I try to remain in the background and be respectful while getting a good vibe as I move around.

I used to be more judgmental, or stuck in my customs, so to speak, when it came to the truth of religion and the world. Obviously, my brain, and probably yours if you have read this far, is a labyrinthine series of premises and conclusions that have been solidified via a rigorous lifetime of self-reflection and Socratic reductionism. These religious-oriented photographs always ask a whole set of questions that span beyond the edges of the frame.

When taking photos in religious spots, try to find the most pious of the parishioners. They make good subjects and don't seem to mind you capturing the moment. As long as you are respectful and not getting in the way of their gesticulations, there should be no problem.

THIS IS RANJIT

Whenever I am in a foreign locale, I tend to walk around as many streets as possible to take in the people and sights. Remarkable things are everywhere, but strangely enough we tend to notice them more when we're away from home. When I am in Texas, I have to try really hard to notice people, places, and objects that are out of the ordinary!

I found this chap on one of my excursions in Malaysia. An older section of Kuala Lumpur is full of thousands of attention-grabbing elements and people to shoot. I stopped to talk to him for a while, which is what I usually do when I take people shots, unless I am trying to be clandestine.

Ranjit, now partially blind, talked sadly about his son for a bit. With his hands he seemed to motion off in the direction of his son, which reminded me of a man reaching in the dark for a light switch.

When taking photos of people, it's best to simply talk with them a little first. In a series I've called "What They Do and What They Dream" is a never-ending collection of people shots I've taken from around the world. Included with each shot is the name of the person, what that person is currently doing in life, and what the person's dream is. I believe you can see a big difference in the faces of the people who are closer to their dreams than those who are not.

This advice is also useful even when you're not taking photos but simply trying to get to know someone. For some strange reason, if you are genuinely interested in people, their history, their background, and how they got where they are, people will convert your interest in them into an automatic interest in you! But here is the kicker: You have to be the kind of person who really is interested in finding out about people. You can't fake authenticity. It just doesn't work!

SUNRISE DISCOVERY OF ANGKOR WAT

Surrounded by my cadre of Cambodians at $18 a day, I felt a bit like a sixteenth century British explorer as I investigated this site. These helpers drove me around, carried my tripod, brought me water when I was thirsty, and seemed anxious for me to colonize the area. A member of my cadre woke me up at 5 AM to get this shot.

Cambodia is very humid, so I felt like I spent a week walking around Hugh Hefner's hot tub with none of the upside. Fortunately, where I stayed I had air conditioning—sweet air conditioning. One important fact that I learned is if you keep your lenses inside a hotel room at 21°C and then immediately go out into a hot humid morning, the lenses will stay fogged up for about an hour! You have to wipe them down constantly to get a clean image. In fact, if you look closely at this image, you can see a bit of fogginess. However, it worked out fine for this photo and seemed to add to the mornin' mood of it.

Would a photographer of a better pedigree already know this? Probably. I bet you learn that sort of thing in school or in a book or from a mentor. But because I didn't learn from any of these options, I can readily admit that I've made a whole host of stupid mistakes. Forever the optimist, I try to look at the positive side of not having any formal training. Sometimes the best and most unique things in life don't come with instruction manuals.

So, the two lessons I can provide for you here are to 1) remember the cold to hot humid rule for your lenses, and 2) don't be afraid of making mistakes or trying new things.

To find a good guide with whom to tour Angkor Wat, see my recommendation on StuckInCustoms.com! But you'd better like riding on the back of mopeds.

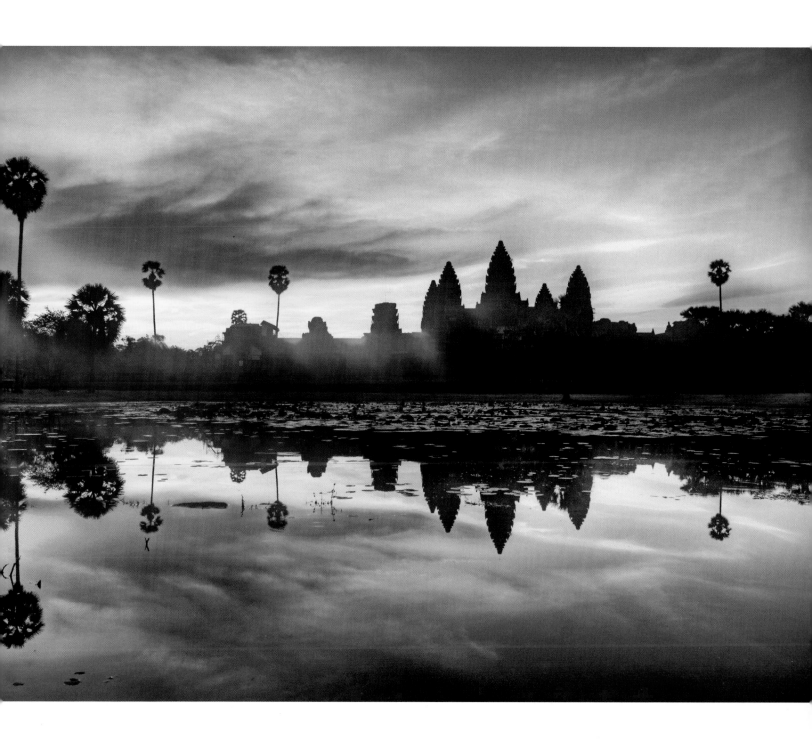

THE FRONT DOOR FACING THE KGB

I spent a bit of time in Kharkov, Ukraine, which is on the northern border, just a short drive from Russia. It's cold there. I still remember landing on the runway in one of those very old planes, just like Lao Che's plane in the movie *Indiana Jones and the Temple of Doom*. The runway was indecipherable from the snowy tundra, and it appeared as though we were landing in any old place. The plane slid to a stop with a bit of a side spin.

After arriving, my hosts set me up in an old, scary apartment building near the old KGB headquarters. I don't know what those offices are used for now, but they still have a sense of foreboding about them.

I almost named this photo "Tragedy of the Commons" after the powerful 1968 article by Garrett Hardin.

Ukraine, once part of Russia, fell under communist rule for a long time. The idea in the article, which I am quite convinced is true, is that shared resources owned by many will usually fall into disrepair, even when it is not in anyone's best interest for this to happen. This comes as unexpected news to socialist leaders who expect that it is in the long-term interest of everyone to maintain a shared resource.

Every elevator and stairwell I visited was in a deplorable state. Many latent thoughts still persist here, including a general distrust of people on the street. After generations of street-filled government informants, nobody smiles. When I naturally smiled at people on the street, I received confused looks in return.

This shot, like The Fallout Bunker photo, uses the aforedescribed double-tone-mapping trick. I took this shot because I wanted to capture the grime and disrepair of the commons. There is a strange feeling in these sorts of places, and I wanted to try to communicate the strangeness through the photo.

A GODLY DANCE AT THE TAJ

I was barefoot like the rest of them. The day must have been around 95 degrees and as stuffy as can be, but the cool marble seemed to keep me from being drenched in sweat. After a long walk, I had finally made it to the inner core of the Taj Mahal around the main tomb structure where pilgrims from all over the country gravitated. The faithful coiled in long lines and snaked their way around the complex, waiting patiently to reflect at the megamausoleum and communing with the god of their choice. How could a billion people be wrong?

When I travel, I enjoy talking to Indians and others about their religion. Inevitably, when I'm in a taxi or man-powered trike-mobile, there is some sort of deity that is jiggling about on the dashboard or handlebars. It ranges from Shiva to Brahma to Vishnu to Krishna to Ganesha and beyond. So, because I enjoy seeing people's response as I probe a panoply of personalities, I sometimes ask, "Who is the god to whom you pay reverence?"

The driver will then talk for quite a while about how he has come to know that God and all the various ways this has influenced his life. Considering the billion different people in India, it amazes me that each has a unique story for the God that person worships but with certain subcontexts that are universal. One commonality, to be sure, is that there is always enough to talk about between your origin and destination.

If you get the chance to go to the Taj Mahal, I highly recommend it. All the people are nice as can be and very eager to engage in conversation about just about every topic. When moving about structures like this, see if you can find ways to illustrate how others are enjoying the monument. It can be tough to get people's faces and the monument, since people are usually facing it. See if you can find interesting ways to pull together a shot!

This photo was shot as a single RAW HDR. Obviously, multiple shots are out of the question here because of so much movement. The aperture was f/4, ISO 160, over 1/1000th of a second with a 10mm focal length. You can see a slight amount of "stretch" on the man's foot in the lower-left corner. The distortion did not bother me, so I left it alone.

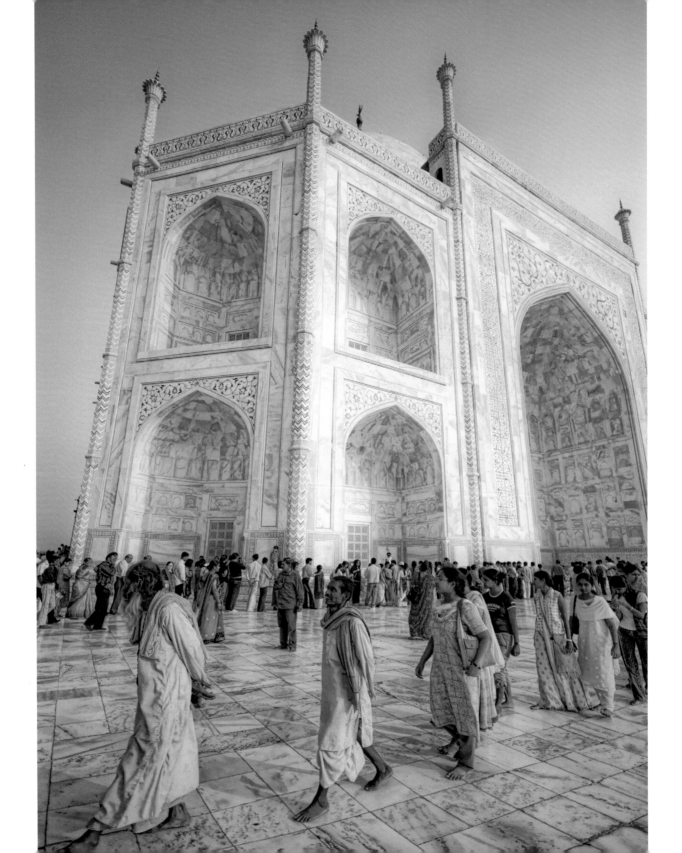

THE GRAND TETONS

We drove south of Yellowstone near Jackson Hole to explore the Grand Tetons. As I was taking this picture, a huge bison came up behind me and caught me unawares. I barely got the fifth exposure to this HDR! It's amazing how big those animals are, yet they can be so quiet.

I often think about why HDR works so well with landscapes and why it is appealing to so many people. I'm sure it goes back to our anthropological roots and our need to be able to traverse a landscape and assess the terrestrial situation with as much information as possible. Over thousands of generations, we have become accustomed to scanning a vast landscape and internalizing, collating, and processing the light, shapes, and line of information around us. The details of the sky and clouds are just as important as the color of the distant mountains. For example, if the distant mountains are a bit blue, our mind recognizes that they are a certain distance away because it makes sense that the atmospheric gas in between is voluminous enough to refract a visible spectrum of blue light. Of course, we don't hyperanalyze this on the scene, but our brain does and sends executive summaries to the decision areas.

I've seen surprising research where hundreds of kids around the world were shown various scenes and asked, "Which one looks like the best place to live?" They are presented with downtown areas, beaches, snowy mountains, forests, savannahs, and so on. Inevitably, no matter the children's culture or current living conditions, they choose the savannah. This speaks to the deeply rooted visual areas of the brain and how we've spent many successive evolutionary cycles becoming accustomed to working inside these sorts of environments to judge a wide variety of light levels at once.

Now if I was shown that survey, I might throw off the results and pick the snowy mountains. I'm more of a mountain guy.

NOTRE DAME OF LYON

I arrived in Lyon for some meetings and went to the old medieval section of the city to grab some shots before dinner. This is the interior of the Basilique Notre-Dame de Fourvière. It is the most lavish and beautiful cathedral I've ever been inside and even surpasses the beauty of the Notre Dame Cathedral in Paris. The Sistine Chapel is probably more lavish, but I've not yet seen it. On my last trip to Rome I was supposed to see it, but Pope John Paul II died the day I was there.

My sage advice for getting tripods into cathedrals and shooting is this:

1. Go in the exit and act like you are lost if someone asks. I did this in Versailles with my dad, who used the excuse that we were looking for my mom.

2. Wear a long Matrix-type coat and stuff your tripod inside like a shotgun. Try not to walk with a limp.

3. Stride confidently through the crowds like you are on a photo assignment and in a hurry.

4. Work your way into the pews and sit down. You can even pretend to say a few Latin words while you are sitting. I suggest "Pater Noster" (Our Father) or "quid pro quo" (rub beads and go to heaven).

5. Slide out your tripod and assemble it on the floor. When other parishioners look at you suspiciously, make the sign of the cross.

6. Watch for elderly people in the main aisle, because they have trouble getting around tripods. Jump out, take your long exposures at 100 ISO, and then sit back down.

7. If security comes to get you, blame StuckInCustoms.com; that will confuse them long enough so you can make a getaway.

8. Don't worry about getting caught. Churches are much more lenient than they were during the Inquisition. Most big cathedrals have crypts where dead saints are interred, but they have never put a photographer in one.

9. If you see a tourist with a tiny camera taking a picture with the flash on, please tell that person to stop. This is your brotherly duty. The flash does nothing in that situation. It's just really embarrassing for that person.

10. Don't worry about what other people think about you. Just do what you need to do and move on. This is also generally good advice for all of life.

MASTS AND SHAFTS

Whenever I look across this harbor of boats toward the vol-cano, I get a feeling of ancient timelessness. I wonder what this image would have looked like in 65 AD before Pompeii erupted. I imagine it was a perfect pyroclastic cone. I also imagine they didn't have HDR photography back then.

This is the bay of Naples across from Mount Vesuvius. I was lucky enough to spend the day here shooting with my great photographer friend Valerio. It was a perfect day for photog-raphy. Valerio, like so many other great HDR photographers on Flickr, is a great inspiration to me. I am jealous that he lives in Italy!

My visit with Valerio resulted in a treasured memory I'll never forget. One evening after taking photos, we decided to get some dinner. He took me to a local cheese shop and bought mozzarella that was so fresh it had never been refrig-erated. Then we went to a tiny garden stand to purchase some tomatoes from a woman it seemed he had known for decades. Around the next corner was a little shop his family had frequented for years that sold fresh olive oil. We took all our ingredients back to his place and had the best insalata caprese I've ever tasted!

The next day we took a boat trip up and down the Amalfi Coast and then out to Pompeii and Vesuvius. What could be cooler than that?

Wake up early when you are in a new place. I don't like waking up early, and those who say they do might just be lying. But the light is usually so good that you can't sleep through it. Once you are out and about, you'll quickly forget about how good your bed felt! Well, mostly.

THE AIRY DOOM OF THE DUOMO

This is the altar area of the Duomo in Milan, Italy. As with most churches and cathedrals, the powers-that-be do not like it when you take a tripod inside. So, as usual, I had to be very sneaky when squeezing off some shots before the security guards found me.

However, about a year later a funny incident occurred; the people from the Duomo contacted me because this photo had become quite famous. They were in the middle of rebuilding the outside of the Duomo and had already constructed the scaffolding. Sometimes in Europe a huge mural is hung on the outside of scaffolding for aesthetic purposes. Well, they wanted to use my photo to adorn the outside of the Duomo—the same photo that I was not supposed to take! Well, we negotiated for a while but never came to an agreement, so this did not happen, but it still makes for a nice story.

As you might be able to tell by the photo, this cathedral is huge! It can hold 40,000 people—as many as some sports stadiums. It's just incredible and cavernous inside, so bizarre things happen to the light. If you've ever tried to take photos of church interiors, you may have noticed that your results are rather disappointing. HDR is the only way to go if you are trying to get a sense of all the light levels inside.

This photo is pretty much straight out of the HDR processing software with very little Photoshop cleanup. I don't normally recommend doing this, but the initial result was so satisfying that I just stuck with it. You will notice, especially if you have tried HDR in the past, that daytime shots can turn out looking quite "dirty" in the sky area. The interiors of buildings also have a lot of dynamic light but not so much that the algorithms need to change the tones of interior colors. For HDR beginners, sometimes it's best to practice taking shots of interiors because mistakes in the processing are often easier to hide, frankly.

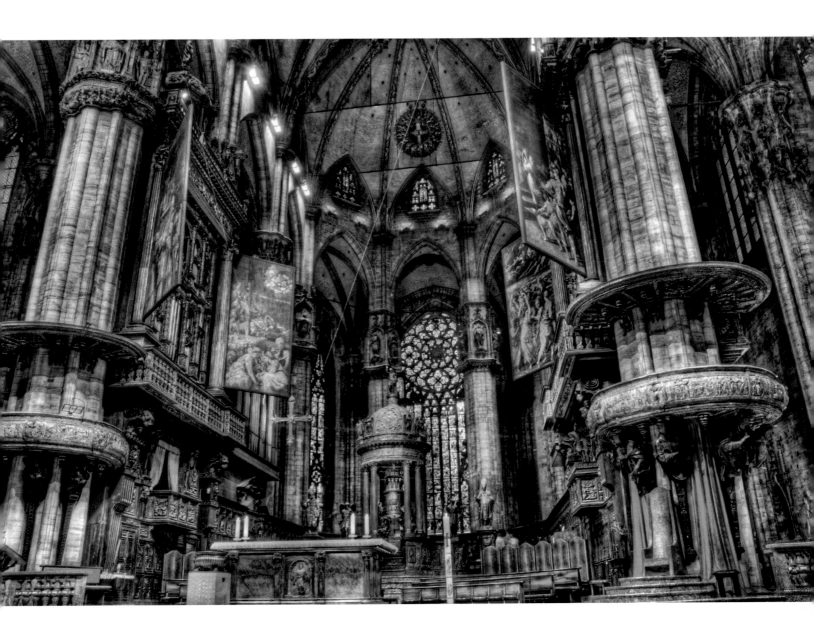

THE GRAND PRISMATIC

Can you believe this is real? Can you believe how big this is? (Note the two people on the path near the top of the photo.)

This place is in Yellowstone, where I've visited at least five times. I've been there so much, I was even fortunate enough to be introduced to the Chief Ranger—Ranger Rick. What a great name! He and I became friends, and he saved my life during one trip. I had forgotten my tripod, and I stopped at his house in Mammoth. Well, he invited me in, fed me, and let me borrow his tripod. What a guy!

I've always wanted to get a photo of the Grand Prismatic Spring. As you can see, most people view it from that little platform, which I have also done many times. The angle is just awful from the platform. You can't see anything. So I had to get higher! I knew from seeing a satellite shot of the place that the inside of the spring has these unearthly blues that were just calling my name.

This shot turned out to be somewhat technically challenging. I made a video in the field of the whole process. I shot it with a 70–200mm lens zoomed in pretty close. The autofocus could not grab onto the steam (it needs contrasty lines), so I leaned the tripod forward a bit to grab onto the edge of the spring. I then set the focus on the camera to manual so it wouldn't change when I was ready for the five exposures. Because of the extra-bright light conditions, I set the ISO to 50 and then adjusted the exposure compensation to -2. As a result, the five shots were not -2, -1, 0, 1, and 2; they were -4, -3, -2, -1, and 0. There are two ways to know this:

- ***Experience.*** *Once you start thinking in light and HDR, you will be more acutely aware of the light around you.*

- ***Trial and error.*** *Let's say you decided to set up your camera normally to shoot from -2 to +2 (your camera may just take three exposures, not like my foolish Nikon, which won't let me step by 2, maddeningly). You would take five shots and then look at the preview. The last one or two shots would look completely blown out—almost white-out conditions. That's obviously way too much light. So that should indicate to you to reset the "center" or "anchor" of those multiple exposures to -2. You'll then get the range from -4 to 0, which will give you a nice dark photo and a nice bright photo.*

If all this technical information still confounds you, I invite you to view the video (it's free) I made about it on my Web site. Just search for "Grand Prismatic" or "Yellowstone" in the search box on the right.

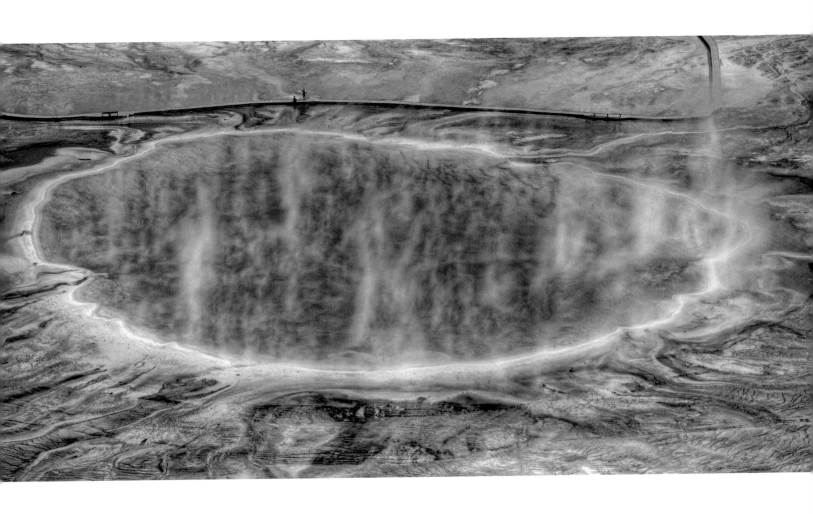

THE PERSPECTIVE OF LIGHT

4

The patterns of light we encounter and record over time are uniquely ours. Those of us who are photographers already understand how light's practice can fundamentally change the way we experience the world. We are accustomed to using the camera frame to reduce entropy and compose a mathematical pattern out of a chaotic world that looks beautiful to us.

Once you start experiencing the world and capturing it in HDR, it can add another layer to this already rich experience. I implore you to throw off the shackles of existing camera technology. For too long we have come to expect and live with the light limitations of a camera. We see the world one way and capture it in another. This does not make sense. If you have been shooting for a long time, this might take a while for you to internalize, depending on how open-minded you are and your personal propensity for change.

A CUBE OF LIGHT

The notion of a "cube of light" will only work if you are exceptional at visualization and if I am able to deftly describe a wonderful concept of light to you. Imagine your best friend is color blind and you both sit down one night for dinner. You try to describe what it is like to see a hot red, midnight blue, or a velvety brown color. No matter how good and poetic you might be, describing color to those with no frame of reference is nearly impossible. This also gives you some indication of how our minds have built a rich vocabulary around color. Unfortunately, we have no common vocabulary for discussing ambient light.

Color-blind people have spent their entire lives living in a world of color but have never been able to see it. Likewise, all of us live inside a happenstance slice of the electromagnetic spectrum, and we struggle with ways to recapture what we experience.

You would agree that someone who sees in color has a better chance of taking a color photograph than someone who only sees in shades of gray. It then follows that someone who sees in "light" can take a better photograph of it than someone who does not. As opposed to the color blind who can never be taught what "red" is, anyone can be taught to see in "light."

The first step is to think about the dimensions of light. We are all used to the three physical dimensions of height, width, and depth. When you take a photo, you certainly have the first two. Begin to think of light as the third dimension, measured in brightness, not in depth.

Imagine a glass cube with a transparent photo on the front. Every part of the entire glass cube has a different light level that allows that photo to *make visual sense*. The thicker the glass, the more room you have for various light levels. The process of auto-bracketing allows you to increase the thickness of the glass, enabling a wide range of light levels that you can remix into your final version of the photo.

SHOOTING IN AUTO-BRACKETING MODE

If you want to take an HDR photo, it is fundamentally important that you capture as much light as possible when you are on the scene with your camera. Setting up your camera in auto-bracketing mode (as I'll describe in

If you want to take an HDR photo, it is fundamentally important that you capture as much light as possible when you are on the scene with your camera.

the tutorial in Chapter 5) allows your camera to capture a series of photos. For example, when you take three photos in auto-bracketing mode, you produce three

cubes of light placed back to back that contain all the ambient light that existed.

You then have the wonderful job of using those cubes and pulling out the light data that you experienced. Keep in mind that the camera took out a razor-thin slice from that cube. In fact, your camera guessed at what you saw! You can use HDR software and fun tools to help you manipulate all of the ambient light to create a final 2D image that contains the light, contrast, edges, and shapes that can give true depth and meaning to a moment captured in time.

LIGHT FROM ITS OWN PERSPECTIVE

We are all used to thinking about seeing light from the perspective of another person. For example, if I am a batter at home plate, I can plainly see the second baseman. I know the catcher is right behind me. I know he can also see the second baseman, but his perspective is a little different. His perspective is a bit lower and a bit more to the right. I can "picture" what the catcher sees. This idea

of seeing a view from another's perspective is quite well understood. But now consider this: Instead of seeing from the perspective of another viewer, think about seeing from the perspective of light. To anthropomorphize light is difficult, but the struggle to do so could give you some nice cerebral ammunition.

As the batter, you are looking at the second baseman, and the light is coming directly toward you uninterrupted. Now, think about the first baseman who is looking across the way at the third baseman; his line of sight is crystal clear. The light from the third baseman to the first baseman is crossing the light you are seeing from the second baseman, but it doesn't affect the light you see at all. (Don't even try to think about the 10,000 paths of light that come from the third baseman and go to the 10,000 fans, cutting right through your view of the second baseman.)

Everyone knows that light acts in waves, and we can somewhat picture thousands of tiny waves in a lake, each one started by a duck, a boat, or the wind. But it gets a bit harder to see the waves that any particular duck has made in the mess of waves. However, when looking at the "light" waves, we can see that particular duck, so the "waves in a lake" visualization is of limited fecundity.

Every spot in the air between you and this page is experiencing billions of light waves crisscrossing in every direction. If you think about it too much, you'll go a little crazy!

Just as your eye and brain work together in a perfect symphony to make sense of all this data, your mission as a photographer is to do your best to emulate this "real life" experience. You have become so adept at swimming in a sea of light waves that perhaps you have come to take it for

Instead of seeing from the perspective of another viewer, think about seeing from the perspective of light. To anthropomorphize light is difficult, but the struggle to do so could give you some nice cerebral ammunition.

granted. Just as the brain uses "software" to make sense of the light, photographers should use software on the computer to help interpret the light for the final photo.

Like many other art forms, it's all a matter of perspective. The more you have, the better it will shine through your art.

THE MORNING STEAM THROUGH THE FOREST IN YELLOWSTONE

There is no better way to understand light than to be in a forest with heavy, wet air conditions at sunrise.

We are so unaccustomed to seeing light while it is en route that we usually get a kick out of seeing its individual rays. There is a similar fascination with lasers. Seeing a little red dot is not nearly as satisfying as seeing a red shaft of light beaming through the atmosphere.

If you ever get the chance to be in a forest in the aforementioned conditions, consider yourself lucky! These circumstances are best for getting an alternative view of light because all the little branches and leaves break up the shafts into thousands of rays. If you take just one step to the right, you'll be amazed at how different the scene looks. It's different than simply taking a step to the right in full daylight, where you might see a slight shift in the perspective of the trees. In this case, each of the thousands of shafts of light moves with your eyes, giving you the feeling that you are swimming in light (which, of course, you've been doing your whole life).

It's similar to snorkeling or diving in shallow reefs. The way the light comes through the particulates in the water is quite delicate and unexpected. These wet, foggy mornings can remind you of that underwater experience. This is especially true once you make the connection that we are also living in a shallow reef: It's just that the water molecules happen to be far enough apart to allow some oxygen molecules between, so we don't require gills to filter out the oxygen.

It goes without saying (especially by now, my gentle reader and confidant) that these situations have more light levels than a camera can grab with a single exposure. Setting up with a tripod to capture a multiple-exposure HDR image is important if you want to trap all the light in the scene. I also advise that you set up your tripod, take some shots, move a few feet, shoot again, and then rinse and repeat. Also, be very aware of the location of your eyes versus your lens. When you move your eyes just a few centimeters, you'll see every shaft of light move; consider that if you have to bend over to use your camera. If you want to be really compulsive about it, think about how the light is hitting your lens a few centimeters in front of your eye, and how that perspective will be a bit different. This slight adjustment does not matter in most landscape situations, but when you are composing each shaft of light, it's okay to be obsessive on occasion.

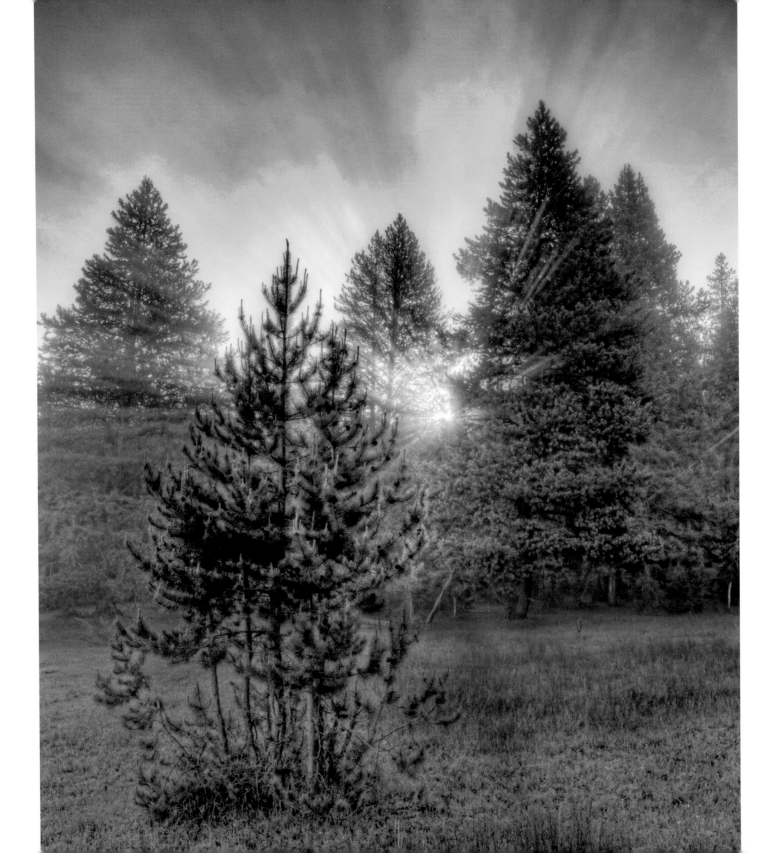

ALONE IN WINTER, AGAINST THE WORLD

This is one desolate place. I was on the coast of Iceland where the sea and the wind were absolutely ripping their way past this lighthouse. I sometimes imagine what it might be like to live inside one of these lighthouses through the winter. I can't even envision it, and after only a short time there in the icy wind, I was happy to leave.

Blues are consistently a favorite color for just about everyone, which leads me to a wonderful conversation I had with the great painter Clyde Aspevig, who I had the pleasure of spending a few days with in Montana. I am often humbled and intimidated by painters because I feel that they are true artists, and I'm just a hack with tricky digital tools.

Clyde and I started talking about the various colors of blue and people's reactions to them. His eyes grew big when I made the flippant comment, "I can't believe how much people like blues! No matter what color blue is in my photo, people always seem to say that is their favorite color of blue!" He agreed enthusiastically and stated he receives the same reaction when people view his paintings.

If you look at some of Clyde's beautiful paintings, you can see a number of elements that just make sense without trying to make sense of them. He uses unconventional techniques of music, anthropology, and motion, and brings them all onto the canvas. His landscapes are reminiscent of the savannahs of Africa, which strike us all at a deep ancestral level. His contrasted objects follow the delicate timbre of music. His skies are textured with a surreal blue motion.

For more about Clyde, visit www.clydeaspevig.com

Shots of lighthouses and towers demand a wide angle lens. To me, the HDR process is secondary to lens selection in cases like these. The lighthouse already had a camber to it and this strangely shaped doorway. The wide-angle lens accentuated these structural components even more.

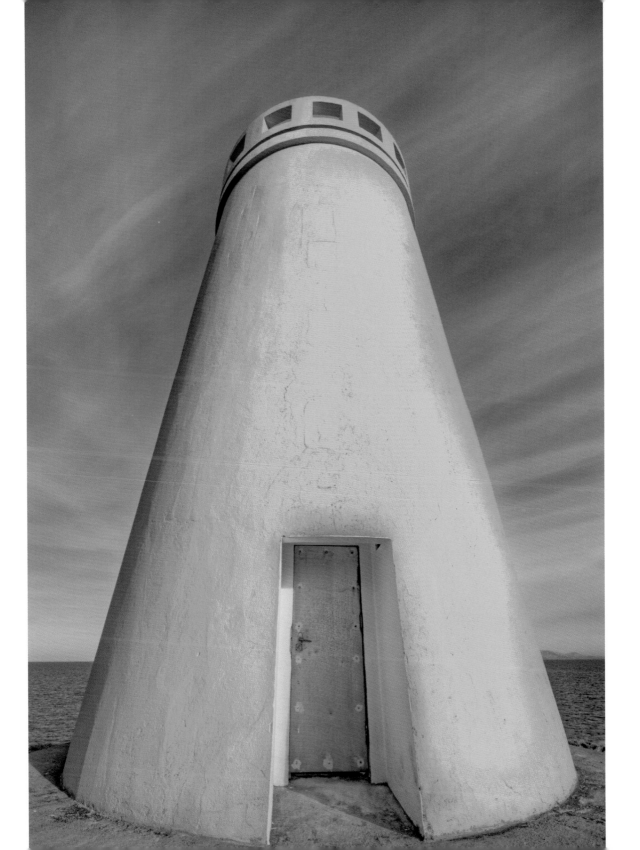

HIKING THROUGH THE JAPANESE GARDEN

The hike was bringing me closer to my goal. The destination inside the Parque Nacional Los Glaciares was the isolated peaks of Fitz Roy.

Every few kilometers the terrain can change drastically. Because all the land had been recently glaciated, the soil was very fresh and full of life. The rough and ice-hewn mountains made for unpredictable weather patterns and cloud formations across the landscapes. Even better, we were there in the middle of autumn, so many of the leaves were changing color.

It was a welcome relief to take off my pack, set it down, and then wander about for some photos. This area was like a perfect Japanese bonsai garden. I wondered what Japanese people think of this place. It was completely natural but looked as precisely designed as any master-planned garden I've ever seen.

We have all become too accepting of the color limitations of the camera. So much light and color is lost in the camera's default operation. It indeed "guesses" the color and light levels. To most (including me), the camera is still a largely mysterious amalgamation of circuits and glass; it makes important decisions on its own, vaguely guided by your settings. We assume the result will be the "right" photo with the "right" color.

The existing colors just wait for you to grab them and make them real in the photo. Van Gogh once said, "Color expresses something by itself. One cannot do without this; one must use it; that which is beautiful, really beautiful, must also be correct."

Setting up for landscape shots is eternally fun in light of the color challenges. Get ready to bend that camera to your will. The composition is the first half of the battle; the HDR process is the second. While taking the multiple exposures, I try to take extra care to notice the colors and textures of the big shapes and the small shapes—the leaves on the trees, the textures of the ground, the shapes in the sky, and everything in between.

In these partly cloudy situations, it's best to remain patient. Watch the dappled shadows from the clouds move across the landscape and be ready to shoot when the most boring parts are shaded and the most interesting parts are well lit by the sun. Direct sunlight is ghastly for people shots but perfect for highlighting appealing bits of the landscape. Remember that even though it may be a beautiful landscape, there are still parts that are "relatively" boring. In this case, I waited for the rain to stop and the sun to hit these brilliant orange trees the right way while everything else was subdued by a passing cloud that had the right template.

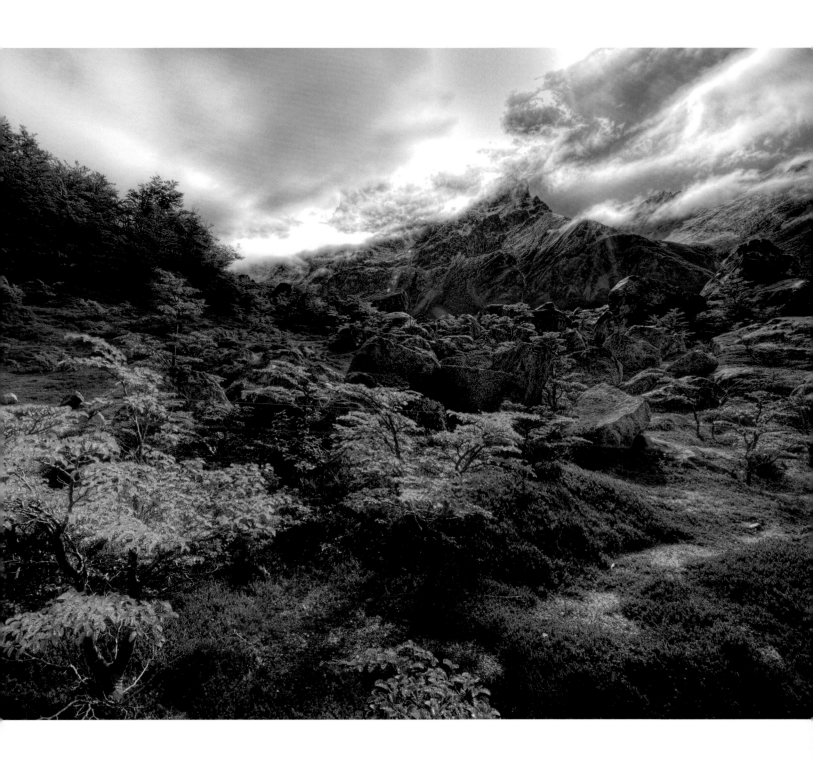

READY TO STRIKE

Outside some of the caves in Kuala Lumpur this guy seemed to be relaxing and taking in the sights. I've often thought about having one for a pet because it is eccentric, and people might mistake me for a Bond villain. I understand iguanas can even be house-trained. But the other similar-looking reptile, the Gila monster, is quite dangerous and the bacteria in its saliva can kill you. So, since I usually get the two confused, I decided it was best not to get one because I would hate to bring home the wrong pet. Also, it's hard for me to imagine one of these lizards playfully pawing my chest every morning.

Reptiles are fascinating to me because of the way they use their Jacobson's Organ (the vomeronasal organ) in a more direct way than we do. This is a very interesting vestigial organ that we all still use on a regular basis, but it's so wired to our reptilian brain that we don't even consciously realize it. In the same way reptiles use Jacobson's Organ to react without thinking, so do we.

Just as we have learned to operate in a world of light, there are other things in our environment that shape our mind. A good example is how we use Jacobson's Organ to navigate the interstices of life.

It's one of the least understood but most socially important organs in our bodies. Located on either side of the nasal septum, these organs are primarily used to sense large molecules like pheromones. We send out genetic and neuroendocrine information from other parts of our bodies, but Jacobson's Organ has nothing to do with smell. It's a deep direct response to other people's pheromones that hits you on a level that people can't understand directly. However, we can understand it indirectly. Have you ever met someone and instantly knew that person was a good person? Have you ever hugged a person and felt more at ease than you should so early in the relationship?

An important point is that we barely understand how the brain reacts to the world. As humans, we depend a lot on light and color to navigate the world around us. Other creatures, like this iguana, do not depend on it and perhaps that is why they need to supersaturate their body colors because their typical viewers' eyes are less sensitive. As we consider how they navigate their world, it helps us understand what is different about ours.

This shot was a single-shot HDR. It really helped to bring out all the texture and color in the iguana's scales. The photo was shot at a low f stop to keep the focus on the creature rather than its surroundings.

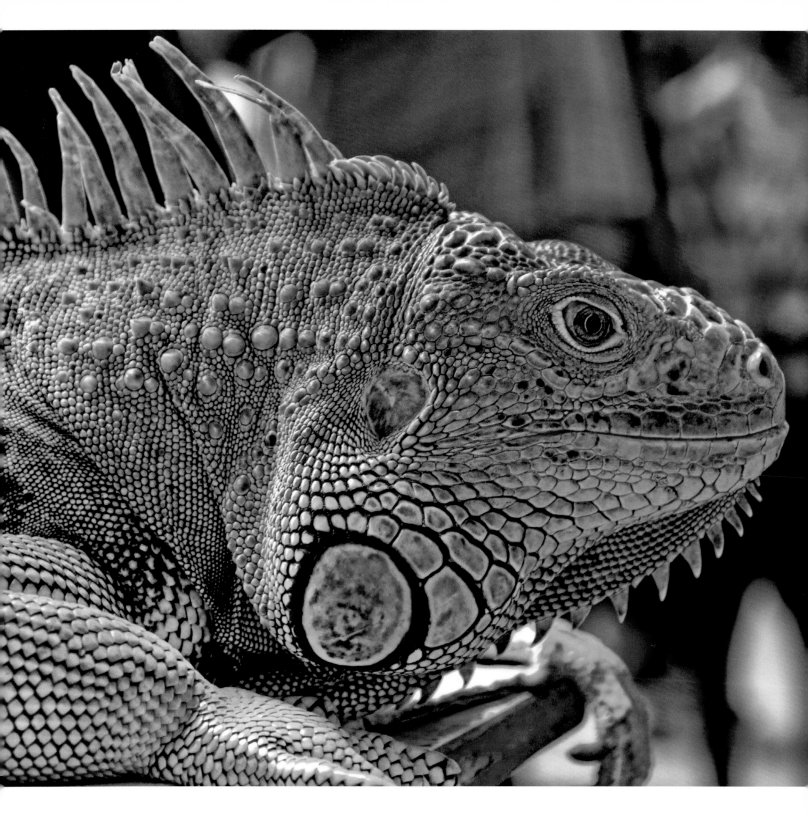

RUSH HOUR

The HDR technique is fantastic for night shots of cities. You would think you could just open the shutter for a long time and let the light stream in. Well, you can do that, but that usually results in parts that are overexposed and other parts that are not quite bright enough. Each of the lights in the busy city streets of Seoul, South Korea, has a different intensity. The lights from the offices are quite dim compared to the signs on the buildings and even the taillights on cars. The HDR process allows each of the lights to come through at an acceptable level.

For all HDR photos, it's best to have some near-black in the photo. As you'll notice in this photo, the darkness anchors the eye and gives everything else a color context. If you're not careful, a haphazard HDR process can wash out all the blacks and keep the light levels in the center of the spectrum. Even in your day-time shots, make sure some darkness is visible if possible.

When I give presentations to a technical crowd, I reuse a trick I learned from Dr. David Eagleman, a brain researcher from the University of Houston who runs an experimental lab. He spoke at a conference I attended at a private ranch in Yellowstone. Eagleman displayed a picture of a black background on a projector and on it were a gray box and a white box. He asked us which one was white. We all chose the white one, of course. Then he put up another box that was white. Clearly, we could see that the two previous boxes were gray. We all felt a bit silly. And then he put up another white box, whiter than the others. And then another. The point was that our brain reaches for the white and the black in any scene and uses that to anchor the other colors and contrast levels around us.

I often recommend taking one final step in Photoshop. After experimenting with exposures, HDR, tone mapping, and the like, sometimes the blacks can disappear. If you want to anchor the viewer's eye, adjust the darkness with the Curves tool or mask in some of the dark bits from one of the original exposures.

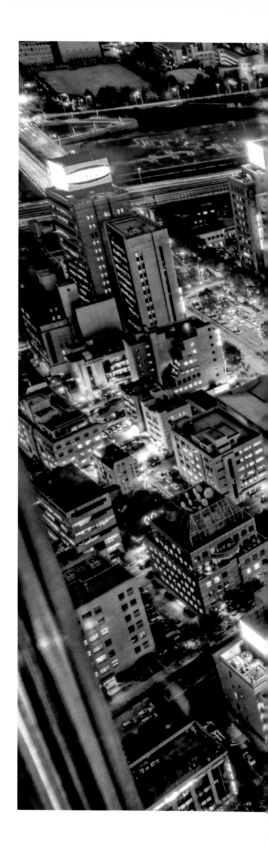

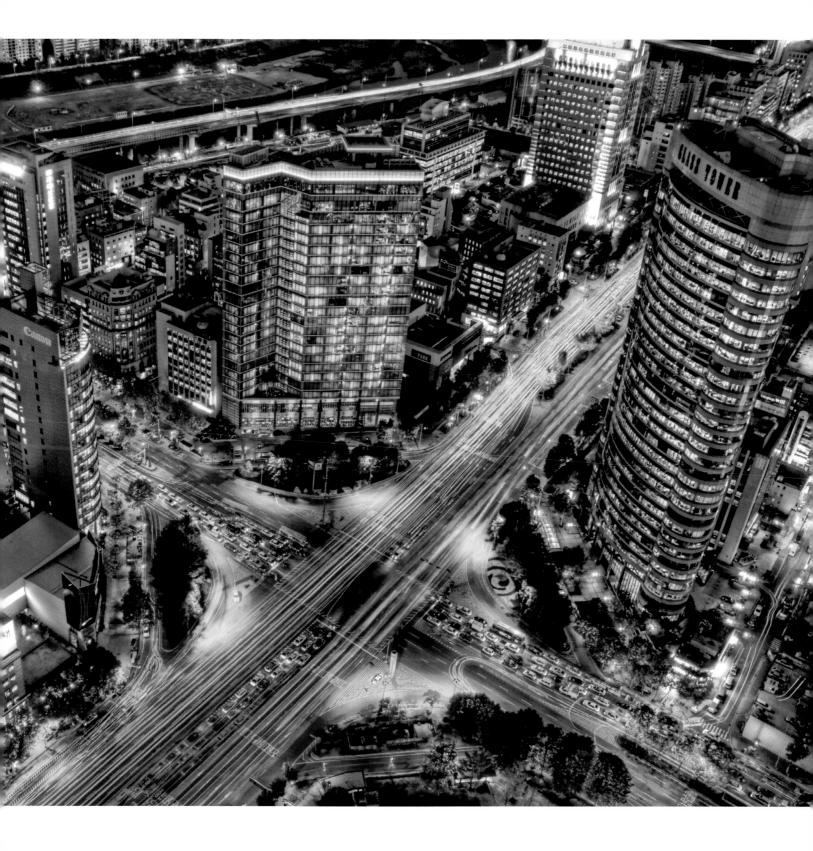

THE ARENAL VOLCANIC PLUME

Near the border of Nicaragua lies Volcán Arenal. This Costa Rican active hot spot is a perfect example of an exercise in volcano frustration.

As photographers, we've all seen amazing footage of volcanoes on documentaries and said, "Wow, I gotta take a photo of a volcano one day!" Well, now I can tell you with ontological certainty that it is nearly impossible to achieve the shot you are holding in your mind's eye.

Essentially, you just have to be lucky to get the red-hot lava flowing down the side. And, as you know, it's hard to plan on being lucky, especially when it entails taking a long plane ride and then driving to a remote location. It reminds me of those poor souls (I will be one some day) who travel to a remote spot in India just so they can see a perfect eclipse, only to wind up with a cloudy day.

To get a good shot, I even took a nighttime hike up the volcano, which was ill-advised for a whole host of reasons. It was a bit like invading Iwo Jima with a blindfold. The jagged, glass-cutting rocks were always dangerously close to within a few shreds of cotton from vital arteries, and the terror of hearing the volcano rumble was enough to make you wonder what in creation you were doing. I did get a few shots of lava and red-hot rocks tumbling down the hill, but they were so lame that I deleted them. The next day I went to a more distant vantage point to try to grab the overall gestalt of the volcano as it growled.

I took this shot from about 10 km from the west side of the dam that forms Lake Arenal at the base of the volcano. I had the tripod set up for several hours waiting for the clouds to form in the right way. The good thing was that it was so windy the whole scene changed every five minutes. Sometimes you have to look away for a few minutes to even realize that your landscape has changed.

CHICAGO THAWS INTO SPRING

To fly over Chicago at sunset in a helicopter was a thrilling experience for me. One of my Chicago fans was very kind to arrange this adventure, and I'll never forget it! The pilot took the door off the helicopter for me, which sounds like a good idea until you start experiencing 100 mph chopper backwash while hanging out trying to get this kind of shot!

We flew for a few hours and circled the city several times. I was sending out tweets while on the flight, and my poor mom was beside herself when she heard about the whole door-off-the-helicopter thing. But I'm a good son, so I notified her when I landed safely. In the center of the shot at the bottom is the famous Navy Pier. We timed this shot to get at the right height the second the sun dipped below the horizon, casting a rainbow of hues into the sky.

You can think about the water as another box of light. It captures the light, redirects it, refracts it, and reflects it. Every angle in every lighting condition gives you a different gradation of color.

This was a single RAW shot. Obviously, from a helicopter, there was no time or stability to take multiple shots from a static position. Fortunately, the HDR process can also work from a single RAW photo. As for the specifics of this shot in these conditions, here are the technical settings for those of you who like this sort of thing. Because of the movement and conditions, this shot called for my Nikon D3X, exposure 0.001 sec, aperture f/2.8, focal length: 15mm (using a Nikon 14–24mm lens), ISO 800, no exposure bias. By the way, if you want to know the specifics on any of my photos, go to StuckInCustoms.com. Find the photo in question, and then link to the Flickr EXIF data. You can get all the information you need in most cases.

You do not need, I repeat, you do not need an $8,000 camera to get this shot. Most of my best shots are taken with lesser cameras. So what do you get with an $8,000 camera that you can't get with an $800 one? Among other features, you get better low-light sensitivity, which means you can capture a lot of light without getting a lot of noise.

STORM HITTING VANCOUVER

I've been to Vancouver twice, and each time I was there, it seemed to coincide with a major storm cell. This was not a problem, of course, since it tends to make photography more appealing. The part that isn't good is always getting wet. But because this has happened to me so many times in different locales, I've adopted a dog-like mentality: I just don't mind getting wet anymore.

Vancouver is one of those cool cities where the harbor is right next to the downtown area. Even better, there's a place to get a shot of the boats with the downtown skyline in the background. This is usually tough to do, since most harbors point toward the sea, and to get a shot across the boats with the city behind them, you actually have to be in a boat.

Whenever I visit a city and am not quite used to it, I usually just spend time driving around (or hiking if roads don't exist) to figure out all the best angles and viewpoints. Like a Navy SEAL team preparing a strike, I do my best to lay out a plan of attack, knowing full well my scheme won't go exactly as planned. But I've found it's better to have a rough itinerary than to have none.

This might sound strange, but it's hard for me to think of a situation where a reflection does not work. I never look at a photo containing a reflection and think, wow that would look so much better without that stupid lake there. Why is that? Well, I'm really not sure. I think we all just like seeing light reflected from unexpected places. At a deeper level, maybe our primate brain just feels content knowing there is a water source nearby. Most likely it's a combination of these feelings. We've built a rich world around the way we deal with light, and the more of that world we can squeeze into a photo the better.

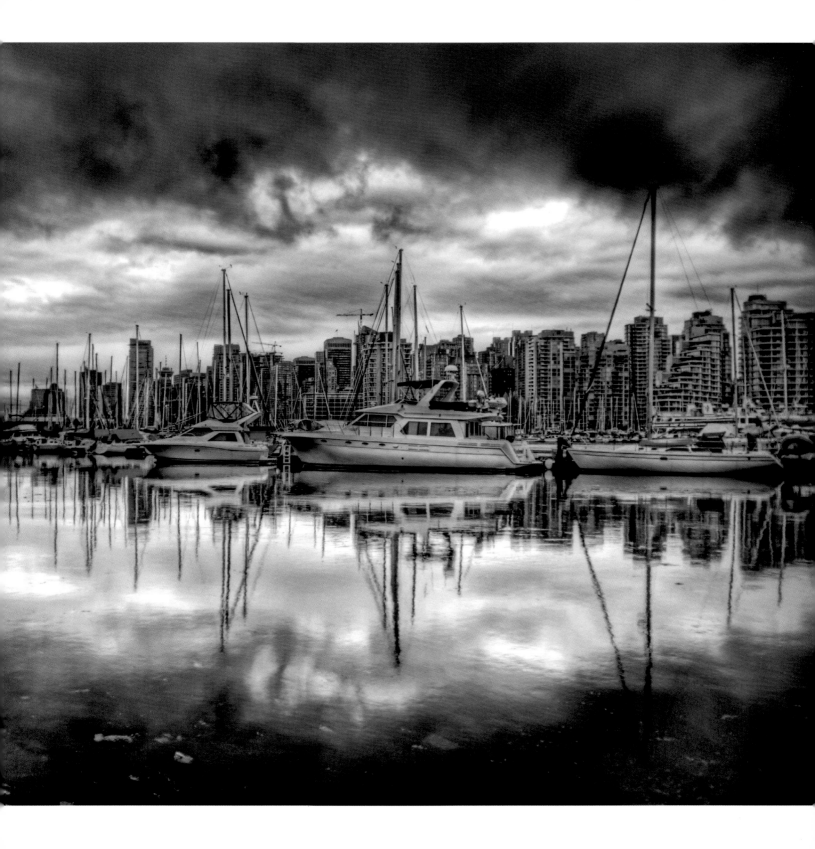

THE ROT BIKER RALLY

Austin is home to one of the bigger biker rallies every summer. The hogs come from far and wide to settle here on Austin's famous 6th Street between Congress and I-35. Hundreds of beautiful motorcycles park up and down the street, and when the sun goes down, many of the bikes begin to glow in one outrageous color or another.

Growing up, I recall the Hells Angels blazing around town. Members of the club were presented to me as some of the scariest people on earth. I somehow thought they had all made deals with the devil and just roamed around the streets looking for more recruits.

But now that I am older and wiser, I enjoy talking to these bikers and have found they are some of the nicest people in the world. They love their bikes, and they love having photos taken. I'm sure I could make an entire career out of just taking photos of these bikes! In fact, I receive so many requests that I've been able to crank my bike photo prices through the roof. A Harley in HDR is a fearsome thing to behold.

Like taking photos at a child's birthday party, the trick in these shots is to get low. All the intricate details are close to the ground, and taking photos by shooting upward always makes them seem larger than life, which of course they are. The other trick is not being afraid to talk to these leather-clad toughies. If you're sheepish, they'll eat you alive.

A SNOWY NIGHT AT THE KIEV OPERA HOUSE

The Eastern Bloc countries always held a certain mystique for me. Because I grew up during the Cold War, I thought that going anywhere near the USSR would be like a Star Trek red shirt visiting the Klingon capital. Kiev, of course, is now a much friendlier place to visit than it was. It still contains a lot of the old imposing Soviet architecture that makes you feel like you are continuously being watched by a government official. While setting up to take photos, I'd notice many a suspicious eye looking in my direction, as if, perhaps, I was a government informant posing as a photographer.

It was quite icy and snowy in Kiev the night I took this shot. I walked near the opera house and discovered this scene. The blue lights inside the building along with the old Soviet car out front created a very cool feeling.

This photo uses the special double-tone-mapping method I describe in the tutorial in Chapter 5. The double-tone-mapping technique, as you might have realized by now, takes all the light in the photo and produces a bit of a "drawing" look. This seems to resonate with people because it has a storybook feel, and many of us remember certain events in this fantastic way. We all live in this often horrible realm called reality, but we don't have to remember it like that.

DANTE'S GATES OF HELL

This is Rodin's huge and famous La Porte de l'Enfer, also known as the Gates of Hell. I found it off to the side of the Musée Rodin in Paris while I was in a tempestuous mood. The sculpture depicts a scene from Dante's Inferno. It contains over 180 of his finest sculptures. If you look closely toward the top center, you can see *The Thinker*—one of his most famous.

It's very difficult to take photos of other people's art. I usually eschew the practice because I feel as though I can never encapsulate and portray the original piece well enough. Capturing a three-dimensional object like a sculpture with a 2D planar device seems to me to be a horrible injustice.

However, I often think back to great photographs of art from the past. One of my favorites is Edward Steichen's 1908 *Balzac Toward the Light, Midnight,* which is a photo of another of Auguste Rodin's famous sculptures. He depicted the statue in a way that I think anyone would appreciate.

If I could be skilled at another art form, I'd love to be a sculptor. The 3D nature of it intrigues me. It's a remarkable experience to be able to walk around a piece of art, a quality that is woefully lost in photography. As you know by now, I like thinking about light in 3D; it is my goal to sculpt in light.

The light and the dark of this photo were most important to me. A deep red with heavy contrast felt right. A distressed and aged texture provided another appropriate element. Did I do it justice? I don't know. Maybe one day I'll meet Rodin outside of these gates and he can tell me.

THE SECRET EMERALD LAKE

I saw the most unbelievable sights in Patagonia. It was like nature rewrote its own rules to build this place. I could make an extended reference to the ill-fated Project Genesis in *Star Trek II: The Wrath of Kahn*, but I won't.

While on the trek, I came across this shockingly clear and mysterious green lake. It was autumn, and after a small rainstorm, all the trees were moist with a glistening glow. The dark blacks, electric greens, and soft reds and yellows danced around the landscape. Because I shoot so many HDR images, I'm convinced that I have little bells in my head that ring whenever I experience disparate light levels.

The water magnified the pure green algae that covered strange underwater formations. Fish were swimming in the water as well, but I kept the ISO so low on these shots that the fish were blurred out. I would have liked to capture the fish in this shot, but unfortunately that was the one thing I couldn't accomplish. The little blue trout would have given the photo just a touch more depth.

Some photographers would have added some blue fish using Photoshop, but I don't do that sort of thing. I've taken a stance not to alter the scenes I shoot so people can trust that all the elements they see in my photos were actually there. On occasion I'll use the Clone Stamp to eliminate a distracting wire, a tourist, or a telephone pole. But to me that's different than adding a blue fish from another photo. Anyway, I'm sure you get the point!

SWALLOWING THE RUINS

I made it to the heart of Ta Prohm, an undisturbed Bayon ruin in the outskirts of Angkor Wat. It was late in the day, and there was a break in the afternoon summer showers.

The best thing about many of these foreign temples and ruins is that you can move freely around them and go to the top and the bottom, whether they are safe or not. You can investigate hundreds of tiny nooks, old broken stone doors, and lost hallways, and analyze mysterious carvings peeking out of the overgrowth. Unlike in the United States, there are no tort-related legal signs barring you from any area—so explorers beware. Even if you did get injured, the jungle and insects would eat you alive before the night was over. It's either that or be slowly digested by a parasitic legal system.

As soon as I walked into Ta Prohm, thunder started rumbling and dappled clouds rolled in. The thunder was extremely eerie and triggered some chest palpitations while I was wandering inside all the moss- and vegetation-covered old tombs. The rain started and stopped several times, so I would take refuge in crumbling crypts and hallways until the rain let up. I took some wrong turns, but I eventually ended up here as the storm began to break.

The temple was built in 1181 AD and was home to 18 high priests, 615 dancers, and 12,500 people. I don't know why the dancer stats are so important, but there you go.

Obviously, I processed this shot with just one color of light. People who shoot black and white photography are quite familiar with this technique. At times color can just confuse viewers' brains, pulling them in the wrong direction. Normally, I have no problem with vivid colors, because it can be fun to let viewers surf all over the photo finding different bits of interest. But when you are processing a timeless and important shape, it's best to keep the light simple.

Did you know that you can produce HDR black and white photography? Of course you can! This is a pretty good example of what you can achieve. In fact, if your black and white photography is part of your bread and butter, you can spice it up with HDR. Keep in mind that HDR doesn't have as much to do with color as it does light. I provide a mini-review of some excellent black and white conversion software in Chapter 6.

BIG BROTHER APPROVES OF YOUR PARK ACTIVITY

Chicago's Millennium Park is a great place for photography. Several cool sights are there, one of which is this giant video wall. It has this strange, glass, brick-like covering and displays unusual images of people softly smiling at you. It reminds me a bit of Big Brother and that there might be a tiny camera behind the wall that the government is using to ensure that your park activity is appropriate.

All of these glass bricks prompt me to think about the idea of the cube of light I discussed at the beginning of this chapter. It's unfortunate that we only get to see the occasional 2D plane of the cube. Imagine if we could take off the front layer of glass bricks. Would we see inside this guy's head, or would he just zoom in even more? It's fun to think about.

I waited patiently for some people to stand in front of the wall so I could capture its scale. By chance, a man and his young son walked up to it, which created the perfect scene. This part of the video loop—one of my favorites—appeared on the screen and most likely mimicked the reaction of the man standing there watching it. Such ideal circumstances don't present themselves too often.

You can only get a scene like this with HDR. There's no other way.

Earlier in the chapter I mentioned how important it is to have very dark tones in your final HDR product. Well, this is a good example. My long exposure did provide a bit of light for the man and his son, but I chose not to use that bit for a variety of reasons: But one reason I feel strongly about is that in many cases it is important to use darkness to help anchor the eye's lower range.

THE LONELY ROAD TO THE DINOSAUR DIG

I've been mesmerized by dinosaurs my entire life, so you can imagine my surprise and excitement when I was lucky enough to be invited on a dinosaur dig with Jack Horner. Jack was the inspiration for the main character, Alan Grant, in Jurassic Park. Jack is also the person you see being interviewed on The Discovery Channel and the like because of his expertise in paleontology.

For a few days in Montana, Jack took a small group of us to a glacial valley and had us stand on a terminal moraine. No one had any formal training in geology (except for my stint in college, by chance), but he made us stand there until we could figure out what we were standing on. He wouldn't tell us the answer, because he knew we all had the answer inside of us already. Jack is an impressive teacher and his technique can be likened to the Socratic method on steroids.

A terminal moraine is the pile of rock debris that has been pushed forward by a glacier before its retreat. The process of using the Socratic method to learn this on our own by using deep thought and questioning—in this case, for over an hour—versus reading an answer from a book in a matter of seconds challenged us to think through our concepts. This experience, combined with a later nature walk with Dr. David Sands, reinforced my suspicions that the current way we teach is broken. We all have the answers inside us if we are rigorous in our instincts of reductionism.

A good sunset requires clouds, and that is beyond your control. But since it is said that luck is the confluence of preparedness and opportunity, keep your camera and tripod no more than ten minutes away in case the world stops conspiring against you.

A MORNING AT THE SECRET LAKE

What is the altitude of this lake? I don't really know for sure, but it's pretty high, and I was sure happy to find it after the hike.

Getting to this spot in the mountain range between Chile and Argentina early in the morning was exhausting. I decided not to carry any water with me because I knew from Google Earth that there was a small lake here. I usually don't like to carry water with me because it's heavy, so I try to find places to drink along the way.

As I was walking up the trail, I had a sneaking suspicion that this lake might be frozen. This does not settle well in the stomach while on a self-induced death march up an icy mountain. Sometimes when you are in the middle of an arduous trail, the only thing you can obsess on is what might go horribly wrong at the end.

Another strange light-related event had happened earlier that morning. I hiked up the mountain with two Russian friends. Both men were pretty extreme and one was in the former Soviet military, having led expeditions into Siberia 20 years earlier to track a rare tiger. We started the hike so early that it was pitch black for the first hour. I had no flashlight, but each of my companions had a light attached to his head, which waved back and forth while walking. I was between them.

The gentleman in front cast a good bit of light, but it was occluded by his body. The one behind me also cast a beam of light, but as it swept back and forth, it crisscrossed my body, leaving an ever-changing black shadow everywhere I stepped. At one point we had to cross a little "bridge," which was really nothing more than a log that had been laid across a stream. The log was covered with ice, and I don't think I ever even saw the darn thing as I crossed it. I had to intuit where it was based on shadows and feel. This caused a sickening feeling I'll never forget.

And speaking of a sickening feeling, I also won't ever forget having two Russian women making campfire borscht for 27 meals in a row, but that's another story.

As you can see, this is a square shot! Whenever I've finished cropping, I twist my head right and left and think about whether or not the crop is right. On the rare occasion when I do a square crop, I'm usually quite happy with it and wonder why I don't do that crop more often!

I try to do most of the composing on the scene, and even though I'd like to think I have a free-thinking mind, I'm obviously influenced by the default rectangle in the viewfinder. How did that rectangle shape come about? It probably evolved from the flattened milling/cutting process of paper, which then led to the printing press, which then led to photo printing and the desire to use every corner of the cut. But with digital images, cutting off the corners is so far removed from that process that maybe our current cropping decisions are based on obsolete premises. However, looking at other arbitrary shape cuts like a circle or a triangle never looks as good as a rectangle or square. Why is this? I'm not sure, but it's worth more thought and exploration.

ICE SKATING AT ROCKEFELLER CENTER

After exploring the top of Rockefeller Center, I headed to the bottom where the famous ice-skating rink resides. The huge lights on both sides of the tower created a cool purple streaming light that exploded from the building, producing a dazzling effect.

The only way to shoot this type of scene is with a wide-angle lens. In this case, it was a 10mm. I often see tourists with their little Japanese cameras trying to take a photo of the building, but there is no way they can even get in half of the building. I feel sorry for them because they have no idea what they are missing.

Sometimes, I'll offer to let a few of these folks look through my camera so they can see what a wide-angle lens captures. They always gasp in shock when they look through it. Truthfully, though, I did the same thing the first time I looked through one!

This was the anchor shot of a 5-exposure HDR. The aperture was f/4, exposure at 0.2 sec, and the ISO at 100. To get that starburst light, the HDR process will help to combine the light received in the five different shots to help provide a "streaming effect." Also, a wide-angle lens seems to help the light stream in an exploding pattern. Be sure to keep the ISO as low as possible so you don't have to deal with any noise problems. Noise will still happen, so I provide some suggestions for how to clean it up in Chapter 5.

CHRISTMAS ON THE CHAMPS-ÉLYSÉES

This is one of the most famous streets in the world, so I wanted to do my best to capture it in a romantic way. The time of day usually does much to affect the mood, so it's often best to shoot these classical places (especially in Paris) in the evening. The dusk light is totally different than the morning light. And, frankly, it's easier to stay up past sunset than it is to wake up before the sun rises.

In a similar manner, HDR is currently modifying photography the way the famous French painter Georges Seurat altered Impressionism by introducing pointillism. His paintings feature tiny spots of paint that only make sense when viewed from a distance. (For a prime example, see his Un dimanche après-midi à l'Île de la Grande Jatte at the Art Institute of Chicago.) Pigments of paint mix differently than beams of light. Red and green paint combine to make brown, but red and green light merge to produce yellow.

When you view one of Seurat's paintings, your eyes and mind receive different wavelengths of light simultaneously as you attempt to blend the color spots and produce the image depicted. Depending on the combination of light waves, your eyes turn those waves into various colors. Our minds have invented a rich vocabulary and meaning that represent color and light. We've moved from pigments to pixels in the digital realm, but the principles of pointillism persist. By the time the light mixes and gets to the eyes of the viewer, the evocation changes into something else entirely. HDR, its network of tools, and its related processes are enabling us to visualize the world in a completely new way.

A question I receive time and again is, "How do you make your pictures glow?" My technique has come from an intense study of the Impressionists and their uses of colors and light. At this point, I have formed only a poor facsimile of what the greats have mastered, but I am trying to improve with every photo. Consider Seurat's yellows. He did not achieve them by mixing paint; instead, the intensity was achieved via other colors mixing in the air between the painting and the eye. The complementary colors in Monet's landscapes mixed to create an image more potent than its constituent parts. The best way to understand how to make a photo glow is to study, practice, make mistakes, and consider the gestalt of the final product rather than the rote assembly of its parts.

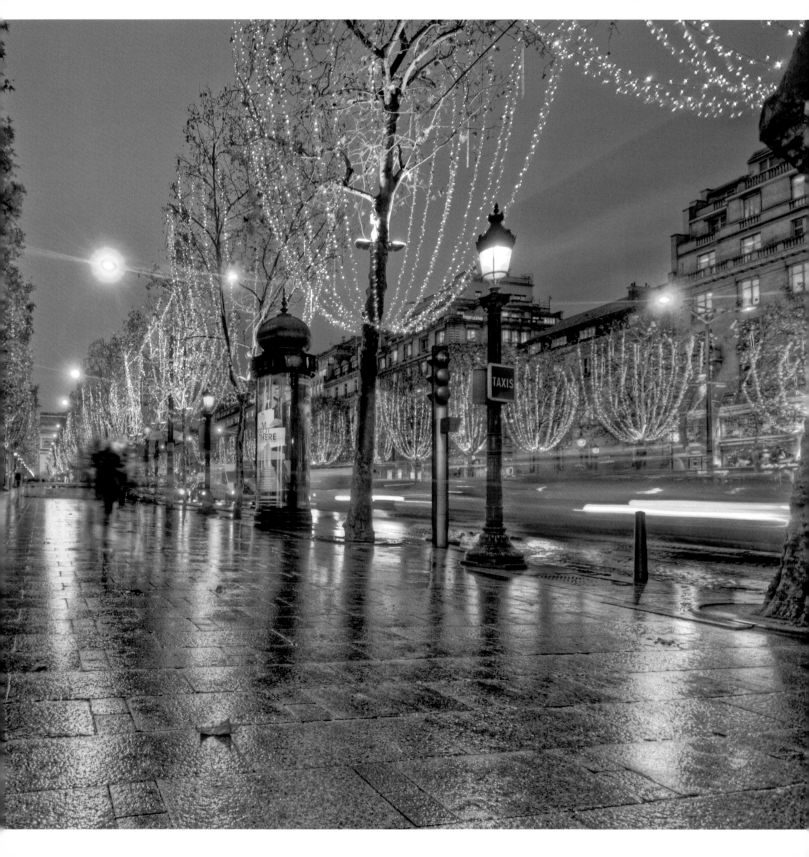

THE NORRIS MUD POTS

In the western part of Yellowstone is a hot zone of geo-thermal activity called the Norris Geyser Basin. I was in another area of Yellowstone to get a sunset shot but then decided to stop here to get some post-sunset photos.

When I arrived, the one other person at the site was just leaving. He was a fellow photographer and was just getting into his car. As he did, he yelled to me in a haughty way, "Sorry dude, the sun has already set. It's too late." Needless to say, his comment angered me. I don't know why I let it get to me, but I did. How did he know if there was not enough light? I didn't know that. Maybe he was right and maybe he wasn't. Anyway, I'm not known for listening to others when it comes to my photography, and I wasn't about to start then—a frame of mind you might consider as well.

Even after the sun goes down, a substantial amount of light is usually available. It refracts and reflects through the atmosphere, and gives you colors that are otherwise washed out by an intense sun. Light and the colors you need are present all the time. Only in the absence of direct sunlight can you actually see how accessible they are to you. It's an important aspect of light to think about.

The blue hues really develop into a new world of color after sunset. Paul Cézanne once said, "Blue gives other colors their vibration." It's true. Meaningful blues can anchor your photo in a very real manner.

I offer another free video about how I took this photo, how I chose the angle, and other conditions that you are welcome to watch. Just check the Videos section of my StuckInCustoms.com Web site.

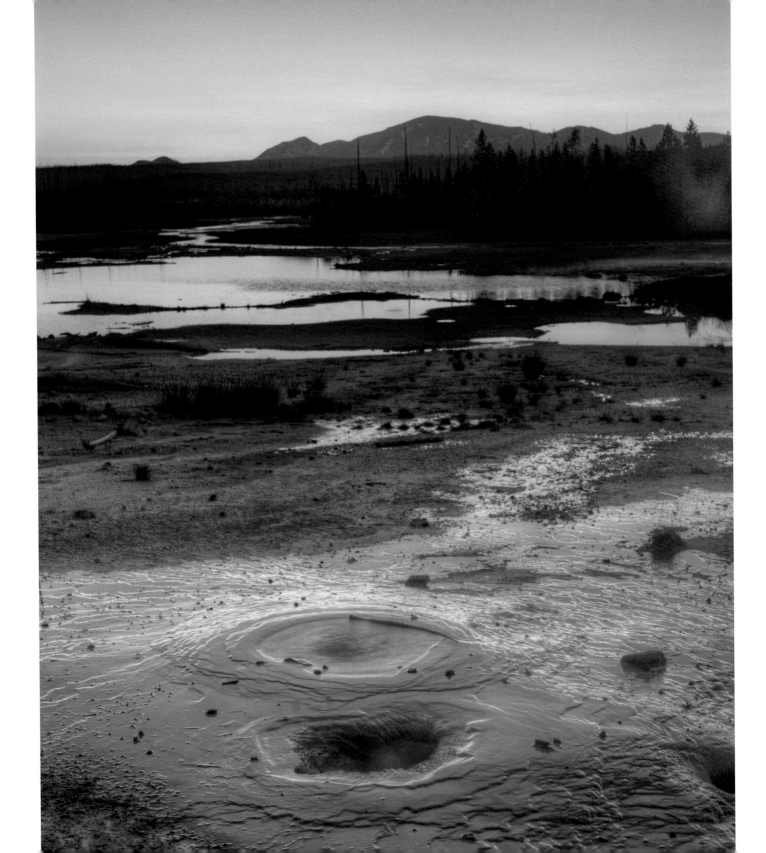

STÜCK IN GERMANY

In the past 60 years, the city of Dresden has been meticulously rebuilt to its former glory. To explore this newly constructed city, I took the 6 AM train from Leipzig to Dresden.

The city impressed me, especially after a childhood of growing up with dreadful images of East Germany and the robo-women their war machine churned out for the Olympics. It was rather dire back then, but everything has changed nowadays.

A few friends recommended that I visit the city, and after spending the day there, I have to say that it compares closely to some of my best photography days in other parts of Europe. The Baroque architecture is stunning and is completely unique and charming.

The fundamental features of HDR allow you to see the true color in the atmosphere. For the old masters of painting and the way they mixed their pigments for their colors, getting pure colors was very challenging, even with their most advanced tools of the day. When they mixed colors, the net result could be quite dull, absorbing more wavelengths than desired. The Impressionist painters had better access to more vibrant colors but still tried to leave them unmixed to keep the reflective colors clean and pure. With today's photo sensors and the tools we use, we are able to reproduce colors like never before.

If possible, try to orient your entire day around setting up for the sunset shot. Think about the location of the sun and how to compose that final shot. If you've had a good day of exploration, you should have a few valid candidates awaiting you at zero hour. If you are spending some of the day shooting HDR, you will already have your settings primed and ready to go for the big show.

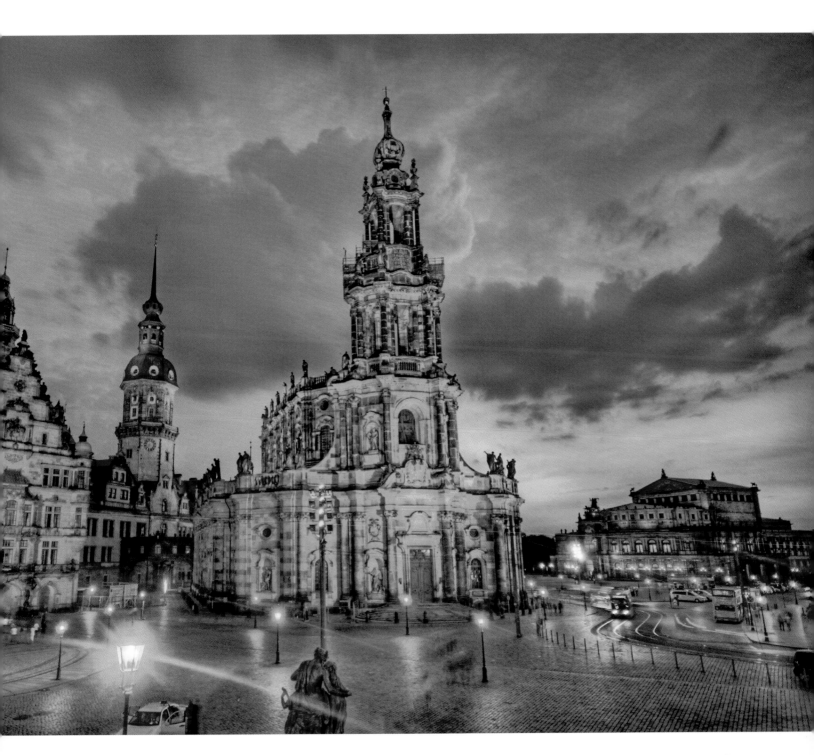

WINTERSCREAM

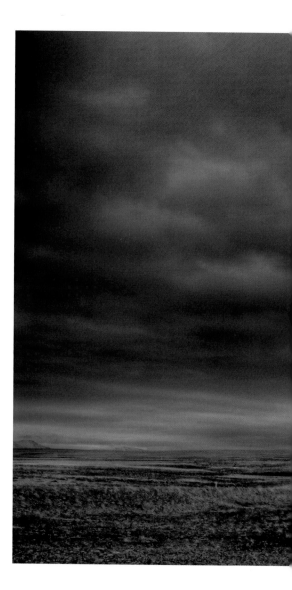

I spent the night in the far northern part of Iceland off one of the fjords when I went to visit my friend Helga Kvam. She knows she's lucky enough to live in this beautiful country and doesn't take it for granted. Helga has an incredible portfolio, and it's not just because she lives in a scenic spot. It was enjoyable to sit down with her and exchange techniques. I find that Icelanders think a bit differently about the world—perhaps because of their geographic isolation.

Her HDR method is a little different than mine. She saves a PSD of the photo with all the various adjustment levels, tweaks, and modifications in case she wants to make changes at another time. I do just the opposite. I flatten the image, save it as a TIFF, and I'm done with it forever! I've read some studies that show if you have limited choices combined with decisions you can't undo, you can increase your happiness. Now, I don't know if this is true, or whether I'm just compensating because I don't have the happiness coefficient of living in Iceland!

After leaving her little farmhouse on the fjord, I drove through the wilds of Iceland. Within no time, a sudden storm started ripping across the plains toward the mountains. A low rumble resonated as I stood in the middle of this tundra. I could not have been more alone. I didn't see another soul for at least a few hours. All the Icelanders were holed up in their little Hobbit homes for the evening.

As much as I relished the idea of being all cozy in a tiny earthen home in the middle of a storm, I actually enjoyed being in the middle of it all. I don't quite reach the level of those I consider lunatics on the Discovery Channel who chase tornadoes. Now that I have three kids, I find that I am slightly less adventurous than before.

I don't normally crop many of my photos like this, but I believe it helped to show the drama of the storm across a wide swath of mountain wilderness. There were so many levels of light in the sky: I felt like having a cinematic view was illustrative of the transitions from light to dark in a storytelling manner.

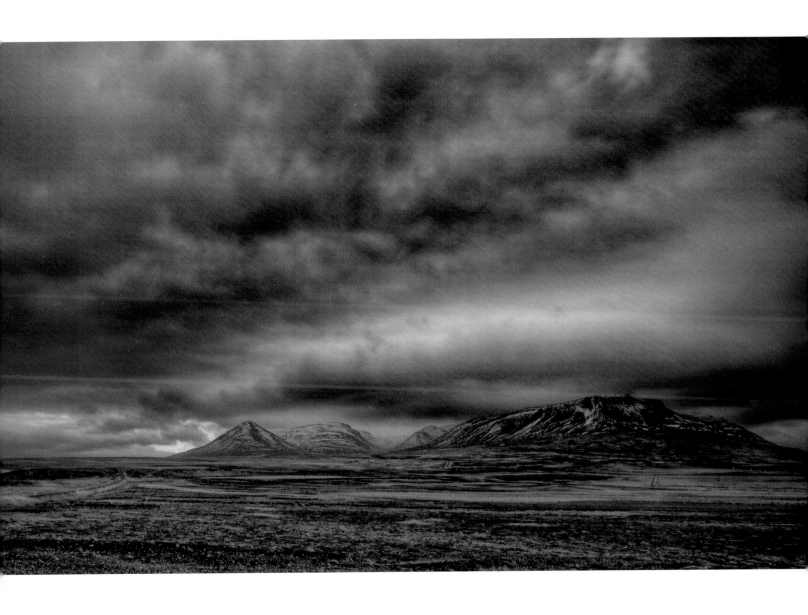

INDONESIAN SUNRISE

For two consecutive mornings, I woke up at 4 AM so I could hike to the temple of Borobudur to catch the sunrise. By the time I arrived, it was still pitch black. I had a flashlight with me, so I found the stairs and wound my way to the top. Why did I do this two mornings in a row? The first morning at the temple proved to be one of the most beautiful sights I had ever seen, so I couldn't sleep through another chance of seeing it again!

I was there about an hour before sunrise. So, the first 30 minutes, before there was any ambient light, I experimented with a few positions and settings. I used the flashlight to help me figure out where I was, composed the photo, and then opened up the shutter on manual. Then I used the flashlight to "paint" light on all the stone bell cages you see in the photo (each bell cage holds a Buddha that faces outward). The experiment produced some mixed results, but it was still worth it. I've seen some amazing works that use this light-painting technique. My efforts paled in comparison.

Not long thereafter, the sunlight started to appear over two distant volcanoes. Seeing these perfect volcanoes appear out of a layer of morning fog was like watching the cover of a fantasy novel come alive.

When you are in these types of situations, consider the shadows and their treatment in HDR. Our usual use of photography, because of its inherent lack of dynamic range, produces heavy or black shadows. We've become used to this and expect it in our photography, which is a shame. But when you are surveying a scene like this, you'll notice this is not true; shadows have color. To prove my point, I refer to Claude Monet, who would often infuse his shadows with color. According to Monet, "Shadows are not black. No shadow is black."

This might be one of my most colorful shots! The conditions were striking as the strange morning light illuminated the fog. And because the landscape changed continuously, I took a new series of photos every minute or so, not knowing which sequence looked best! Afterwards, while processing the images on my computer, I was able to evaluate multiple sets of five exposures to determine which had the most alluring color combinations.

I chose a wide-angle lens for this shot, which has its plusses and minuses in this situation. The biggest minus is that the lens made the volcanoes look awfully small. Items toward the middle of the frame are rendered the smallest because of the way the light bends inside the lens. This reality is unfortunate! But it's the price I was willing to pay to compose the rest of the shot. I felt that the unique shape of these cages was more compelling than the volcanoes, but not by much!

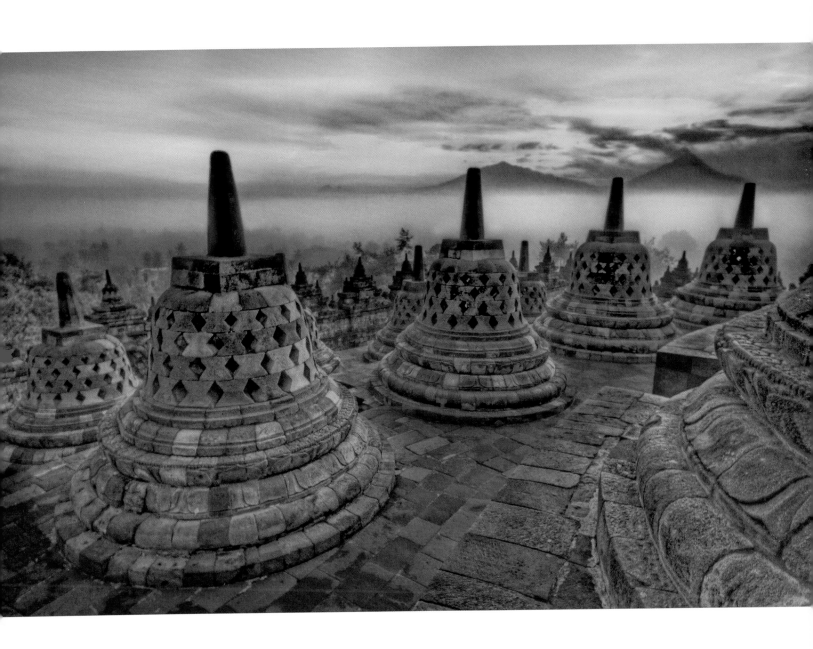

4 THE PERSPECTIVE OF LIGHT | **169**

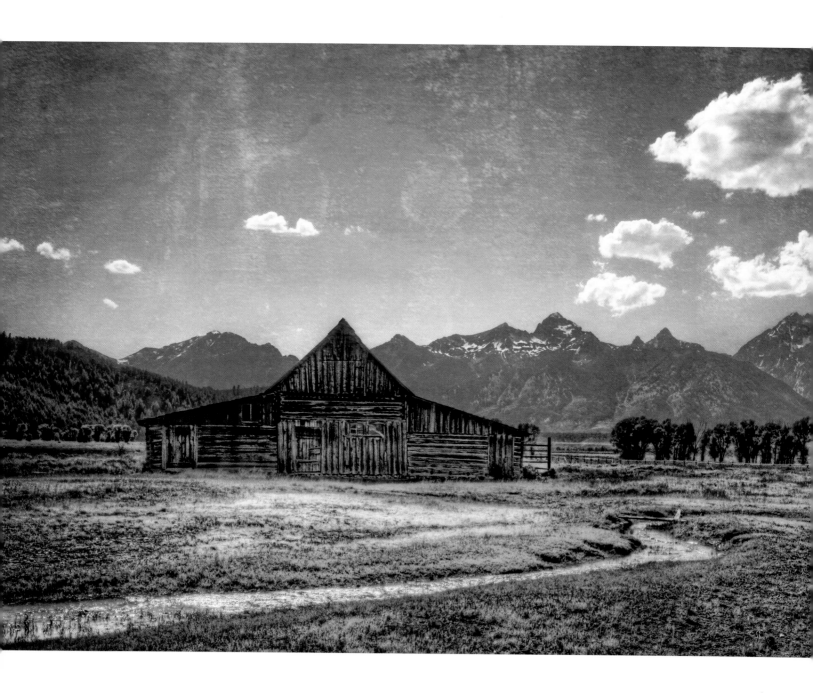

THE BARN OF YOUR DREAMS

To close this chapter, I'll finish with a photo of a barn on a farm outside of Jackson Hole, Wyoming.

We all experience light a bit differently. We each notice little bits here or there that paint the image in our minds. I am convinced that a certain breed of photographer sees the world in a storybook way and strives to make each photo tell the fairy tale the way the photographer sees it.

An insightful quote from Renoir says it all: "To my mind a picture should be something pleasant, cheerful and pretty. Yes, pretty! There are too many unpleasant things in life as it is without creating still more of them."

When you imagine a picture of a barn in your mind, there are conflict-ing truths that are equally true. For example, the details matter, but they don't matter. The colors matter, but they don't matter. The way the sky is textured matters, but it doesn't matter. How can all of these notions be true? I don't have the answer, but it is challenging to think about. Consider trying to work these mysteries into your final work.

In a photo like this, I like to keep the eye moving from spot to spot. The barn is important, but I wanted its peak to be part of the moun-tains. The field with the meandering stream should vaguely point to the horizon, but the horizon should draw the eyes out in any direction, and have them be happy to be there. The texture that was applied brings a new level of unreality to a sight that is clearly quite real. All these decisions are made when setting up and while post-processing. Think of every photo as a journey with multiple chapters as you create your own story.

THE HDR TUTORIAL

5

After seeing the many HDR photos, anecdotes, tips, and techniques in the previous chapters, you've made it to the tutorial. In no time, you'll be making HDR images of your own. I know I can teach anyone to do this. All you need to do is follow this updated version of the popular online tutorial. I started the skeleton of this tutorial a few years ago, and I continue to evolve the technique, the steps, and the presentation as I receive feedback from users. Because this tutorial has gone through many improvements, it's pretty solid and should satisfy the vast majority of needs. It is the product of iterations of design and refinement by me and my peers who have helped guide me down this path. In essence, this tutorial has become a beast of its own that has grown and become fitter over time.

HDR: STUCK IN CUSTOMS STYLE

HDR actually defines a broad range of substyles that can be sliced and diced many ways; there is no defined vocabulary to describe these various categories. I have been told by many, and I believe objectively, that I have developed a unique style within this genre. These are the techniques I will share with you.

Often, my goal is to produce an image that is rich, realistic, and romantic—my three Rs. Every photo is a wonderful challenge. The first photo out of the camera is probably the most important part of the equation. It should already

have those three Rs. The techniques that follow can help to accentuate those factors as needed.

It is also my aspiration to follow humbly in the footsteps of Renoir, who stated, "A painting requires a little mystery,

> *I have been told by many, and I believe objectively, that I have developed a unique style within this genre. These are the techniques I will share with you.*

some vagueness, some fantasy. When you always make your meaning perfectly plain you end up boring people."

So, let's work on this process together.

THE BARE ESSENTIALS

When it comes to tutorials, you will note that this one is quite unconventional. I keep instructions simple, practical, and straightforward. I won't describe every button, possibility, option, and suboption. You don't have time for all that. You just want the basics so you can make beautiful photos as quickly as possible.

I am a firm believer in giving you the fundamental tools you need, teaching you the best practices, and then

sending you off into wild experimentation. By giving you just the basics, you can go beyond them on your own and develop your own style. Feel free to start by emulating, and then branch out on your own.

At the end of this process, I guarantee that you will have created a few shots that will impress your friends and loved ones.

WHAT YOU NEED

As photographers, you probably already have all the equipment you need to take HDR images. You do not need a special camera beyond most of the standard-issue Digital SLRs. If you do not have a DSLR, I provide suggestions in the Digital SLR section on my Web site that are sorted into Good, Better, and Best categories. Note that my recommendations are all Nikon related because these are the products with which I am most familiar. However, Canon and many other brands have counterparts for the Nikon models I have suggested and are perfectly good for creating HDRs. With a basic camera and a bit of software, you'll be good to go.

SOFTWARE

The only two applications you really need to produce HDR images are Photomatix Pro and Photoshop. The cost of Photomatix Pro is less than $100, and you can save even more when you purchase it by using the STUCKINCUSTOMS coupon code. I've tried many kinds of HDR software, and many companies send me their products to try. And

although there are many other possible options, in my opinion Photomatix Pro is the best. It holds a prized spot on my quick-launch bar!

You can buy and download Photomatix Pro directly from the Photomatix site at www.hdrsoft.com.

The only two applications you really need to produce HDR images are Photomatix Pro and Photoshop.

I'll assume you know how to get Photoshop. If you are purchasing it for the first time, I recommend the basic version. You don't need all the extra bells and whistles in the Extended version unless you know beforehand that you'll be using them for sure.

In the next chapter, I mention a few more tools that are optional.

HARDWARE

I almost titled this section, "How to get some equipment on the sly so your spouse does not ask too many questions."

But here are the tools you'll need to capture your favorite images.

Camera

Because equipment is always evolving, I list the latest data and analysis on www.StuckInCustoms.com in the section called Digital SLR recommendations.

You'll need a DSLR camera that has a feature called *auto-bracketing*. Most decent SLR cameras have this feature. Essentially, it allows you to hold down the shutter button while the camera takes multiple photos at different shutter speeds. Commonly, in this mode, if you hold down the shutter, your DSLR camera will take three photos very quickly. Each will be at a different exposure. For example, it may take the first at -2, the second at 0, and the third at +2.

Lenses

If you are just getting started, the "kit" lens that comes with the camera will probably be sufficient for you. Since I have a penchant for landscapes and think they are wonderful subjects for HDR, I usually use a wide-angle lens. Lenses that range from 10–30mm work well when you're trying to photograph landscapes. Below this range you'll get a fish-eye warped look, which can be interesting if you are into that sort of thing. Again, you'll find lens recommendations, which I constantly update, on my Web site as well.

Tripod

I highly recommend purchasing a tripod, since you will inevitably be shooting sunsets and the like with your new-found HDR skills. You *must* be able to keep the camera still during the multiple exposures.

The best advice for buying a tripod is to take your camera to your local camera store and try out two or three different setups. Every head is different. Every set of legs is different. Store employees are always helpful and will assist you in finding one that feels right to you and is easy for you to use. Ordering a tripod over the Internet is almost as scary as ordering the ultimate pair of jeans.

THE HDR PROCESS

The HDR process is not difficult. In just a few steps you'll be producing striking images. Here is a short overview of the three major steps:

1. Take photos.

2. Create an HDR in Photomatix Pro.

3. Import that result into Photoshop and remix it with one or more of the original RAW images to create a beautiful final result.

I'll use one of my HDR images to guide you through the steps. Once you have taken some photos at different exposures, you can use those to follow along as well. I'll describe each step in detail and then provide some bonus steps—cleaning up noise, using double tone mapping, integrating movement, batch processing, and converting a single RAW file into HDR—to complete the process.

Let's start by looking at a before-and-after shot of Times Square in New York City.

The before shot (final shot on page 178).

1 TAKE PHOTOS

Why not start by taking a photo of your home at sunset? You don't have to travel, and you'll have many light levels available to you.

1. Set up your camera in aperture priority mode because you want everything to line up so the lens does not flex in focus between the shots. What aperture should you use? Well, this tutorial doesn't really advise on this sort of thing, but f/9 or f/10 should keep everything in focus. There's a lot more to aperture than that, but this should suffice if you are just starting to understand aperture.

2. Turn on auto-bracketing. If you have three pictures in the auto-bracket, set it up at -2, 0, +2. On my Nikon D3X, I usually take five pictures at -2, -1, 0, 1, +2. You'll find this +2 to -2 range satisfactory for 98 percent of light situations.

3. Make sure your pictures are saving as RAW. JPEG is OK, but RAW gives you more flexibility later in the processing steps. RAW photos contain a lot more light information than JPEGs.

After you take the photos, you'll notice the results are a dark exposure, a normal one, and a bright one. This is because your auto-bracketing has adjusted the shutter speed automatically for the three shots. The longer the shutter is open, the more the light gets in.

It should be obvious by now that the fast shutter speed only lets in a bit of light. This dark exposure gives you nice details and colors on the brightest objects in the scene. Conversely, the brightest exposure gives you details and colors in the shadows. Thus, you are capturing all the light in the scene.

The figure to the left shows the five pictures I have selected from the Times Square image in Adobe Lightroom, which I use to organize my photos. You can also easily see that the images are all taken at different shutter speeds.

The images lined up and ready in Lightroom.

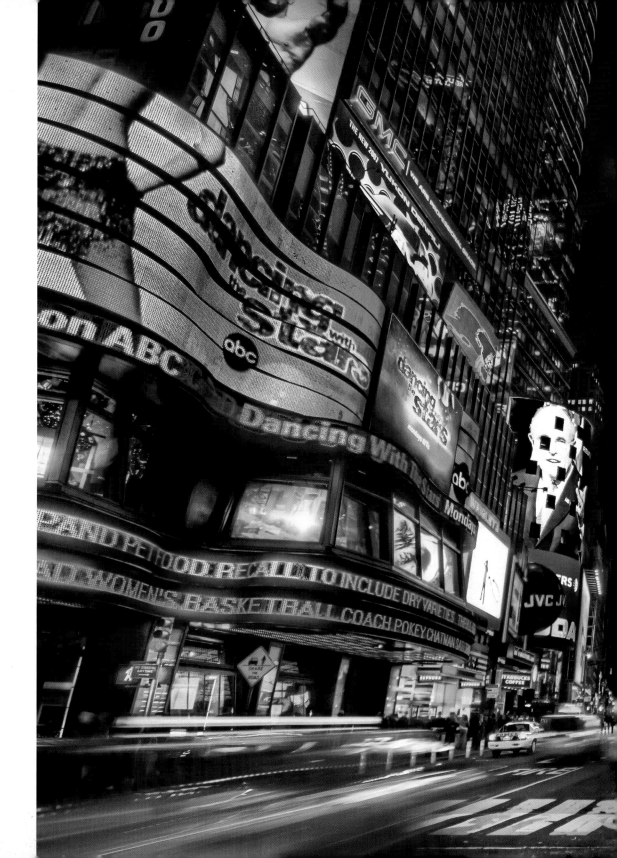

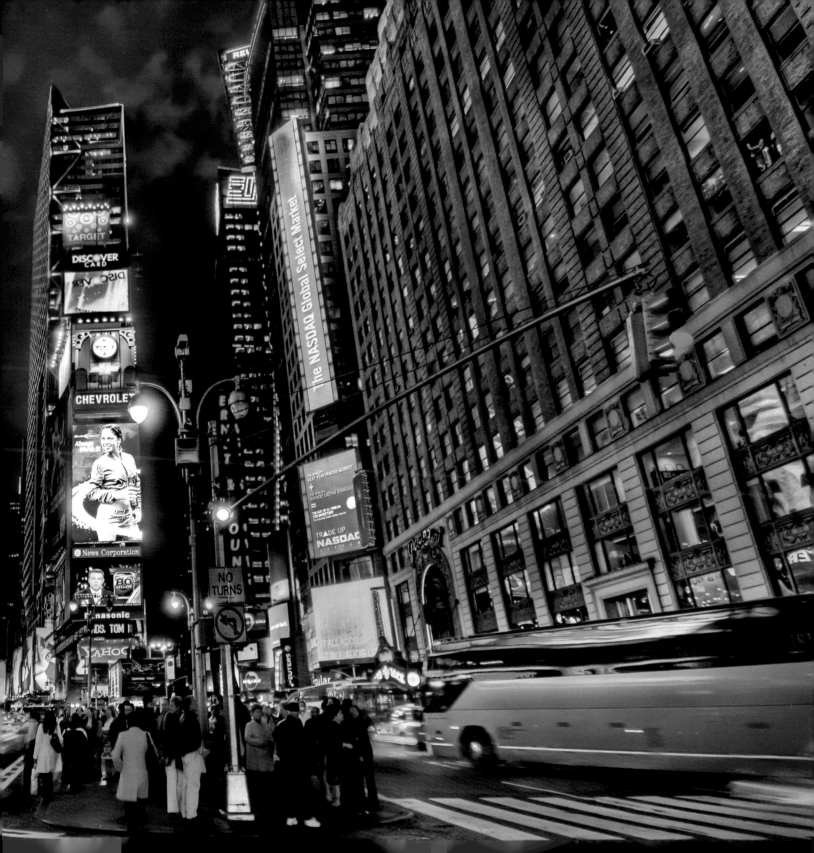

2 CREATE IN PHOTOMATIX PRO

Now it's time to fire up Photomatix Pro, which will take your three or more shots and convert them into an HDR image. You can then tone map the image and save it as a JPEG.

You can use Photomatix Pro for a few tasks:

- To generate a single HDR from auto-bracketed shots (most common for beginners and the bulk of this tutorial)
- To generate a batch of HDR images after you return from a shoot
- To convert a single RAW photo into an HDR

I'll discuss each task in detail, so let's start with the first.

When Photomatix Pro is loaded, just its menu appears. Note that I am using Photomatix Pro 3.2 on the Mac. The PC version will be very similar. Photomatix Pro is updated frequently, but later versions should still work within the margin of error of these screen shots.

1. Choose Generate HDR Image. Then browse to and choose the images you want to use.

2. Choose the options you like, and then click Generate HDR.

I only select Align Source Images if I feel that there might have been a tiny amount of tripod shake. Otherwise, I don't select it. To be honest, the other options are hit and

Note: Here I've used Lightroom to convert the five RAW images to five JPEGs. You can use Photomatix Pro to open the RAW photos as well, but Photomatix Pro will immediately do the conversion. I spoke with the engineers at Photomatix, and they suggest it is best to do the conversion on your own.

miss. I never choose Attempt to Reduce Ghosting Artifacts because I do that manually later in the process.

3. An image will appear. Click Tone Mapping.

4. Now this is the fun part! All these Willy Wonka-like controls are at your disposal to play around with and modify your image.

My biggest word of warning here is that every photo has different needs. The only way to get used to these settings is to process about 50–100 photos with them. Be patient. Eventually, all these sliders will make sense to you.

In fact, you really only need a few of the sliders. These are the most important:

- **Strength.** Keep this slider at 100%. You can dial the extremity of the result back later when you remix it with one of the originals in Photoshop.

- **Color Saturation.** Keep this setting reasonable. By that I mean don't oversaturate your photo. There's a difference between color that pops and color that bleeds too electric.

- **Luminosity.** This slider produces the "painterly effect." The farther to the right you move it, the less contrast will appear in the photo. If you find you've introduced "halo" problems in daylight shots, move this slider to the far right to remove the halos. I describe another way to eliminate halos later in the sidebar "Daytime Sky Considerations."

- **Microcontrast.** This is a mysterious slider that increases and decreases details and fluctuations in colors on a very small scale. As with the other options, play with this setting until it looks and feels right.

- **Smoothing.** This important slider affects the "HDRness" of the shot. The more you move it to the left, the more psychedelic your image will be.

- **White Point and Black Point.** Move these sliders right and left until the bell curve in the histogram rests inside

the box. If the histogram bleeds off the left or right side, you are losing light, and that is not good.

What about all the other sliders? They might be useful in their own way, but I honestly don't use them much. The Micro-smoothing slider can help reduce noise, but I use a special noise-reduction program I'll discuss shortly.

5. Click Process. Then save your image as a JPEG or a TIFF. I choose JPEG for speed and because I end up remixing so much of it with the original RAW image that the extra TIFF information would be lost anyway. Processing speed is important to me.

HDR ON DRUGS

Now that you have read so much about the photos I've provided throughout this book, I can assume we are friends, right? I have a favorite saying that I've used in a few of my interviews, which I'll repeat here: "Friends don't let friends do HDR on drugs."

Look at the following image. I implore you not to do this. So many people make their HDR images look like this, and it honestly gives us all a bad name.

3 IMPORT INTO PHOTOSHOP

Now you need to do a few relatively simple things in Photoshop to clean up your HDR image. It looks nice, but it still needs some work. In the Times Square photo:

- The cars and pedestrians became "ghosted" because the HDR process was confused by objects being in different locations in the different frames.
- The ticker around the ABC building is too blurred.
- Many digital billboard images are blown out.
- Noise is present.

Note: Perhaps the most important modification you can make in Photoshop is not in the Times Square photo, and it is what I call the "daytime adjustment." If this was shot in the daytime, the HDR process would make the sky too dark. It is important to remix the original sky with the HDR image to make the photo more realistic. There is no doubt that the sky is brighter than the ground, right? So make it so by using the techniques described in this section.

You'll start by importing your four photos (the original three exposures and your new HDR image) into Photoshop and stacking them in layers.

I have six photos, the original five plus my new HDR. However, there is no need to import them all. In fact, sometimes you just need to import one or two, depending on the elements you feel need remixing. Your original photos will most likely be quite good, so you'll only need to mix them "as needed." This requires experience, but here you'll see what I've done for the Times Square photo.

1. Use Adobe Bridge to select all the photos, and then choose Tools > Photoshop > Load Files into Photoshop Layers (my preference). Alternatively, you can load all four images separately, and then copy and paste each of them into a single Photoshop file. Each new paste will make another layer.

2. If you loaded the RAW photos into Photoshop, you may see the Adobe RAW importer dialog. With it you can make some last-minute adjustments to your photos before they import into Photoshop. Since you'll be blending these with the tone-mapped result, I recommend that you make adjustments here to make the photos as "HDR-like" as possible. Read on to understand what I mean.

[handwritten note: Camera RAW adjust]

Notice that the first figure on the next page shows the brightest of the five exposures. I plan on using the bus, the taxicab, and the pedestrians from this shot. Because I want them to blend smoothly, I've set the RAW importer to give an HDR-like quality to the photo. I've increased the Fill Light, the Recovery, the Contrast, and the Vibrance settings. These are perhaps my four favorite sliders to use, and they alone can apply some of the qualities of an HDR image to your underlying photos.

3. Make sure all the images have been imported into Photoshop, as shown in the second figure on the next page. They should also be in the same PSD and layered on top of one another. I've placed the result of the Photomatix Pro tone mapping on the top. Beneath that are three of the exposures—the darkest, the medium, and the brightest.

Let's remix the best elements of those underlying photos to help bring the scene into its proper appearance. Most people neglect this part of the process. I do this with every HDR photo, and so should you.

4. Place the darkest of the three directly under the tone-mapped photo. You'll mask through the top layer and reveal the layer underneath. I'll provide just a basic description of masking here.

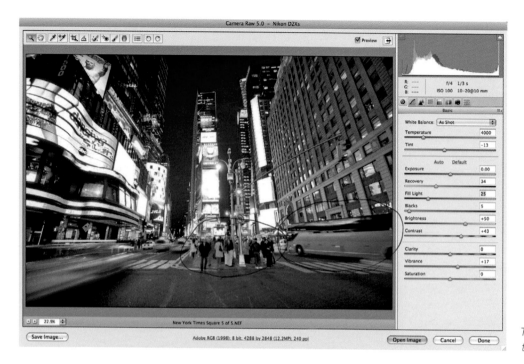

This image shows the brightest of the five exposures.

Make sure all the images have been imported into Photoshop.

5. Click your top, tone-mapped layer, and then choose, Layer > Layer Mask > Reveal All to create a little white box beside your layer (first image on page).

If you use the Brush tool to paint black in that white box, it will reveal the layer beneath. If you use the brush to paint 50% gray in that box, it will show 50 percent of the layer beneath.

6. Choose the Brush tool. Set the Opacity to 50%. This means that your brush will show 50 percent of the current layer and 50 percent of the layer beneath wherever you paint.

Because the layer beneath is the darkest, I want to mask in the ticker and some of the bright billboards so they are readable (just like when I was there). I use the brush to paint through to the layer beneath. Since the brush is set to 50%, I'll make multiple strokes to reveal even more of the layer.

If you look closely at the little white box, you will see a series of gray and black strokes. This shows the parts of the image that have been masked.

7. Select both layers by Shift-clicking, and then choose Layers > Merge Layers.

Photoshop provides multiple ways to do everything. But this is the method I prefer—masking, then merging, then masking and merging again. I do this until I have one final image.

In the image to the right I've combined the top two layers into one. There are just two remaining.

8. Repeat steps 5–7 as needed.

As you can see in the figure to the right, I've repeated the masking and merging. At this point I'm masking in the brightest of the original shots. I want to get the pedestrians and the cars, as well as a few other items that look best in the brighter version. Note that in many instances, I'm not masking through to 100% but instead doing a soft merge of the two layers by using a lighter brush. Sometimes I set the brush at 10% opacity if I just want to slightly merge two layers.

If you examine the white box again, you can see that I heavily mixed in the cars and the pedestrians but I went lighter in other areas.

The figure below shows the details of the masking: You can see the white box and how the pedestrians were masked through at 100 percent.

4 CLEAN UP THE NOISE

I must admit, I've tried a variety of noise-reduction software packages. Many are good, and they are all better than what Photoshop and Photomatix Pro can do on their own.

But the best application on the market is called Noiseware Professional. It is pretty inexpensive. And as with many other pieces of software I use, the manufacturers have provided my readers with a special discount code labeled STUCKINCUSTOMS to save you money.

You can see that the Times Square photo had a ton of noise in the sky, which is not good! This happens a lot in HDR images. The following figure shows just what Noiseware Professional can do. The results are impressive. I can't tell you how much work and time this application has saved me.

5 DOUBLE TONE MAPPING

Earlier in the book I made reference to the double-tone-mapping technique. It might be a hidden feature of Photomatix Pro; I'm not sure. To be totally honest, I did it by mistake one day, which is an added benefit of doing something over and over. On occasion, you'll make a mistake and be pleasantly surprised.

Note that this technique is quite "artistic." It certainly veers away from realism to an extreme degree. However, I believe we all have photos that demand a nice artistic treatment. Like my friend Frederick Van, host of the excellent weekly podcast "TWIP: This Week in Photography" says, "Those pixels are there to be punished!" High five Fred!

I'll illustrate this technique with a photo of the new Hong Kong airport. While dodging the Chinese police, I was able to get up on a catwalk with my tripod to take this shot. I do not recommend doing this.

1. Use Photomatix Pro to create an HDR (as you did in an earlier section).

The settings I used are shown in the figure, but again, every photo is different, so these settings will probably not work for you. Do not set your Microcontrast to +6.3 because "Trey did it like that." Okay? You really need to experiment and make mistakes. There is no right answer or universal settings for any photo.

2. Click Process.

3. Your photo will be ready to save, but *don't* save it. Tone map it *again*. The Tone Map button will be disabled, but

you can still press Command-T (the hot key) to return to tone mapping.

Because I'm a hot key kinda guy, you can understand how I made the "mistake" of a second tone mapping the first time. It was a late night and I had just completed an HDR image. I was looking at the final product and wondering if I'd already tone mapped the image. So, I pressed Command-T again, and something wild happened.

4. The Tone Mapping dialog appears. This time, the image will look even more extreme. So, you must change the settings in a different way than before.

5. Notice the Saturation. The second time through tone mapping can really blow out colors. Be ready to drop the color saturation way down.

6. Notice the Luminosity. Drag its slider most of the way to the left.

7. Be sure to lower the Strength meter (at the top) a bit if it is too psychedelic. Every photo is different.

8. Click Process again. Save the image.

You now have a double-tone-mapped image. Next, you'll want to bring it into Photoshop and clean it up. Remember to remix it with the original RAW images to bring it to a level of realism that you feel is appropriate. With a double-tone-mapped image, this can be quite difficult since you are now well beyond the look of the original image. However, there is still room for improvement—as with everything.

6 INTEGRATE MOVING PEOPLE AND OBJECTS INTO AN HDR IMAGE

There are two ways to get moving people and objects to look decent in an HDR image:

- With a multi-image HDR, choose one of the constituent images in which the moving images look best.
- Use a single RAW to create an HDR image (described in a later section).

Let's focus on the first method and continue to use the image from the Hong Kong airport. Because this image is a bit "extreme" in the world of HDR, it will prove to be a good example of how to integrate an original image with the final product.

1. Choose your favorite of the originals that has the moving subjects in the positions you like. Use the "RAW importer" as you bring it into Photoshop to adjust the Exposure, Recovery, Fill Light, and other sliders to make it look as HDR-like as possible.

2. Use Topaz Adjust (a review and more information are provided in Chapter 6) on that layer to make it look even more HDR-like. Topaz has many prerendered settings on the left. Cycle through them and select your preferences. You can also change the settings in the other sliders

on the right. Don't worry about what the building and the nonmoving objects look like. If they look outrageous, it's okay. Just worry about making the moving objects look appropriate.

3. When the moving objects in your original image are finally HDR-like, you can begin the masking process.

The first figure below shows the double-tone-mapped image at the top. I made a pink layer beneath so you could see where I masked through, essentially where the moving objects were.

In the next figure, you can see more detail. Note that there was no need to mask the people who were not moving.

The final image is shown on the next page.

BATCH PROCESSING

Photomatix Pro also has a batch-processing mode. It is quite easy to figure out how to use, so rather than describe the process, I'll describe the HDR workflow after a shoot in terms of batch processing.

1. Fill a single directory with all the resulting images from your shoot. For example, I might place 50 images in a folder. I shoot my HDR images in groups of five, so that means there will be ten HDR images when I'm done.

2. Choose Automate > Batch Processing.

3. Make sure Generate HDR Image is selected. Do not select any other option except perhaps the Align Images option if you think the photos might contain camera shake.

4. In "Select X images at a time" type 5 or 3 depending on the number of images in your groupings.

5. Click the Select Source Folder button and navigate to the folder that contains all the images.

6. Your images will appear alphabetically in the listing. Ensure that you only have image files in the target directory and no other rogue files because they will disrupt the batch process.

7. Click Run. This process will take a while, so it's a great time to get coffee or a glass of wine, depending on your mood.

8. Open the resulting .hdr files in Photomatix one at a time and follow the tone-mapping process described earlier. You can then continue with other needed tasks to complete your HDR images.

CREATING AN HDR FROM A SINGLE IMAGE

Creating an HDR from a single RAW image is quite simple. I commonly do this with an image with moving subjects that are of core importance to the meaning of the photograph. Of course, it is usually better to try to get multiple exposures because you simply have more light with which to work. However, a single RAW file still contains enough light information to produce an acceptable HDR result.

1. In Photomatix Pro, choose File > Open, and then locate your RAW photo.

You will see the following message or something similar.

Your RAW file has been converted into a pseudo-HDR image.

Please note, though, that more than one exposure is needed to properly capture the dynamic range of most scenes.

A good quality HDR image requires taking several exposures and combining them using "HDR->Generate".

OK

Note: You can disable the showing of this window in Preferences.

Yes, we know more images are better, but you can still create a great HDR image using this method. Click OK (like you have a choice!).

2. The Tone Mapping dialog appears, as before. The reason I'm using the road/landscape image in this example is because it is a daytime shot. Recall my warning about how Photomatix Pro will "dirty up the sky." Well, you can see that happening in the image in the figure.

When you make your adjustments, *do not worry about the daytime sky.* This advice is also valid for multi-image HDRs. You will fix the sky shortly. Just make the adjustments so you are happy with everything *but* the sky.

3. Save the tone-mapped result, and then open it in Photoshop along with the original RAW shot. You'll probably want to use the RAW importer to make the original RAW image look as good as possible. (Last step on next page.)

DAYTIME SKY CONSIDERATIONS

Many people new to HDR notice that daytime sky often looks murky right after the tone-mapping process. This is either because of a "halo effect" that has a horizon glow before giving way to a darker upper sky or because of overly dark, gray, or muted colors. Both problems can be overcome by remixing the original RAW to whatever degree looks appropriate. Sometimes I'll remix in 100 percent of the sky from the original RAW. Other times I will just fix the part of the sky where the clouds have turned pure black during the tone-mapping process. Whichever option you choose, always consider making a wholesale adjustment to the sky area in daytime shots via the masking method described earlier.

4. Create a layer mask and then paint with a brush to reveal the layer beneath. I created another hot pink layer so you can see where the mask was made. Making the original sky blend in is extremely important.

The following figure shows the final result. Note that I left the lens flare in the image. I like them and usually leave them in the final photo. Many photographers don't like them, but I think they are colorful and pretty.

When you create a single-image HDR with people in the photo, they will not look right. The HDR process will make their skin dirty and mottled. In these situations, you'll need to mask in the original skin while blending in with the background as much as possible. But there is a lot of room for experimentation in people photos, so be open-minded and see what you can discover.

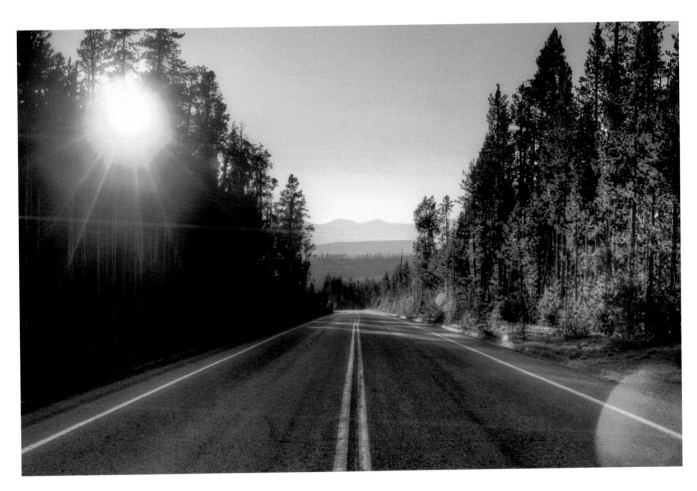

SOFTWARE AND TOOLS

I have an abstruse relationship with my tools. They are like mysterious friends that hang out on my computer and taunt me. I poke and prod at their enigmatic features, goading them to give me something unexpected and exciting. I'll never get to know them as well as I'd like, but I do spend a lot of time working with and thinking about all the software I use.

In this evolving world of photography, we owe it to ourselves to become familiar with all the wonderful tools that have been created by brilliant inventors. It doesn't appear that owning an assortment of software is a "trend." I see no end to the variety of software tools that will become available and improve in the coming years.

Photoshop is a great foundation, but it doesn't have all the features I need. Now, I'm sure plenty of Photoshop gurus will go through every piece of software I recommend and say, "Oh you can do that in Photoshop!" Well, yes, in some cases you can, but the particular process is usually difficult and not many people have the time to take all the steps necessary to accomplish some of these tasks. Do you think Titian (~1488–1576) would have grabbed Signac (1863–1935) and said, "Good God man! You can grind your own paint!"

THE HISTORY OF TOOLS

Back in the earliest days of painting, artists would often create their own paints from scratch. Later, during the 1800s, the creation of art tools became an entire trade industry of its own. The Impressionists did not create their own paints; they bought them.

You will find most analyses of art to be woefully lacking when it comes to tools that the great artists used. Philip Ball states it succinctly: "This neglect of the material aspect of the artist's craft is perhaps a consequence of a cultural tendency in the West to separate inspiration from substance." He goes on to quote art historian John Gage, who confesses that "one of the least studied aspects of the history of art is art's tools."

I was happy to discover many facts about the Impressionists in my studies. It is now clear to me that I'm not the only one who obsesses over tools and the people who make them. The quality of paint that the artists would purchase in the 1800s was extremely important; often, unscrupulous paint dealers would lace their pigments with chalk or gypsum, which might result in greater yield at the expense of long-lasting colors.

Ball also describes the lengths to which the Impressionists like Pissarro and Cézanne would obsess: "As a protection against such practices, many artists strove to establish a good relationship with a particular color merchant, relying on him to provide quality control." That made me feel better about getting on a Skype call to the woman in the Netherlands who runs Photomatix so I can make sure the

Philip Ball states it succinctly: "This neglect of the material aspect of the artist's craft is perhaps a consequence of a cultural tendency in the West to separate inspiration from substance."

product is in tip-top condition. If I find something unsatisfactory with the tools I use, I call the manufacturers and let them know how to make them better!

Unfortunately, I can't contact Nikon or Adobe by phone. They are too big to listen to my concerns and ideas. But I have a big list whenever that day arrives! Mind you, that does not keep me from using and recommending their products.

MORE THAN JUST TOOLS

Because I find that software is more important than hardware, I'll focus on a few valuable applications. I did not lay out all my equipment and take a photo of the spread, because I felt that would focus your attention in the wrong direction. As long as you have a DSLR that has auto-bracketing, no other hardware matters. What does matter is you, the software tools you use, and the attitude you have about your tools.

I'll provide only short descriptions of the various software packages and why I use them. I recommend trying them out one by one when you have the time. They all have trial versions. In the end, I'm sure you'll find them quite *fun* to use! It might be strange to say, but so much of creating art is just pure fun. These tools will absolutely bring a smile to your face.

A Disclaimer *I only review and recommend software and hardware that I actually use. Because I am viewed as a trusted expert in their software, I end up sending the manufacturers of these applications massive traffic. Often, some of these companies will also be financial sponsors. Whether or not they are sponsors, I only use the best of breed and I recommend them accordingly.*

That said, here are some words for Nikon (who is not a sponsor). I have always used Nikon's equipment and think it is a great company. Nikon could actually make some very simple changes to make its cameras more HDR friendly. These straightforward changes would make the readers of this book oh-so-happy photographers!

In tribute to the great painters, I obsess over the tools of light. This photo was shot in Huangzhou, China. The glowing and mottled light on the boats called for an Impressionist capture.

MY TOOLS

I cannot tell you how to create art, but I can tell you about some of the best tools on the market.

MY CAMERA AND LENSES

I have a Nikon D3X. Yes, it's big and expensive, but keep in mind that many of my best shots have been taken with a D70, a camera that is rather low end.

What do you need? You can find a list of recommendations on my Web site in the Digital SLR section. However, as new models come out, my recommendations are likely to change. If you are really into the technical details of cameras, you might enjoy digging in and getting more information on each camera.

As I mentioned earlier, I do recommend that you get a camera with auto-bracketing. It is sometimes also called *exposure bracketing*. Most DSLRs have this feature.

As for lenses, well, you get what you pay for. The Web site also has an ever-growing list of recommendations. Note that for HDR photography, how low the f stop goes on the lens is not a concern. Often, the more expensive lenses have a low f stop, which means you can take sharp photos in low-light conditions (a layman's description, please forgive me, photo nerds). When you shoot HDR, more likely than not you will use a tripod, so it doesn't matter if your wide angle lens only gets down to f/4.5. Your shutter will be open for a long time anyway, so an f/2.8 would not do much for you in those conditions. Also, using a low f stop to achieve a shallow depth of field rarely comes into play in landscape HDR photography.

MY TRIPOD AND HEAD

I use a Manfredo tripod and a Bogen head. However, I do not recommend that you purchase these just because I use them. It is in your best interest to take your camera to your local camera store and try out a few tripods and heads. You'll be using your tripod a lot, so you want to make sure you can very easily and quickly set it up, adjust the head, and then dismantle it.

PHOTOSHOP

Photoshop is a great product and it keeps getting better. If you do not already have it, don't be intimidated by it. Just learn a few features at a time. I always recommend that novice Photoshop users get on the Web and watch "Photoshop User TV." It's an excellent free podcast. Every week the hosts provide three tutorials or so. Follow along and copy them. Each week you'll learn a new tool or a new trick. Just give it a few weeks and you'll get the hang of it. Don't be afraid of making mistakes—you can't! Unlike real life, there's always an Undo just a click away!

As for which version of Photoshop you should buy, I recommend the basic package. If you really want to save money, you can probably find an old copy of Photoshop CS3 on Craigslist. To avoid any kind of scam (maybe), I recommend that you call a few people first and ask them how they used it. Ask them their favorite features, why they upgraded to CS4 (or later), what features they like, and so on.

I just can't get these kinds of results from other software packages. Whether you have multiple source files or a single RAW (as in this case), Photomatix (discussed on the next page) consistently produces the best results.

PHOTOMATIX PRO

Photomatix Pro (www.hdrsoft.com) is the best HDR software available. I've tested about six different HDR packages, and some competitors' products are interesting. There are even free HDR software packages on the market that some people really seem to like. I've seen some good results, but I always come back to Photomatix Pro.

HDRsoft, the company that makes Photomatix Pro, has a tremendous head start, it is well financed, and many new features are in the pipeline. Also, many other great HDR photographers swear by this product.

Check out these HDRsoft products:

- **Photomatix Pro.** *Approximate cost: $99; use the discount code STUCKINCUSTOMS for 15 percent off*
- **Photomatix Pro Plus.** *(Includes plug-ins if you prefer to work that way) Approximate cost: $119; use the same discount code for 15 percent off*

NOISEWARE

Many good noise-reduction software packages are available. I prefer Noiseware (www.imagenomic.com) for two main reasons: 1) its smart algorithm gets rid of just the noise, not the other details in the photo; and 2) the user interface is very smart and easy to use.

Imagenomic also makes another product called Portraiture that is great for people shots. I use it on many of my portraits. It's a very cool app, and it has almost the exact same user interface as Noiseware, so moving from one to the other is simple.

Check out these Imagenomic products:

- **Noiseware Professional Plug-in.** *Approximate cost: $69; use the coupon code STUCKINCUSTOMS for 10 percent off*
- **Professional Plug-in Suite.** *(Includes Portraiture, Real-Grain) Approximate cost: $299*

TOPAZ ADJUST

Topaz Adjust (www.topazlabs.com) is a great product for sharpening and adding "pop" to your photos. Often, the HDR process can "wash out" some of your lines of definition. Your final product should have some contrast to it, and this application can help provide it.

Topaz Adjust is very easy to use. You can also couple it with another product called Topaz Denoise, which decreases the amount of noise that is created in the Topaz process. One feature that Topaz has that I especially like is its presets. Normally, I find most presets never seem to have a template that I need! But Topaz offers a great system for viewing templates through very useful preview thumbnails. Now *this* is a fun product!

Check out this Topaz Labs product:

- **Topaz Photoshop Bundle.** *Approximate cost: $139; use the coupon code STUCKINCUSTOMS for 10 percent off*

NIK SOFTWARE

Nik Software (www.niksoftware.com) also produces some fun products. Its software is quite robust and allows you to do thousands of things with its apps. The two applications I use most are Color Efex Pro and Silver Efex Pro.

Topaz Adjust features a very easy to use interface that can make a photo pop in unexpected ways.

Downtown Houston using the Film Effects treatment—one of the 52 filters that Color Efex features.

An image of a shop in Buenos Aires, Argentina; I used the Tonal Contrast filter on this image.

This is just one of many dozens of default treatments in Silver Efex. Each treatment can be further refined as the photo dictates.

Color Efex has a rich interface that lets you use a variety of filters on your photo. There are so many filters that I couldn't possibly describe them all here. In the following figure, you can see the various filters listed on the left. In the right column, you can see how each of those filters has various levels of granularity. There are so many adjustments you can do on the right that it's quite overwhelming! But it's overwhelming in a good way. Do you recall that I mentioned that my tools are like mysterious friends? Well, this is one of those very complex friends that will always reveal something different and interesting with every visit.

Silver Efex is invaluable for black and white conversions. But perhaps you believe as I used to that you can do great black and white conversions in Photoshop. Well not like this! Silver Efex is truly amazing. Not only does it have a wide range of presets, but the micro adjustment you can do after applying a preset is enough to make Ansel spin in his black and white coffin.

Check out these Nik Software products:

- *Color Efex Pro. Approximate cost: $99 to $299 depending on how many filters you want; use the coupon code STUCKINCUSTOMS for 15 percent off (www.niksoftware.com/colorefexpro)*

- *Silver Efex Pro. Approximate cost: $199; use the same coupon code for 15 percent off (www.niksoftware.com/silverefexpro)*

- *Complete Collection. Nik also offers a Complete Collection that includes the two preceding applications and many other products for approximately $599.*

LUCIS PRO

Lucis (www.lucispro.com) makes a very different and interesting line of software. Its two products are Lucis Pro and LucisArt. The latter is a more limited and inexpensive version that has less functionality.

You'll find an extensive Lucis Pro tutorial on StuckInCustoms.com that shows how it can be used on its own to produce HDR-like results.

I frequently use Lucis Pro toward the end of the process to add sharpness and "pop" to the photo. People often ask me, "Do you use Lucis or Topaz more?" Really, it's about 50/50. It's quite hard to recommend one over the other because they are both so different. Each is useful in its own way.

Regular users of Lucis Pro end up having a fairly acute eye. Sometimes, I'll post a photo and will receive a comment from a viewer who will know that it's seen a touch of Lucis. The software applies a different look that is difficult to describe, but just like the elusive definition of pornography, you know it when you see it.

LucisArt is fantastic for getting in and adjusting the contrast on a small scale. It can help give your images definition and edges.

Check out these Lucis products:

- **Lucis Pro.** *Approximate cost: $595; use the discount code TREYRATCLIFF for $70 off (www.lucispro.com/homepage1. htm)*

- **LucisArt ED.** *Approximate cost: $279; use the discount code TREYRATCLIFF for $50 off (www.lucisart.com)*

Lucis Pro is a more robust product that can be used to make tremendous adjustments to your images. In this image, I have only used Lucis Pro to achieve this look (no HDR treatment was made with Photomatix first).

GENUINE FRACTALS

Genuine Fractals is a wonderful program for increasing the size of your photos without losing quality. Not only do I use it, but so do many of the professional print houses that need to make large prints.

Even though making large prints may not be on your horizon, there is another unexpected use for this program. Sometimes, you will have a wonderful photo that can actually be sliced and diced many different ways. You could even put a crop around a small area and still have a very interesting photo. If you crop too small, you'll lose all the

resolution. Genuine Fractals can help stretch it back to normal size.

You can also use Photoshop to increase the size of the photo, but it does not do nearly as good a job of "guessing" as Genuine Fractals. Download the trial version and try doing side-by-side examples to see what I mean.

The company, onOne Software (www.ononesoftware.com), also makes a number of other great software products. Its suite has a cornucopia of fun! I am just now starting to explore all the various tools in this package and am finding some very useful features.

Check out these onOne Software products:

- ***Genuine Fractals 6.*** *Approximate cost: $159; use the discount code STUCKINCUSTOMS (www.ononesoftware.com/products/genuine_fractals.php)*

- ***Genuine Fractals 6 Professional.*** *Approximate cost: $299; use the preceding discount code and URL*

- ***Plug-in Suite 4.5.*** *(Contains the preceding products and many more tools.) Approximate cost: $499; use the same discount code (www.ononesoftware.com/detail.php?prodLine_id=8)*

Genuine Fractals lets you dramatically increase the size of the image using this UI. Also integrated into the stretching process is a sharpening filter that is adjustable and works quite well.

DROBO

Backing up photography has always been a problem for me. I used to have a bulletproof 17-step process for backing up all my files. The only problem with it was that I would forget which drive had what on it. So then I would create a whole new system that had 18 bulletproof steps.

In walks the Drobo. It completes me.

The Drobo, by Data Robotics, Inc., is an external box that holds multiple hard drives. All you do is slide in SATA hard drives (no screws required); the result is a massive drive that holds terabytes upon terabytes. It's completely idiot-proof and requires only a one-step process. I simply select my files in the OS and drop them on the Drobo.

The Drobo is redundant. So if one of the drives in your Drobo fails, the remaining drives contain a copy. Visit the Data Robotics Web site at www.drobo.com and view a short video that shows how it all works.

Check out this Data Robotics product:

- **Drobo.** *Approximate cost: $399; use the coupon code STUCKINCUSTOMS to save $25 (www.drobo.com)*

BACKBLAZE

Backblaze is another backup solution that I use in addition to the Drobo. Backblaze takes all my files and backs them up onto the Web (the cloud). It's important to have offsite storage in case of a house fire or burglary. If you do lose your local data, Backblaze will even send you a complete DVD containing all your data overnight. And all this for $5 a month? What a deal!

Even if you don't have a mission-critical photography portfolio, I still recommend Backblaze for your family photos. They might not be financially important, but they're worth a million dollars to you.

Check out this Backblaze product:

- **Backblaze.** *Approximate cost: $5 a month for unlimited storage; browse to www.backblaze.com/stuckincustoms to save 10 percent*

INDEX